# THE RE
# WUTHERING
# HEIGHTS

## THE STORY OF
## THE WITHINS FARMS

STEVEN WOOD & PETER BREARS

ADDITIONAL PHOTOGRAPHY BY ANNI VASSALLO

AMBERLEY

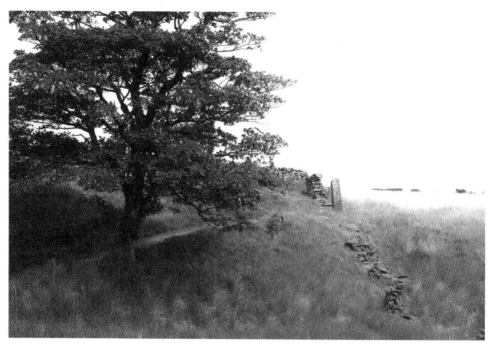

Foxgloves and rushes by the sycamore on what was Lower Withins Land (*Anni Vassallo*).

*In memory of Michael Baumber, 1935–2015,*
*Haworth historian.*

First published 2016

Amberley Publishing
The Hill, Stroud
Gloucestershire, GL5 4EP

www.amberley-books.com

Copyright © Steven Wood & Peter Brears, 2016

Front cover image by Anni Vassallo
Back cover image: the Tack family of Ingrow at
Top Withins, c. 1920

The right of Steven Wood and Peter Brears to
be identified as the Authors of this work has
been asserted in accordance with the Copyrights,
Designs and Patents Act 1988.

ISBN 978 1 4456 5343 3 (print)
ISBN 978 1 4456 5344 0 (ebook)

British Library Cataloguing in Publication Data.
A catalogue record for this book is available from
the British Library.

Typesetting by Amberley Publishing.
Printed in the UK.

# CONTENTS

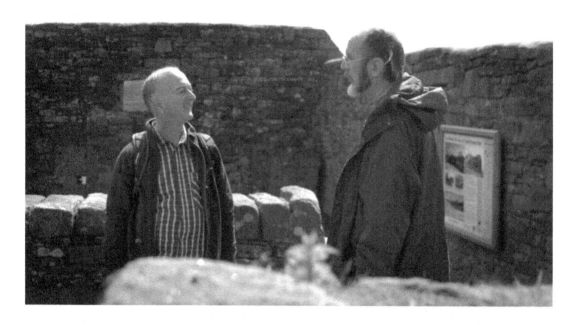

Steven Wood and Tony Robinson at Top Withins. (Photograph Wildfire Television / Channel 4)

# PREFACE

In June 2014 I was in Yorkshire for a new series of *Walking Through History*. The episode I was filming told the story of the Brontë sisters from their births in Thornton to their final resting place in Haworth. The highest and most remote part of my walk was on Stanbury Moor around Top Withins, the supposed site of Emily Brontë's *Wuthering Heights*.

There I spoke to Haworth historian Steven Wood about the lives of the farmers on that wild moorland farm. He was able to tell us far more than we could possibly use in our programme. For instance, our director was particularly interested to discover that the Withins had principally been dairy rather than sheep farms, but that bit of the interview fluttered down to the cutting room floor.

Steven later sent us lots of old photographs and maps for the programme. Among the pictures we simply didn't have time to include were some wonderful drawings of the interior of Top Withins as it was in the Brontës' time. These were drawn by Peter Brears, a leading authority on past domestic life.

I was very pleased when I found out that Steven and Peter were going to write a book about the Withins farms. It tells the full story of the three little hill farms at Withins and the people who lived and worked there, and is richly illustrated with splendid old photographs and maps and Peter Brears' fascinating drawings of Top Withins as it used to be. This book will delight anybody who is interested in the history of the Yorkshire Pennines or who loves Emily Brontë's *Wuthering Heights*.

Tony Robinson
January 2015

# INTRODUCTION

Every year thousands of local and international visitors to Haworth and 'Brontëland' follow the 3-mile moorland track up to Top Withins, the ruined farmhouse popularly believed to be the original 'Wuthering Heights' of Emily Brontë's dramatic novel. To perform this pilgrimage has become an essential rite of passage for all Brontë enthusiasts. This route passes through some of the most characteristic of South Pennines landscapes, an area of high heather moorland and rough pastures enclosed by miles of drystone wall. Seeing nothing more than the few remaining sheep, they gain the impression that this had always been an area of bleak, unproductive desolation, nothing either in the landscape or in any available literature suggesting any previous period of prosperity. However, nothing could be further from the truth, for this area was a highly important production centre for the international textile trade for over 300 years.

This book, the first in-depth study of an upland South Pennine community, brings together the widest variety of sources to present a detailed account of its social, agricultural and domestic life, along with its distinctive vernacular architecture and material culture. Originally colonised as an island enclosure completely surrounded by the moors by the 1560s, the Withins flourished from the income generated by the dual economy of wool and dairy farming supported by the production of sheep, poultry, a few pigs and crops such as oats, largely for home consumption. The resources of the moors were also exploited: stone for buildings, peat and coal for fuel, and the copious springs of soft water for domestic and wool-processing purposes.

In the following chapters the history, development and use of each of the farmsteads is explored, these descriptions enabling the technical progress of wool preparation and weaving to be traced from one century to another. This will be particularly useful to industrial archaeologists and anyone wanting to understand the local textile industry, since it explains many of its confusingly complex processes in simple terms. By combining the evidence of the moor's ruined farmhouses, early drawings, photographs, probate inventories and various other sources, it has been possible to recreate a number of their interiors and explain all manner of fascinating features of the domestic life lived within them.

Unlike many other studies of this kind, a vast amount of archival research has been undertaken to follow the family histories of all those who lived on the moor. This not

only explains their interrelationships, but follows their removals from one farm to another, and their changing occupations, especially during the gradual transfer from domestic to mill or factory textile production from the middle of the nineteenth century. The story of Timmy Feather, the last of the area's traditional handloom weavers, forms a particularly apposite and poignant conclusion to the history of this formerly essential industry. It also follows the depopulation of the landscape, partly due to the decline of handloom weaving, and partly to the banning of cattle from the catchment areas of the new waterworks serving the ever-growing demands of the towns further downstream.

All this will appeal to the general reader interested in the social, industrial and landscape history of the South Pennines and 'Brontëland'. However, it will be especially revealing and enlightening to both seasoned locals and once-in-a-lifetime international Brontë enthusiasts. For their benefit the walk they usually follow has been developed to run from the village of Stanbury (terminus of a convenient bus service from Keighley and Haworth) up to Top Withins or 'Wuthering Heights', and down the South Dean Beck by the Brontë Bridge, Brontë Waterfall and Brontë Seat, back to Haworth. By describing over two dozen farms and numerous other features along its 6-mile route, it reveals the long-hidden stories of the moorlands, transforming their current image as a depopulated, infertile waste into one filled with families actively engaged in successfully earning their livings from its fruitful resources.

We should mention here W. B. Crump's pioneering work, *The Little Hill Farm*, which first appeared in 1938 (a revised edition was issued in 1951): readers will be amply rewarded if they look out for a copy of Crump's scarce little book.

Peter Brears, Leeds
Steven Wood, Haworth
July 2015

Sunlight raking along the Sladen Valley, a view from Middle Withins. The trees of Newton can be seen near the top of the slope on the left (Anni Vassallo).

# ACKNOWLEDGEMENTS

We have been helped by very many people, more or less directly, in the course of preparing this book. Particular thanks are due to Ann Dinsdale and Lynn Wood who read the whole text at various stages and made valuable suggestions. David Riley made several improvements in Chapter 11. Christine Kayes, a descendant of the Sunderlands of Top Withins, has provided much information and encouragement over the years. Jim Laycock cast an expert eye over the accounts of textile processes while Dr Colin Waters did the same for geology. David Smith's remarkable collection of Haworth Township postcards has, as ever, been an invaluable source of pictures – some reproduced here, others drawn on for information. The late Richard Harland, while solicitor to the Craven Water Board, abstracted the early deeds of the Withins farms. In 2006 he gave these notes to Keighley Local Studies Library. But for his invaluable work, Chapter 1 would probably not exist. The late Michael Baumber's transcriptions of the Withins probate inventories underlie the reconstructions of the interiors of Middle and Top Withins. Susan Houghton typed up all Peter's manuscript chapters (she was very fortunate not to have to deal with Steven's handwriting). Rosemary Cole gave helpful advice on the index.

Tony Robinson kindly provided us with our foreword and Wildfire Television allowed us to use the photographs of him and one of the authors on page 4.

Anni Vassallo spent many days taking splendid photographs of the moors around Withins. One of these can be seen on our front cover.

In addition our thanks are also due to many more who provided information, photographs, access to their property or encouragement of various kinds: Will Atkins, Margaret Barrett, George and Elaine Bingham, Ian Dewhirst, Beryl and David Dodsworth, Avril Foster, John and Miles Greenwood, Karen and Nicholas Gwatkin, the late Harold Horsman, Margaret Jennings, Eddie Kelly, Emily Mayson, Barry Metcalfe, Heather Millard, Hettie Mitchell, Mike and Bridget Pearmain, Daru Rooke, Sarah Walden, Simon Warner, John Webb, Chris and Dave Went.

We are also indebted to the following organisations and their staffs: The Borthwick Institute of Historical Research, Keighley Local Studies Library, Bradford Local Studies Library, the Bradford and Leeds offices of the West Yorkshire Archive Service and the Ordnance Survey.

Apologies to any whose names have escaped the net. Any errors that remain, despite all this help, are entirely our responsibility.

# 1

# HISTORY OF WITHINS,
# 1567 TO 1813

High in the headwaters of the South Dean Beck on Stanbury Moor there stands a ruined farmhouse. It was known to those who lived there as Top Withins* but is internationally famous as 'Wuthering Heights'. The connection with Emily Brontë's novel draws many thousands of pilgrims every year to a ruin which would otherwise be passed only by walkers on the Pennine Way who would scarcely give it a glance. Indeed, were it not for the Brontë connection, there would be little left to attract attention.

It was in March 1872 that George Smith of Smith, Elder & Co. wrote to Charlotte Brontë's friend Ellen Nussey asking for her assistance with a new, illustrated edition of the Brontë novels. The artist Wimperis was to visit Yorkshire to make sketches of scenes from the novels and wanted information from Miss Nussey about the places which inspired them. Unfortunately Ellen Nussey's reply does not survive, but we know that it was written as George Smith thanked her for it in a second letter in May 1872.

The resulting engraving which appeared in the 1873 illustrated edition of *Wuthering Heights* is clearly recognisable as the upper part of the South Dean valley. Lower and Middle Withins are represented accurately but in the position occupied

---

* There is some confusion over the spelling of the name: is it Withins or Withens? Both of these spellings have occurred frequently in recent writing. Since the first appearance of the name in 1567 there have been a number of different spellings used in the records. From the early deeds, parish registers, monumental inscriptions, rating valuations, tithe award and census returns we have (with the first and last dates of their appearance): (the) Wythens (1567–1653), (the) Wythins (1567–1691), (the) Withins (1591–present), Withen (1608–53), Wythin (1620 only in the field name Wythin Hyll), Withings (1672–1743), Withens (1715–1850), Writhins (1719–28), Whithings (1745), Within (1786). Smith (PNWRY) also notes the spelling 'Withnis' which he quotes from a will of 1644. He notes that the name is derived from the Old English wīðign (willow). The nineteenth-century sources are almost unanimous in preferring Withins, only the tithe award of 1850 opts for Withens. Both authors of the present work have independently jettisoned their preferred spelling 'Withens' in favour of 'Withins', largely because that is the Ordnance Survey's spelling.

by Top Withins, Wimperis has placed a much more imposing building to represent Heathcliff's house.[†]

Few visitors will be aware of it but this is the tenuous link which draws them to Top Withins and which has had a marked effect on the fate (and fame) of the building.

Top Withins was just one of three farms which scraped a living from around 100 acres of enclosed land on Stanbury and Haworth Moors for 300 years or more. Lacking the Brontë connection, the other two – Middle and Lower, or Near, Withins – are much more ruinous and will be noticed by few of those who pass on their way to 'Wuthering Heights'. Unusually the three Withins farms are separated from their next nearest neighbours by a strip of moorland that has never been brought into cultivation. This is the only example in Haworth township of an island of cultivation on the moor (with the possible exception of Woodcock Hall in Oxenhope).

We do not know when people first enclosed and cultivated land at Withins but it was during a period of rapid population growth in the sixteenth century and certainly before 1567. In that year Thomas Crawshaye 'of Wythens in the County of York, yeoman' and his sister Anne sold their Withins property to George Bentley, clothier, of Sowerby. The property consisted of 16 acres of land and 'the edifices thereon builded' and the whole cost Bentley £44. These 16 acres are likely to have been customary acres rather than statute acres. This means we cannot know the precise extent of the land at Withins in 1567 but it was probably around 16–24 acres. This seems to suggest that there was a single farm at that time.

In 1591 William Bentley left his Withins estate to his three sons, Martyn (the oldest), Luke and John (the youngest). Each had an equal share of the property and it is clear that there were three farms at Withins by this time. It is difficult to say which brother had which farm but such evidence as there is seems to point to Luke, Martyn and John having owned Top, Middle and Lower Withins respectively. William Bentley made provisions in his will to avoid disputes between the three brothers. The rights of each over the properties of his brothers were carefully specified. The watering place for animals and the well house were on Martyn's land while the delf, or stone quarry, was on Luke's land. Luke and John had the right to use the well house and watering place on Martyn's land. John had the right to get stone from Luke's quarry. It seems to have been John's job to maintain the walls between the three farms and the stone was to be used for this purpose.

---

† Groups of two or three farms with the same name are quite common in the Haworth area and are often distinguished by qualifiers such as Near, Bottom, Low, Lower, Middle, Far, Upper and Top. All too often, particularly in earlier sources, no such differentiation is made. Obviously it has been desirable to fix upon standard forms for the three Withins farms for this book. The 1813 valuation is the first source to make a distinction: Withins Bottom, Withins and Withins Top being the forms it uses. The 1850 tithe map uses Near Withins, Middle Withins and Top of Withins. The census of 1901 uses Lower Withins, Middle Withins and Top Withins. The Ordnance Survey maps and plans do not distinguish the upper two farms but use Lower Withins for the bottom farm. In other twentieth-century sources we find Top Withins being called Upper Withins and Far Withins. After considering all these records we have chosen to use the names Lower, Middle and Top Withins.

The early deeds mention a number of fields by name: Helywell Field, Calfheye, Wilheye, Cabbage, Four Nooked Close and Wynewell. All of these probably belonged to Middle Withins. In 1653 there was a reference to Calfhey as the new name for what was anciently called Willhey, although both are already named in 1591. Perhaps Willhey was absorbed into Calfhey. Cabbage, Four Nooked Close and Wynewell appear to have been created from the old Helywell Field some time before 1620.

In the court rolls for 1612 there is a record of John Bentley of Wythins being fined ten shillings for putting more cattle on the wastes of Haworth than he could maintain in summer.

There is mention of arable land at Withins in 1591. In 1620 there were three arable closes at Middle Withins forming at least parts of Cabbage, Four Nooked Close and Wynewell. It seems very likely that the principal crop would be oats, which formed the staple diet of many in the Yorkshire Pennines until the early twentieth century. The field name Cabbage probably reflected the growing of some green vegetables either for the table or for fodder.

The deed of 1620 also mentions that Middle Withins had a 'lathe or barn' on Within Hill. The site of this laithe is still clearly visible on the ground.

These three Bentleys are described as clothiers, as was their ancestor George Bentley in 1567. The Bentleys' earnings from the textile trade would have helped to finance the development of the Withins farms. Until the eighteenth century wool from local moorland sheep would have been carded, spun and woven into woollen cloth. By 1720 woollen manufacture was giving way to the weaving of shalloons – a worsted cloth. These were woven from a long stapled wool that would have had to be brought in from lower-lying land in Lincolnshire and other counties. As we shall see the domestic production of worsted cloth continued to support the farms at Withins well into the nineteenth century.

Successive generations of Bentleys continued to live at Withins and extended the cultivated land. In 1640 there was mention of an estimated 25 acres of meadows and pastures called the Newlands.

The Bentleys owned the three messuages at Withins until 1691 when they sold the estate to William Midgley, Lord of the Manor of Haworth. By this time the Bentleys themselves were no longer living at Withins which was occupied by John and Joseph Crabtree. John Crabtree was already living at Withins in 1688 according to the manorial records (Whone, 1946). By 1620 John Bentley had already moved to Northowram and let Middle Withins to Abraham Hanson. We do not know which John Bentley this was: whether Martyn's younger brother or some other relative. Other tenants who are mentioned in the deeds are Richard Dryver (1653), John Ickorngill (1653 and 1657), John Holmes (1670), Paul Greenwood (1682/3), John Ramsden (1682/3) and John Smith (1682/3).

It might be mentioned here that a number of early occupants of the Withins farms are mentioned in the Haworth parish registers. Some of these families we know about but many are otherwise unknown. The families mentioned with dates (and number of appearances in the registers) are: Crabtree 1715–23 (4), Driver 1668–77 (8), Fe(a)ther 1793–1810 (11), Greenwood 1672–1719 (2), Holdsworth 1792–1801 (5), Hopkinson 1678 (2), Jackson 1788–1812 (6), Kay 1676 (1), Moore 1806–12 (5), Sharp 1725–26 (3), Sunderland 1719–1812 (10).

The simple picture of the Withins estate being sold by the Bentleys to William Midgley in 1691 is complicated by a number of earlier conveyances of what was probably Middle Withins: Bentley to Wheelwright (1653), Wheelwright to Pighells (1657) and Pighells to Crabtree (1670). Adding to the complication is a probate inventory of the property of Jonas Wheelwright of Withins dated 1696. It is not at all clear what was happening during the second half of the seventeenth century. What is clear is that the whole of the Withins estate had passed from the Bentleys to William Midgley by the end of the century.

The deed of 1670 referred to above is the first time we hear the name Crabtree in connection with Withins. Whatever the nature of the interest that John Crabtree acquired in that year we do know that by 1679 he was living at Withins. In 1679 he enclosed a further 4 acres from the moor. The newly enclosed land seems likely to have been around Stones and New Laithe at Top Withins. New Laithe was first named in 1717 when John Crabtree inherited it from his grandfather of the same name. There is a 1723 inventory of the possessions of John Crabtree of Withins. It refers to three properties: 'the upper farm', 'the lower farm' and 'at Stanbury'. It includes a surprisingly large valuation for animals including £40 worth of sheep, £33 worth of beasts as well as a horse and a pig. Presumably these represent the stock of the three farms mentioned. It is interesting to note that the upper farm had grass valued at £3 and no corn. The 'lower farm' had grass and corn worth £10. The textile equipment which is listed (looms, spinning wheels, a reel, and combs as well as wool and worsted yarn) makes it quite clear that worsted was being woven at Withins by this date. In 1770 another John Crabtree left Top Withins to his son Jonas. At that time it was tenanted by Joseph Kershaw. The Crabtrees and their collateral descendants, the Sunderlands, lived at Top Withins until it was abandoned at the end of the nineteenth century.

In 1723 David Midgley made provision in his will for ten poor Haworth children under the age of seven to be clothed 'with good and convenient clothes of blue and other necessary wearing apparel' each winter. The money for this charity was derived from the rents and profits of Middle Withins. This provision of clothes was still going on as late as 1929.

In 1743 Nathan Midgley and Timothy Horsefield (or Horsefall), the owners, had the farm at Top Withins extensively rebuilt. Three stone masons, Joseph Pighills, Isaac Heaton and Matthew Whalley, contracted to pull the old house down and to build new walls, carve new windows and reroof the building with thackstones.

Captain Joseph Midgley sold Middle Withins, along with the Lordship of the Manor of Haworth, to Edward Ferrand in 1811 (Whone 1946). Top Withins was already owned by the Crabtrees by this date. Who owned Lower Withins is uncertain but it is clear that by 1813 the Midgleys had sold all three farms.

This history of Withins up to the early nineteenth century is largely derived from abstracts made by the late Richard Harland from deeds formerly held by the Craven Water Board. Starting with a valuation of 1813 we have other, more detailed, sources of information that make it possible to deal with each of the three farms individually from then on.

# 2

# FARMING AT WITHINS

Those who walk along the Pennine Way up to Withins today see a desolate and deserted landscape, its stone-walled fields enclosing only rough pasture, some being little better than rushy peat bog or open moor. Its three farmsteads are all decayed ruins, emphasising the impression that this was always a harsh, impoverished and unproductive environment. In fact, its history shows that, quite to the contrary, Withins was a financial success for over 300 years, ever since it was enclosed from the surrounding moorland sometime before the mid-sixteenth century. It prospered on the dual economy of farming and textile production, forming part of the great West Riding woollen industry as it absorbed and replaced that of the medieval weavers of York, Beverley, Lincoln and East Anglia. Here there were no guilds to restrict production and trade, and land, food and labour costs were all comparatively cheap. It was the efficiency of local farming/clothier families such as those at Withins that enabled the industrial West Riding to become the centre of the worldwide trade in woollen cloth, with merchants attending cloth markets in each of its major towns and exporting its products throughout Europe and the Americas.

The Elizabethan entrepreneurs who first settled here had to invest a daunting amount of time and labour into the conversion of bleak, high-altitude acidic heather moor into productive pasture, meadow and arable land. First the loose stones and boulders had to be collected and broken up, and a quarry opened to produce sufficient material to build drystone walls, initially to separate the whole Withins enclosure from the moor, and then to divide it up into separate holdings and closes. Since the surface soil was a mass of stones bound together with the tough, entwined roots of heather and field-rush, it had then to be dug over by hand, since it was far too intractable for even the strongest plough. Dressing with calcined limestone carried here from the Yorkshire–Lancashire border, together with the spreading of manure, were then essential in order to fertilise the sterile soil, and make it productive. No one would ever undertake such a formidable task without the expectation of profitable returns, and the existence of a good market for their produce.

The traditional diet of the South Pennines and upland West Riding was almost entirely based on oats, eaten as porridge and oatcake, beef, usually salted down for winter use, lesser amounts of mutton, and pork in the form of ham and bacon. Vegetables such as cabbages, onions and potatoes were usually grown in small garden

plots, rather than as field crops, and there was a constant demand for dairy produce in the form of butter, skimmed milk for drinking, skimmed-milk cheese and eggs. As may still be seen in Haworth and its surrounding hamlets, most of the local weavers' cottages had either no adjoining land, or at best a small croft on which to keep a pig, poultry or use as an allotment. All their main subsistence foods had to be bought in, thus providing the Withins farms with a constant and expanding demand for their produce.

The context in which local farms operated in the seventeenth century has been studied by W. Harwood Long, using the evidence of almost 1,000 probate inventories, the lists of a person's possessions taken just after they had died. These show that the wealth of an average West Riding hill-farmer/weaver was around £50 – slightly more than his contemporaries in the infertile northern Dales and North Yorkshire Moors, but far less than the £83–£119 of those farming the productive lands of Holderness or the Wolds. As to the relative importance of his various products, almost half was dedicated to cattle and the hay used to feed them over the winter months:[1]

| | | | |
|---|---|---|---|
| Cattle | £21.00 | or | 42.2% |
| Hay | £2.50 | | 4.9% |
| Sheep | £5.00 | | 9.5% |
| Horses | £5.00 | | 10.1% |
| Pigs, poultry, bees | £0.50 | | 1.0% |
| Equipment | £4.00 | | 7.6% |
| Miscellaneous items | £2.00 | | 3.7% |
| Corn | £10.00 | | 21.0% |
| TOTAL | £50.00 | | |

The value of the corn, amounting to one-fifth of the whole, is rather misleading, for although some hill farms grew oats largely for their own consumption, this region depended heavily on the oats, barley and wheat brought in from the Wolds, and paid for from the profits of the cloth trade.

It is interesting to compare these average local values with those of contemporary inhabitants at Withins, such as Jonas Wheelwright who died in 1696, using the same headings as closely as possible:

| | | | |
|---|---|---|---|
| Cattle | c. £8.00 | or | 50% |
| Hay | c. £1.00 | | 6% |
| Sheep | £2.00 | | 12% |
| Horses | c. £2.00 | | 12% |
| Pigs etc. | nil | | |
| Farming Equipment | nil | | |
| Corn | c. £3.00 | | 19% |
| TOTAL | £16.00 (or 21% of his entire estate) | | |

and of John Crabtree who died in 1723:

| | | | |
|---|---|---|---|
| Cattle | £33.00 | or | 31% |
| Hay/grass | £22 4s. | | 22% |
| Sheep | £40 10s. | | 38% |
| Horse | £ 4.00 | | 4% |
| Pig | 16s. | | 0.8% |
| Farming equipment | £2 13s. 6d. | | 2% |
| Misc. items | £1.00 | | 0.9% |
| Corn | £2.00 | | 2% |
| TOTAL | £106 3s. 6d. (or 73% of his entire estate) | | |

Representing the poorer and wealthier of the Withins farmers, these accounts both stress the importance of cattle and their hay, which make up over half the value of their land use. Some of the bull calves might be sold off over the summer as veal, while the remainder were usually castrated and kept for a year or more to be sold as oxen, particularly in the autumn to provide salt-beef for the weavers' winter dinners. In contrast, the female heifers were kept on as milch-cows, fed on grass from spring through to autumn, and then over-wintered in barns. Each of the Withins farms had a barn either directly adjoining or adjacent to its farmhouse, with a loft above to store the hay and a mistal below with stalls in which the cows were tethered. Here they could be conveniently milked, the cream being separated and turned into butter, and the skim-milk made ready for sale in the farm dairy. Such was the demand for these products that each farm built a detached field-barn to house more cows. Middle Withins had one on 'Wythin Hill' by 1620, the foundations (at SD 99753575) showing it to have measured some 36 by 24 feet, divided internally into two separate rooms. A few hundred yards to the south-west of Lower Withins stood Heys Laithe, which measured some 40 by 30 feet, and incorporated a sink, probably for dairy use. Middle Withins had a later field barn, known as Jack House, which lay around 130 yards north of its farmhouse, where only its overgrown foundations now remain. Top Withins' field barn, the New Laithe, first named as such in 1717 but perhaps dating from the enclosure of its meadow in 1679, still stands as a roofless ruin across the South Dean beck at SD 98293523, one end being used as a mistal, and the other probably as a dairy. From the three farmhouse dairies and the supplementary dairies in the field barns, skim-milk, cheese and butter would have been carried down for sale in Stanbury and Haworth to provide a reliable and constant source of income.

Sheep represented some 10 per cent of the value of most local farmers' stock, since they made the best use of the rough grazing provided by the unenclosed moorland. Unlike cattle that would wander off, they could be largely left to their own devices on their accustomed patch. Their coarse wool was largely unsuitable for the production of good-quality cloth, and so tended to be sold off at a cheaper rate than the better, lowland wool brought in for textile production. However, they also produced income from the sale to the butchers of lamb in the summer and mutton in the winter.

John Crabtree's 38 per cent value of sheep, suggesting a flock of around 160, is quite exceptional. He certainly would not have used their wool for his worsted cloths, but may have found them more profitable to serve the local market for fresh meat. As for pigs, these were usually kept for the farmer's own use, just one or two being killed each year to provide bacon and ham for him and his family.

In locations such as Withins, the possession of a horse was particularly important as a means of transport, acting as a pack animal to carry loads of wool, oatmeal, peat and lime up to the farms, manure into the fields, and woven pieces of cloth down to the fulling mills and to the cloth markets in the town. They could also pull a plough to prepare the few arable fields for crops of oats. The height, slope and exposure of the fields around Top Withins, at around 1,380 feet or 423 metres above sea level, make it very unlikely that any crops were ever grown here, and there are no remains of ploughed fields. However, the appearance of '1 plough and harrow and other things belonging' in John Crabtree's inventory of Middle Withins confirms that he was raising corn, probably for his own use. Jonas Wheelwright's 'corn' and 'oatmeal and wheat in the barn' is of particular interest, since it suggests that not only the expected oats but also wheat was being grown at Lower Withins around 1700. This must have been something of a gamble however, for it is hardly suitable for fields of poor soil in a wet and windy height of over 1200 feet or 370 metres, with an average of only 3½ hours of sunshine each day. When Joshua Sunderland was farming the Withins Allotment in 1856 he sowed his seed corn, almost certainly oats, on 5/6 March, perhaps after the worst of the snow had melted. Having reaped it and propped the sheaves together into 'hattocks' (stooks) at the end of September, it never dried. As his diary records, it could not be 'got in till the latter end of Octr. & then in a very wet and growing stait'. All his efforts had been in vain, the crop being almost impossible to thresh and now unfit for anything except for feeding in very small quantities to his livestock. Too much would give them dangerous attacks of colic.

The factor that made farming possible at Withins was the wool textile industry, for without the income it produced it would have been virtually impossible to earn a living from the land alone. It is no coincidence that its desertion and gradual return to nature followed the collapse of the handloom weaving trade and then the closure of the textile mills. From the sixteenth century the local woollen industry had progressed through a number of developing stages. At first it concentrated on woollen cloths made almost entirely within each farmstead, then moving on to worsted cloths of combed long-wool, and eventually to weaving alone, using yarn brought in from the spinning mills. Purely by chance, each of these consecutive phases is illustrated by documents relating to each of the Withins properties, starting at Lower Withins and finishing at Top Withins, as described in the following chapters.

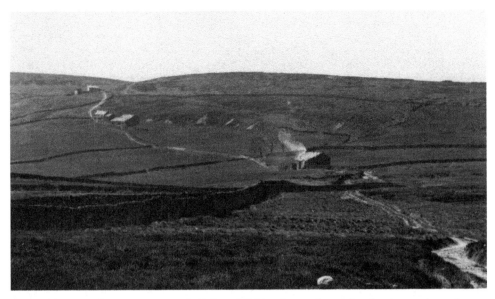

An early twentieth-century view of all three Withins farms. Some details, the smoke at Lower Withins and the track between Middle and Top Withins, have been added by the photographer.

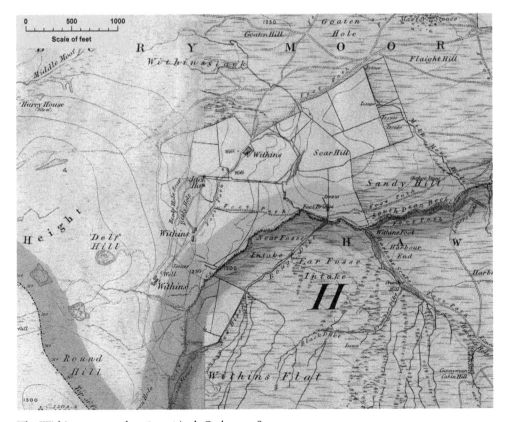

The Withins area on the 1852 6-inch Ordnance Survey map.

# 3

# LOWER WITHINS

Since the remains of the farmhouse at Lower Withins are now largely buried beneath collapsed walls and are heavily overgrown, it is difficult to determine its architectural development. There was certainly a stone-built farmhouse here in the second half of the sixteenth century, since the sill of a mullioned and iron-barred window with the same hollow chamfers as those at Top Withins still remains in the north-western part of the barn. This suggests that the original house, about the same size as Middle Withins, occupied this space.

At a later date, perhaps in the late eighteenth or early nineteenth centuries, a major rebuilding took place, initially with the conversion of the house (or barn?) into a larger barn, with an extension along the front wall incorporating a large arched doorway. All of this was built in the regular coursed gritstone typical of this region and date. The next stage was to add (or rebuild?) a new farmhouse against the south-western wall of the original house, to which its walls abut. Its doorway and mullioned windows were all flat-faced in common with those found on many other local houses built from around the mid-eighteenth up into the twentieth century. Sometime before the 1840s, when the first Ordnance Survey was undertaken, a porch resembling that at Top Withins was added to the door, offering essential protection from the elements. Having fallen out of use in the early twentieth century, Lower Withins was demolished around 1930, leaving only parts of its front wall and parts of its yard wall standing a few courses high (see Pl.3).

Around 150 yards to the south-west of Lower Withins the trackway takes a rapid turn to the west close to a tree and a stream. Within this angle a level platform has been formed, measuring some 40 by 30 feet, bounded by walls to the north and east. These are the remains of a large barn that had its doorway at the northern end of the eastern wall, and a sink set into its northern wall. The recess for the sink still remains, but its original rectangular basin, which narrowed to a spout projecting through the exterior, was unfortunately removed some years ago. Sinks such as this are particularly rare in barns, since they were unnecessary for keeping either hay or cattle. They were useful in dairies however, suggesting that this corner of the barn was intended for processing the milk from milch-cows housed here indoors over the winter months. The stream here, together with the 'well' shown on the first edition Ordnance Survey maps (by which time the barn

had already disappeared), would have provided all the water needed for the cows, and to clean dairy utensils, etc.

When Jonas Wheelwright of Withins, yeoman, died in 1696, a detailed inventory or priced list of all his moveable goods and assets was made by John Crabtree of Middle Withins, Thomas Midgley and Richard Wheelwright. This had to be submitted to the consistory court at York Minster by his executors, in order for them to obtain probate and administer his estate.

| | |
|---|---|
| Imprimis his purse and apparel | £3 |
| 1 cupboard in the house and pewter | £1 5s. |
| 1 chest and ark in the house | £1 |
| 1 board, 3 pans and 2 chairs | 12s. |
| 1 bed and bedding and 1 chest in the parlour | £1 10s. |
| 1 pair of looms and warping rings and an ark in the chamber | 17s. 4d. |
| 3 cows, 2 heifers and a mare | £10 |
| In corn & hay | £2 |
| 14 sheep | £2 |
| In oatmeal & wheat in barn | £2 |
| 1 bond of £30 of John Hanson & James Hartley of the County of Lancaster | £30 |
| 1 bond of £20 of John Shackleton & Geoffrey Shackleton of the County of Lancaster | £20 |
| In wooden vessels, spinning wheels and all other hustlement whatever | 10s. |
| The sum of the whole inventory | £74 14s. 4d. |

*Transcribed by Michael Baumber from the original at the Borthwick Institute*

Unfortunately the tenure of both Top and Lower Withins is uncertain in the late seventeenth century, and this document gives little indication as to which of these was Jonas' home. However, the 'oatmeal and wheat in the barn' strongly suggests that he was living at Lower Withins.

The inventory is of particular interest since it provides a good example of how a typical local yeoman farmer/weaver furnished his house and earned his living. Domestic life was firmly based in the main kitchen/living room, always known as the 'housebody' or 'house' in this region. This contained:

| | |
|---|---|
| 1 cupboard in the house and pewter | £1 5s. |
| 1 chest and ark [for storing oatmeal] | £1 |
| 1 board [a table] and 2 chairs | 12s. |
| In wooden vessels, spinning wheels and all other hustlement [miscellaneous items] whatever | 10s. |

Adjoining the housebody on the ground floor was the parlour. Today this word is understood to mean a sitting-room, but in West Yorkshire up to the mid-eighteenth

century it was still the best bedroom occupied by the master and mistress of the house. Here it had:

> 1 bed and bedding and 1 chest [for clothes and linens] in the parlour       £1 10s.

The upstairs room, called the chamber, was devoted to storage and weaving, having:

> 1 pair of looms and warping rings and an ark [for oatmeal] in the chamber 17s. 4d.

Note here that the expression 'a pair of looms' referred to one, not two, looms.

At this date Jonas Wheelwright would have been weaving 'woollens' generally from fleeces having relatively short fibres. If the sheep had been washed just before shearing and the fleeces were not too greasy, they could be used directly after being divided into their separate qualities by a professional wool-sorter and taken to the markets by a wool-stapler. Most of the wool was brought in from the lowlands and wolds of the Midlands, that of the local moorland sheep being relatively coarse and insufficient in quantity.

The first operation was called willeying,[1] the fleece being laid out on a table and beaten with rods, probably of springy willow, to loosen its locks and knock out any dust or grit. Small locks were then worked between a pair of 'cards', these resembling rectangular table-tennis bats, their leather-covered faces covered with thousands of tiny, fine, sharp wire hooks. The resulting soft, fluffy rolls were then spun into yarn using a great wheel. This had a long, low base-board mounted on three short legs, an almost vertical post at its right end supporting a multi-spoked wheel of three or four feet in diameter with a broad, flat rim. As this was turned with the fingers of the right hand, its loop of cord called a driving band rapidly rotated a horizontal spindle mounted on a second post at the left-hand end of the base-board. Having pulled out and twisted a few fibres from the roll to form a short length of yarn and wound it around the spindle, the actual spinning could begin. Holding the roll in the extended left hand, its fibres were gradually drawn out as it was slowly pulled back at 45° to the spindle, which added enough twist to form up to a couple of yards of yarn. The wheel was then spun rapidly to add more twist, reversed a little as the left hand was moved to 90° to the spindle, and rotated again to gather the yarn onto the spindle. The actions were constantly repeated until the spindle was full, when the yarn was transferred onto a reel or swift. This took the form of a pair of large bobbins set at the top and bottom of a vertical rod, or else a single circular frame mounted on a vertical or horizontal axle onto which the yarn was wound to form a large loop or hank (see Pl. 4).

Half of the yarn was next wound onto warp bobbins, the spinning-wheel now acting as a bobbin-winder. These bobbins were mounted on a frame called a creel and multiple strands were drawn out to produce the warp – the yarn which ran along the length of a piece of cloth. For making the local 'Keighley kerseys' or 'Keighley whites', the warp had to be just over 18 yards long. Jonas Wheelwright prepared his on 'warping rings' mounted on firm posts, just like the 'warpinge stocke with rings and yarn in it' recorded in Manchester in 1588.[2] The usual method however, was to use a 'warping wough' or 'bar-trees', a frame 3½ yards across fixed to an inside wall. This

had a row of long horizontal pegs down each side, the yarn being passed between them in a long zigzag until the required number of warp-threads had accumulated.

If left untreated, the warp yarn tended to break and snag as the shuttle passed across it, and so it was submerged in a weak animal-glue solution called size. Local weavers did this using a sizing-cradle – a cradle-shaped wooden trough with a glazed pottery wringer shaped like an hour-glass with open ends fixed in its hood. After the warp-yarn had been loosely separated and dried, groups of usually forty ends called a 'porty' were each placed between the wooden pegs of a 'raddle' a long comb-like device that spread them out evenly.[3] Once held in place by a long wooden bar running across the top of the raddle, the ends of each porty were tied on to a long rod and then tightly wound on to the warp-beam, the strong wooden roller that fitted across the back of the loom (see Pl. 5).

In order to weave the simplest of cloths, it was necessary to raise alternate yarns in turn so that the shuttle could pass between them with its 'weft' or cross-yarn. To do this each separate yarn had to be hooked through the central eye of a vertical loop of cord called a 'heald' or 'heddle', mounted top and bottom between two pairs of narrow wooden 'heald-shafts'. Cords from the ends of one top shaft passed up and over pulleys to the ends of the other top shaft, so that when one was pulled down by a treddle operated by the weaver's foot, the other rose up, and vice versa. A pair of lease rods was passed between alternate yarns halfway between the warp-beam and the healds to make it much easier for the weaver to identify and mend any that broke.

From the healds, the warp passed through the reed, 'slay' or 'rocking-tree', a series of short, narrow, close-set vertical metal strips mounted between two horizontal wooden bars hung from the top of the loom. Its purpose was to beat the weft back into the woven cloth, to make it firm and even, as it progressively accumulated on the cloth-beam mounted at the front of the loom, directly before the weaver (see Pl. 6).

To do the actual weaving, the remaining half of the hanked yarn was wound from a swift onto a number of long narrow bobbins, called 'pirns', to fit inside the shuttle, the spinning wheel now acting as a pirn-winder. At this date the weaver still had to throw the shuttle from one hand to the other between each alternate opening of the warp threads, or 'shed', as well as working the reed and the treadles, so that weaving remained a relatively slow and laborious process. Another of his tasks was to constantly adjust the 'temple', a pair of parallel wooden laths with pins at their outer ends that kept the selvedges of the cloth an equal distance apart before it rolled onto the cloth-beam. Without this the cloth would gradually become narrow, thick and unweavable.

Having woven his 'piece' of woollen cloth and stripped it from the loom, Jonas Wheelwright would have laid it on the stone-flagged floor of the housebody, soaked it in urine and cow dung and trampled it underfoot to start to felt its fibres together.[4] This process continued down at the local fulling-mill, where it was beaten by the heavy wooden hammers of water-powered fulling stocks. After being rinsed and stretched full-length on parallel rows of beams lined with rows of sharp-pointed iron tenter-hooks to dry for two or three days, it was now ready to be folded up, slung over the back of his mare, and carried off to the cloth markets of Bradford or Halifax.

# 4

# LOWER WITHINS FROM 1813

In 1813 Bottom Withins (as it is called in that record) was owned by George Robinson, the tenant being John Moore. The farm had 24 acres of land of which an unusually high proportion – 12 acres – appears to have been meadow. (The 1813 valuation does not specifically identify meadow land but it does give the value of each plot in shillings per acre. This combined with the field names provides good evidence for which fields were pasture and which were meadow.) One might suspect that Moore was renting extra pasture from another landowner but the valuation does not confirm this. One of Moore's meadows, Little Meadow, had deteriorated by 1838 and had reverted to pasture by 1851. Further pasture was added in the 1830s when the New Intakes were created by Moore's successor. From the baptismal registers it appears that six sons were born to the Moores at or near Duke Top and a further two at Withins. The Moores moved to Withins between 1803 and 1806. Two of their sons died of scarlet fever in 1810. Mary Moore died in 1822 and John Moore of Withins died aged sixty-seven in 1831. Three of their sons appear to have been working as farmers and weavers in the Cold Knoll area in 1851.

By 1838 the ownership of Lower Withins had passed to Isaac Lancaster and the tenant was Simeon Robinson. Thomas Waddington was to join Lancaster as co-owner of Lower Withins by 1851. Their executors still owned the farm in 1863 but ownership had passed to Henry Saville by 1881.

Simeon Robinson was responsible for the intaking of the Allotments (later known as the New Intakes) in the 1830s, which extended the farm to 35 acres. Of these 35 acres around 9 acres were good quality meadow, a further 2½ acres were less good meadow land and the rest was pasture. Simeon Robinson was still at Lower Withins in 1851 at which time the farm was estimated to have nearly 37 acres of land. Whether this was the result of further intaking or a more accurate survey is not clear. 10 of the 37 acres were meadow, the rest being pasture.

At the time of the 1851 census Simeon and Susan Robinson had ten children living at Lower Withins. Two boys and two girls were under the age of ten and were not working. Of those who were working two girls were employed in a local textile mill. The elder (Jane, 17) worked as a power-loom weaver, and the younger (Susannah, 13) was a spinner. The oldest boy (John, 22) was a wool-comber. The next two (Rodger, 18 and William, 15) were handloom weavers and the youngest (Simeon, 10) was a

bobbin winder. The weft yarn, which would be bought from a local mill, was wound onto bobbins (or pirns) by young Simeon to supply the handlooms operated by his older brothers. We cannot know which local mill (or mills) the Robinsons dealt with – probably it would have been Griffe, Ponden or Lumb Foot which were between 1½ and 2½ miles away. Griffe is perhaps the most likely as it was the nearest mill which had both spinning and weaving departments. We do know that the relationship was two-way: the Robinsons provided the mill with combed wool and labour and bought yarn from it. Here we have a good example of the dual economy: a hill farm made viable by textile manufacture. We also see a stage in the transition from domestic to factory production of worsted cloth. In later years the contribution of the textile trade would be entirely in the form of mill employment for the farmers' children.

By 1851 Simeon Robinson was farming land at Upper Height as well as the Lower Withins land and by 1861 he had moved there. The fact that he was living at Middle Withins at the time of the 1871 census, while his family were at Upper Height, suggests that he continued to farm at least some of the Withins land. He remained at Upper Height until his death in 1895 at the age of ninety. His wife Susan had died aged seventy-seven in 1885. They are buried in St Michael's churchyard in Haworth (grave D5).

The Robinsons were succeeded at Lower Withins by Robert and Zillah Jackson and their daughter Carolina and son James. Robert was the younger son of Mary Jackson of Middle Withins. He had married Zillah Sunderland in the late 1840s and farmed at South Dean for some years before moving to Lower Withins. In 1861 Robert Jackson was listed only as a farmer of 37 acres. By this time handloom weaving was in rapid decline but it is rather surprising that the thirteen-year-old Carolina was not working as a spinner. The need for extra income had not gone away however. In 1871 we find Robert Jackson and his seventeen-year-old son James working as reservoir labourers. At that time Keighley Corporation had recently started work on the construction of two large reservoirs in the Worth Valley. The supply reservoir was at Watersheddles in Lancashire and the compensation reservoir was at Ponden. It is likely that the Jacksons worked at Ponden which was only a mile from their farm.

There were two new members of the family in this census: a son John Thomas, aged six, and an unnamed grandchild just one day old. With Robert and James employed in hard manual labour much of the farm work must have fallen to Zillah and Carolina. The birth of Carolina's son can only have made the situation even more difficult.

Ten years later, in 1881, Lower Withins was being farmed by Robert and his younger son John Thomas Jackson. Carolina was working as a dressmaker and now had two illegitimate children, Mallison (or Mallinson) who was ten and a daughter Mary Ann who was two. James Jackson had left home and was working as a quarryman. He and his wife Hannah lived next to his grandfather James Sunderland's farm near Hob Cote in Oakworth.

Robert Jackson was still at Lower Withins in 1885 but he moved to Hob Cote Farm in that or the next year. He died at Hob Cote in 1886 aged sixty-two and is buried at St Michael's with his wife's parents, James (died 1886) and Betty (died 1875) Sunderland (grave D354). Kelly's trade directory for 1889 (Kelly 1889) has an entry for Thomas Jackson at 'Withings' so it looks as though John Thomas Jackson

continued to farm at Lower Withins after his father's death. However, by 1891 John Thomas Jackson was running the farm at Hob Cote where he was living with his mother Zillah. She died at Scar Top in 1898 at the age of seventy-three. Zillah Jackson is buried at Stanbury Cemetery with her elder son James Sunderland Jackson and his wife Hannah (grave A60).

After the departure of the Jacksons Lower Withins was occupied for a while by John Moore whose father farmed the Withins land. He seems to have been the last inhabitant. It was purchased from the Savilles by Keighley Corporation Waterworks in 1903 for £1,100, and they demolished it in 1930.

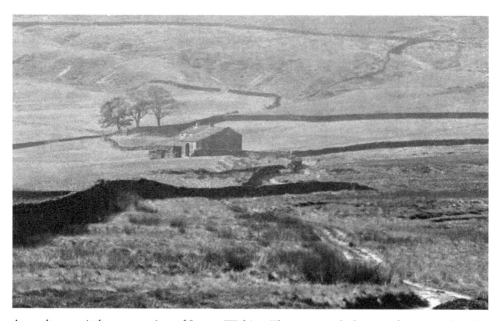

An early twentieth-century view of Lower Withins. The trees mark the site of Heys Laithe. The small valley above the trees is Benty Hole.

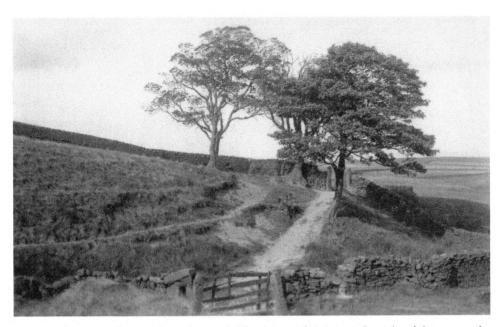

The site of Heys Laithe seen from the south. The dairy sink is just to the right of the tree on the left. The gate in the foreground marks the boundary between the Lower Withins and Middle Withins fields.

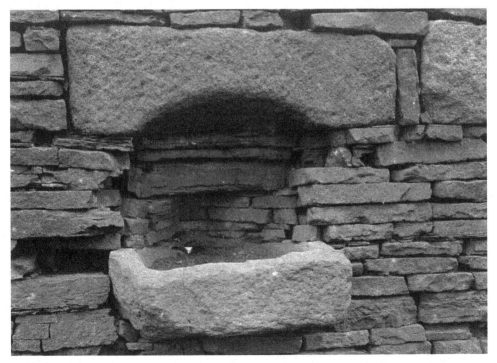

The dairy sink at Heys Laithe. A close-up view of the dairy sink in a photograph taken by the Stanbury schoolmaster Jonas Bradley in 1912.

# 5

# MIDDLE WITHINS

Lying at the centre of the Tudor enclosure of Withins, this was almost certainly the site of the farmhouse sold by Thomas Crawshaye in 1567. No trace of that building is evident today, since it appears to have been rebuilt in the middle to late seventeenth century. Its replacement had a simple rectangular groundplan enclosing a large housebody and a smaller, unheated parlour, entry being by a doorway at one side of the end gable wall.

A number of very similar farmhouses still survive locally, including Middle Deanfield (SD991376), just over a mile to the north, Near and Far Slippery Ford (SE002405 & 001403), 3 miles to the north-north-east, and Clough House, Oakworth, (SE031386), 3 miles to the north-east. Other examples, such as Lower Green Edge, Warley (SE035285) and Flailcroft, Todmorden (SD923248) can be found in the upper Calder Valley to the south. All have been stylistically dated between the middle and later seventeenth century, some having a datestone to confirm any closer dating.

At some later period, perhaps in the mid-eighteenth century, a single-storey extension was added to the cool, north end of the farmhouse. It incorporated a new front door and an entry passage into the farmhouse, as well as a poorly lit single room with a shallow window or wall cupboard along its western wall. Since the doorways are too narrow and awkward to admit cattle, it appears to have been built as a dairy-cum-larder used just like that up at Top Withins. The first-edition Ordnance Survey map shows a small lean-to extension at the southern end of the front wall, this perhaps being the outside toilet (see Pl. 7).

The barn, probably contemporary with the farmhouse, lay almost in line with it, a few yards to the north. Originally a single ridge-roofed building entered by a large door in the middle of its eastern wall, it was later extended to the east to increase its capacity, and then with small outbuildings to the north and south.

Having fallen out of use before c. 1910, when it was photographed with its windows either blocked or broken, Middle Withins and its barn were largely demolished, leaving only the ground floor of the farmhouse intact. Having discovered that the fine mullioned windows on the front wall were about to collapse, County Alderman J. J. Brigg of Kildwick Hall contacted J. Northwood, engineer to the Keighley Borough Waterworks who owned the site, and arranged for them to be repaired. Over April and May 1935 the main six-light window was rebuilt, the wall-top levelled and pointed,

and all the fallen wallstones and roof slates removed to make the ruins safe and tidy for the countless visitors walking from Stanbury or Haworth up to Top Withins. They remained in this state up to the 1960s, after which they gradually crumbled to their present state, with the walls only a few courses high and the interior and frontage heaped with tumbled masonry.

John Crabtree, namesake of his great-grandfather who had rebuilt the farmhouse, died in 1723. As was customary at this period, an inventory of all his goods was prepared by three local men – Colin Redman, Edward Battersby and William Sunderland. It lists the contents of each room in the order taken by its appraisers, showing how they were furnished and used. By combining this information with the evidence of the actual building, it is possible to recreate an accurate tour around the Middle Withins farmstead in 1723 (see Pl. 8).

| 1723 John Crabtree of Withins | |
|---|---|
| Imprimis his purse and apparel | £5 |
| 1 bed and bedding and 2 chairs | £1 8s. |
| 1 clock in the housebody | £2 |
| 1 cupboard, dresser & pewter | £2 17s. 6d. |
| 1 table and long settle | £1 2s. |
| 1 table and coffers | £1 |
| In chairs and cushions | 10s. |
| 2 ranges and other iron things | £1 17s. |
| Bed and bedding in the chamber | £1 or £1 10s. |
| Wool and combs and other washing tools | £2 |
| 2 chests with meal and other things | £2 |
| 2 chests and 2 coffers | £1 |
| Looms | £1 |
| Worsted yarn | £2 |
| Corn sacks | £1 |
| 1 churn and other wood vessels | 11s. |
| Pans and other iron things | £1 6s. |
| Wheels and a reel | 7s. |
| Books | 4s. |
| Carts and wheels | £1 2s. |
| Peat and turves | £1 2s. 6d. |
| Old hays and poles | £1 4s. |
| 1 plough and harrow and other things belonging | £1 11s. 6d. |
| Grass at the upper house | £3 |
| Grass and corn at the lower house | £10 |
| Grass and corn at Stanbury | £8 |
| Sheep | £40 10s. 0d. |
| 1 horse and furniture belonging to him | £4 |
| 1 swine | 16s. |
| 1 bull, 1 ox and other beasts | £33 |

| Grand total | £142 8s. 6d. |
|---|---|
| Debts owing by the widow | 6s. |

Appraisers Colin Redman, Edward Battersby & William Sunderland
*Transcribed by Michael Baumber from the original at the Borthwick Institute*

The front door was located to the right-hand end of the farmhouse, in a slightly later single-storey extension. It led into a long passageway, an ideal area for coats, hats and sticks before and after tending the stock and crops in the surrounding moors and enclosed fields. The first door on the right led into the dairy, where milk was left in the shallow 'wood vessels' for the cream to rise, then being skimmed off, poured into the tall wooden plunge-churn and converted into butter. There was a good local market for both skim-milk to drink or eat with porridge, and for butter, in the local weaving villages.

At the end of the passage the original external doorway to the left led into the housebody. This had its peat fire burning in an iron 'range' on a wide-open hearth, the smoke ascending into a large wattle-and-daub smoke hood supported by a strong oak lintel. To its left a wooden screen called a heck protected it from draughts from the door, while a narrow fire window to its right provided light for cooking. From a high-level bar or rannle-balk high inside the chimney, a number of adjustable pot-hooks called reckons would have been suspended to hold the cooking pots over the fire. These 'pans and other iron things' were valued at £1 6s. 0d. Excluding the hearth, the housebody was a large room, some 19 x 16 feet with a stone-flagged floor and a fine six-light mullioned front window. It was well furnished with:

| | |
|---|---|
| 1 table and long settle | £1 2s. |
| 1 table and coffers | £1 |
| In chairs and cushions | 10s. |
| 1 cupboard, dresser & pewter | £2 17s. 6d. |
| 1 clock in the housebody | £2 |
| Wheels and a reel | 7s. |

There is no direct evidence as to how these were arranged but, if it followed later practice, the main table for practical work was set under the window, with the dining table and its chairs towards the middle of the room. The long settle would have projected from the chimney corner opposite the window to provide a warm and comfortable social area, particularly in the long winter evenings. The clock, cupboard, coffers and dresser, with its display of highly polished pewter, would then have been distributed around the side and back walls.

A door in the wall opposite the fireplace led into the parlour where John Crabtree kept 'his purse and apparel' along with his 'bed and bedding and 2 chairs'.

A staircase, probably rising along the back wall of the housebody from the passage door, led up to the first-floor chambers. These housed the usual range of chests for storing clothes and linens along with the oatmeal needed to make porridge and oatcake for everyday meals, and a second bed:

| 2 chests and 2 coffers | £1 |
| 2 chests with meal and other things | £2 |
| Bed and bedding in the chamber | £1   (or £1 10s.) |

Here too were the tools and equipment required for making worsteds, the fine, smooth-surfaced cloths that had recently started to be made in the South Pennine hills. The earlier woollen cloths of the region had used the shorter-fibred fleeces. These were prepared by dragging small locks between a pair of 'cards', implements resembling rectangular table-tennis bats with leather-covered faces covered in thousands of fine wire hooks. The resulting soft, fluffy 'rollags' were then spun into yarn and woven into woollen cloths, some thick and soft to make blankets. Others were hammered in urine in a fulling-mill to felt their fibres together, stretched and dried on tenter-frames, had their fibres raised with the natural hooks of teazle-heads, cropped to produce a very short even pile, and finally pressed. These cloths, ideal for coats, upholstery, billiard tables etc. continued to be made in the 'White Cloth' area between the Shipley–Leeds section of the Aire Valley and Brighouse–Wakefield section of the Calder Valley, and the 'Coloured Cloth' area stretching diagonally from Shipley to Wakefield.

In contrast, worsteds used the longest fibres of the finest fleeces, such as those of the Lincolnshire and Leicester sheep. These had to be arranged straight, even, silky-smooth and parallel in a process called wool-combing. To do this, the fleeces were first washed with soft soap to remove all dirt and natural grease, wrung out with the 'washing tools', dried and disentangled. Separate handfuls were then taken up, one end being held down under the heel of one hand on the edge of a bench, called a comb-stock, while the other was pulled down within the other hand to initially straighten the fibres, into a crude 'sliver'. These were then laid out on the bench and sprinkled with olive oil – an essential lubricant for the actual combing process.[1]

John Crabtree's 'pairs of combs' were T-shaped and made of ash, their heads covered with a thick slab of horn to provide firm fixings for parallel rows of close-set, long, sharp-pointed iron teeth, each set around 60° to the handle. There were usually between three and five rows, the longest across the outer edge of the head, and the remainder progressively shorter. Since they had to be used hot, they would be accompanied by a comb-pot. This took the form of a cylindrical sheet-iron stove around 2 feet in diameter, its interior containing a charcoal or peat-burning grate. This supported an iron comb-pot plate with a raised rim, this enabling the teeth of the comb to be propped just above its surface to heat evenly without developing damaging hotspots. A heavy stone slab called a comb-pot top was set a few inches above this plate in order to prevent the combs from overbalancing and to contain the heat. It was also ideal for keeping mess-pots of porridge, stew or tea piping hot for the wool-combers, most drawings and later photographs showing these standing there ready for use. Such comb-pots were usually known as a 'pot o' one', 'pot o' two' etc. up to 'pot o' six', depending on the number of men they were to serve (see Pl. 9).

Since the combs had to be kept hot, one was always being heated while the other was in use. To start combing, the handle of a hot comb was secured to a horizontal wooden bar called a 'jenny' that projected at about waist-height from a vertical wooden 'pad-post'. Here, with the teeth pointing upward, the crude sliver of wool was lashed on to it with a downward sweeping action, a little at a time, until it had built up into a long fringe. The comb was then transferred to its 'pad', an iron bar fixed horizontally at chest height on the pad-post. This had a projecting 'pad heel' stud at its inner end to fit into an iron-sleeved socket in the end of the comb handle, and another at its tip called the pad neb to fit into a second socket through the side of the handle. These held the comb so that the teeth were horizontal, enabling the wool-comber to 'jiggle', swinging his second comb vertically through its fringe of wool, long teeth first, and then engaging the shorter teeth as the fibres were gradually combed straight and partially collected on the second comb. As jiggling progressed, the strokes became almost horizontal, the combs sometimes being changed round until each held a long fringe.

At this stage each comb was placed on the pad in turn, the wool pushed halfway up the teeth where there was more spring, and then gently drawn off using one hand after the other to form long continuous slivers. Having been broken up into shorter lengths, these were lashed on and jiggled a second time, called straightening, and drawn off through an oval hole cut through a disc of horn called a 'diz'. This produced a long continuous sliver of equal thickness, but with its longer fibres at its bottom end. For this reason pairs of slivers were put side by side, their bottoms at opposite ends, and finally rolled up into a bundle called a 'top'.

In 1723 the spinning jenny and the flying shuttle were still to be invented, and so one wool-comber still required twenty-five spinners to convert his tops into yarn, and 3½ weavers to turn that yarn into a piece of cloth.[2] Some of the tops would have been spun on his own 'wheels and a reel' but most would have been put out for spinning elsewhere, especially if, as might be expected, he had at least three or four wool-combers working full-time from a 'pot o' four'. In the 1760s his neighbour, Robert Heaton of Ponden Hall, was sending out his tops to be spun both locally and into the Craven dales and forest of Pendle up to some 20 miles to the north and west.[3] After collecting them, he had the yarn woven close to his home, and sold on to international merchants such as James Cousen of Bradford, J. Bramley of Halifax, Woolridge & Stansfield, Lloyds & Cataneo and Mr Guttee of Leeds, or Jones, Harvard & Jones of London. John Crabtree was probably operating on a similar scale in this pioneering period of the industrial revolution, partly manufacturing in his own home and partly acting as an entrepreneur, putting various stages of the processing out to others.

Unlike woollens, worsteds usually did not require any form of wet-finishing, each completed piece being cut directly from the loom, 'burled' to correct any weaving faults, neatly folded up and carried off to the cloth markets. The cash received was then used to buy fresh supplies of long-wool from the wool-staplers ready to be combed, sent out for spinning, and brought back for weaving into yet more pieces.

# 6

# MIDDLE WITHINS FROM 1813

The 1813 valuation shows that Middle Withins was owned by Edward Ferrand and was occupied by Robert Jackson. As we have already seen, Ferrand had acquired Middle Withins when he bought the Manor of Haworth from Joseph Midgley in 1811.

There were probably two men called Robert Jackson at Withins in that year. Robert senior had lived at Slippery Ford with his first wife Mary (née Sunderland, who was possibly born at Withins) and their children – including Robert junior – were born there. After Mary's death Robert senior married Ann Midgley the daughter of a Nathan Midgley of Stanbury. This was not the Nathan Midgley, Lord of the Manor of Haworth, who had owned Middle Withins, but possibly some relative of his. Robert junior, the son of Robert and Mary Jackson, was born at Slippery Ford in 1779. He married Mary Greenwood in 1805 and in the next few years they had three children baptised at Haworth church. Ann was born in 1806 at Coney Garrs, John in 1807 at Dickson House and James at Withins in 1812. After a long gap another son, Robert, was baptised in 1824. These baptisms show that Robert junior moved to Middle Withins between 1807 and 1812, perhaps when Ferrand bought the property in 1811. It is not clear whether Robert senior moved there at the same time or not. What is certain is that his gravestone in Haworth churchyard (B23) describes him as 'of Withins'.

A rate book of 1819 records that Jackson and Feather paid equal rates at Middle Withins. These Feathers were almost certainly Timothy Feather's family: we know that Timmy was born at Withins.

In 1837 Edward Ferrand died and the property passed to his sister Sarah Ferrand. Early the following year Robert Jackson junior died at the age of fifty-eight, leaving his widow Mary as the tenant of Middle Withins. Their second son James died in 1839 at the age of twenty-seven.

When the census was taken in 1841, Mary Jackson was living at Middle Withins with her surviving children, Ann, John and Robert. Mary was described as a farmer; Ann, John and Robert were all stuff (i.e. worsted) weavers. In all probability Robert would have been bobbin winding while Ann and John did the weaving. All of them must have been involved in the farm work as well.

Between 1838 and 1851 the valuations record an increase of around 3 acres in the area of the cultivated land at Middle Withins. Unfortunately the field boundaries

appear to have been very much altered in that period and it is difficult to establish just where the extra land was added. There is a significant difference in the areas quoted by the 1851 valuation and the Tithe Award of 1850. This is due to very different figures for the area of the rough moorland portion of Fawkes Intake: around 44 acres in the tithe award and 21 acres in the 1851 valuation. This discrepancy is unexplained but, as it concerns marginal land of little value, it is probably of no great significance. Apart from that very rough pasture the farm had about 29 acres of pasture and 13½ acres of hay meadow.

By 1851 young Robert Jackson (the third of that name) had married and moved to South Dean from where he was to move to Lower Withins (see the account of that farm above). Middle Withins was occupied by Mary Jackson, then sixty-seven, and her elder son John who was forty-three. The only other occupant was Mary's grandson James Dewhirst, aged seven, who was the son of Ann Jackson and her husband John Dewhirst.

Mary Jackson died in August 1851 leaving John Jackson alone at Middle Withins. He carried on alone for ten years or more but eventually the 60-acre farm became too great a burden and by 1871 he had moved to a much smaller farm at Height Laithe near Ponden. He was still there in 1881. He died in 1889 aged eighty-one at Hob Cote where his sister-in-law Zillah Jackson and her sons James and John Thomas were living.

After John Jackson's departure from Middle Withins it is doubtful if it was ever inhabited on permanent basis again. We do know that Simeon Robinson was living there at the time of the 1871 census but his family were at Upper Height where the Robinsons had moved from Lower Withins. It seems likely that he was still farming some land at Withins and moved up there at certain times of the year only.

This seasonal occupation of Middle (and/or Lower) Withins may have continued for some time as a young farmer named John Moore was at Withins in 1891. A newspaper report of 1948 speaks of 'Jack (*sc.* Moore) occupying the cottage at Low Withens' (T&A 1948). John Moore's father, Heaton Moore, farmed at Cold Knoll and held the tenancy of the Middle Withins land at that time. A trade directory of 1889 strongly suggests that John Moore was farming at Middle Withins in the late 1880s. However, Harwood Brierley in his account of his visit to Top Withins in 1893 (Brierley 1893. See Appendix B), said that Middle Withins had been untenanted for some time and that Lower Withins was used only at certain times of the year. It is worth noting that the census was generally taken around lambing time. When Whiteley Turner visited Top Withins in 1905 (Turner 1913. See Appendix C) he said that the house, though unoccupied, showed signs of 'occasional visits by shepherds'.

Interestingly it seems most probable that this John Moore was the great-grandson of John Moore who farmed at Lower Withins in the early nineteenth century and died there in 1831.

In 1893 the ownership of Middle Withins had passed from the Ferrands to F. J. Thompson of Leicestershire. Keighley Corporation bought the farm from his nephew Harry Thompson Arnall Thompson in 1904 (Whone 1946). The sale included the Manor of Haworth, Haworth Moor, Brow Moor and Harbour Lodge as well as Middle Withins, hence the high price of £10,500.

The building became a liability and it was partially demolished in 1930. Oddly enough the corporation then did some repair work on the large ground-floor window in 1935, leaving the ground floor frontage more or less intact. Since then it has been reduced to little more than rubble.

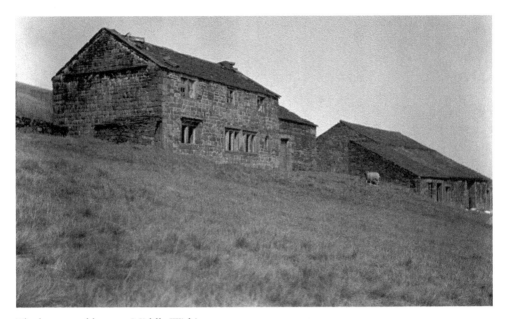

The house and barn at Middle Withins, 1911.

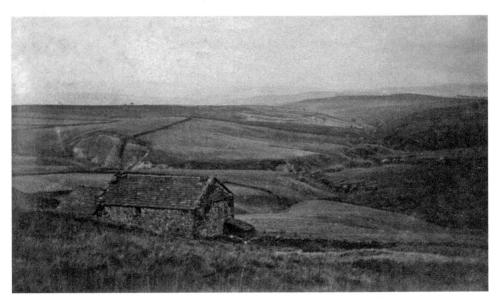

Middle Withins from the moor, 1915. Scar Hill with its large shale cliffs is just above the house. To the right of Scar Hill are Harbour Scars, Harbour Hole and Crumber Dike.

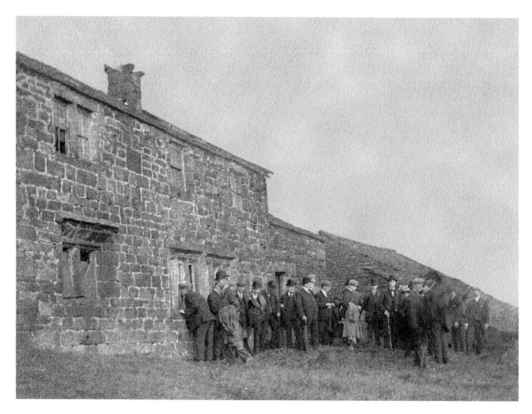

A party of inquisitive ramblers at Middle Withins, photographed by Jonas Bradley.

A symphony of textures and contours. View from Middle Withins (*Anni Vassallo*).

# 7

# TOP WITHINS

The numerous British and international visitors that plod up to the farmstead at Top Withins are usually intrigued by its confusing ruin, wandering around its interior in an attempt to make sense of its jumble of surviving walls, rebuilt walls and tons of tumbled masonry. Their bafflement is hardly surprising, for its structure is the result of numerous changes made over a period of around 450 years, making its development very difficult to determine with any degree of accuracy. Fortunately a useful range of sources, including archives, photographs and, most importantly, parts of the building itself, are still available for study. By drawing these factors together, it has been possible to propose the following sequence of construction and rebuilding which brought Top Withins to completion around the early to mid-nineteenth century (see Pl. 10-14).

## The Elizabethan House

The decision to build the earliest farmstead in this particular location on a steeply sloping area of high moorland was most probably determined by the presence of its spring of clear water. Here there was an annual rainfall of over 60 inches or 1,500mm each year, showers falling on an average of two out of every three days.[1] Situated at 1,376 feet, some 420 metres above sea level, Top Withins lay only around 100 feet, or 30 metres, below its surrounding hills, and it must have been deliberately sited here to take advantage of the highest available spring. This lies around 40 feet to the east of the house, and appears as a small rectangular structure on the Tithe Map of 1850. From its sides water would have been carried into the house for drinking, brewing, washing and cleaning purposes, and into the barn and stable for watering the cattle and horse. Although overgrown, it still runs clear, following the northern side of the Pennine Way down toward Middle Withins farm, which it also served, before descending into the South Dean beck. Its supplies were essential for cooking, brewing, dairying, washing, wool-textile production and watering cattle over the winter months.

A further advantage of the site was its good stone. In 1591 William Bentley of Withins made his will in which he confirmed that his sons Martyn and John were to have ready access to their brother Luke's Top Withins lands to extract stone. Some

of this was used by John to build walls to separate the fields of Top, Middle and Lower Withins, but it had probably already supplied the main building stone for their respective farmhouses, as well as that erected here by Thomas Crawshaye before 1567.

Local experience had proved that some of the best stone lay just below the thin turf on the brink of the high moorland plateaus, as on the hill just to the west of Top Withins. Here, at around 1,400 feet above sea level, was a bed of Rough Rock Flags, which, occurring in relatively thin layers, was easily quarried and useful for building as may be seen in many of the walls of the Top Withins farmhouse. The overgrown remains of Luke Bentley's delf (the local name for a quarry) can still be seen on Delf Hill, together with the long-disused sledge or cart tracks leading down to the farmhouse and on in a north-westerly direction towards Stanbury.

The rough rock flags were unsuitable for carving lintels, doorways and window frames, but other suitable rocks were to be found nearby, notably the Woodhouse Grit. These were ideal for making both lintels and neat rectangular building blocks, such as may be seen in the evenly coursed walls of the barn end at Top Withins, and in the other Withins farmhouses.

Any settlement at Withins was dependant on a good supply of fuel. There was insufficient woodland here to maintain fires, but fortunately the whole of the upland area was covered with beds of peat of varying thickness. These had formed as the waterlogged remains of cotton-grass and sphagnum moss had accumulated and consolidated into a soggy dark brown mass over the last five millennia. Overgrown sledge or cart tracks from Top Withins suggest that the main peat diggings were around Withins Height to the west of the farmhouse and toward the Alcomden Stones to the north-west.

Each farm harvested its own supplies in June, when the topmost layer of living vegetation was neatly pared off. Defined in 1775 as 'flaights', this 'surface of the commons, or waste, uncultivated places, cut off, and dried for fuel' had to be sliced free of the peat using a triangular-bladed T-handled flaight spade.[2] It might then be either dried for fuel, or relaid over the peat bed to protect it for future use and to avoid erosion. Flaights must have been cut around half a mile to the north-east of Top Withins, where the Pennine Way crosses Flaight Hill, a further Flaight Hill lying a mile to the south, on Wadsworth Moor (see Pl. 20).

Once the flaights had been stripped off, the pure, black peat could now be cut using a wooden peat spade shod with an L-shaped iron blade. In this area each peat measured some 10 x 3 x 15 inches (25 x 7.5 x 38cm) when cut. At this stage it was still relatively soggy and easily broken, and so the peats were laid out in rows on the moor until they became firm enough to handle. After being set on edge for a while, they were built up into small stacks to finally dry out as hard, tough slabs. Now they were carried down to the farm, probably using a horse-drawn sledge to follow the track up to the north-western gable of Top Withins. Here it would be passed in through the narrow doorway for storage in the peat house.

Peat was seen as a healthy fuel 'which when prepared for fuel, by drying in the sun, is reckoned a wholesome firing. It has been remarked, that where the use of it prevails, pestilential disorders have been more rare, and less fatal'.[3] It could be burned both on

a flat hearthstone and in a grate or range, giving a good, steady but almost flameless heat, and giving off a pleasant 'reek' or smoke. 'Colons' were often used as kindling, these being the dried stalks of heather or furze, including those left on the moor after the heather had been burned off to promote new growth as food for grouse.[4] If all went well, the peat harvest was all gathered in before 12 August when the grouse shooting season commenced. Over the following year the Sunderlands would now be able to climb the steps leading from the farmyard up into the peat house, collect the peats and use them to heat their house, cook their food and boil their washing, all for nothing more than their own labour.

Peat continued to be the main fuel in the uplands around Haworth throughout the nineteenth century, but from the 1830s a number of local farmers began to extract coal from their own enclosures.[5] Before 1850 a 111-feet-deep pit had been sunk down to a 12- to 14-inch seam just to the east of the South Dean farmhouse, around a mile down the valley from Top Withins. Five men and two boys were working here in 1851. The formation of the Stanbury Coal, Iron & Lead Co. in 1862 sought to develop the seams of good-quality engine coal found here but, undercapitalised and then made totally unviable by the arrival of the railway from Keighley up to Haworth in 1867, it had to close down completely. Much cheaper coal from the Bradford and Halifax collieries could now be carted up from Haworth.

Given these natural resources, the Elizabethan pioneers who first enclosed the upper part of the South Dean to form the Withins farms clearly recognised that a good, if basic, living was to be had here. This was entirely dependent on two factors, however: the incomes to be derived from the farming of sheep and cattle, and the growing prosperity of the domestic wool-textile industry. Standing at 1376 feet, or 420 metres above sea level, Top Withins remains one of the highest and most exposed of the little hill farms of the South Pennines, its eastern prospect extending as far as the North York Moors and the power station at Drax, some 65 and 45 miles away respectively, these both being visible on clear days. Beyond, there is no higher land for some 2,500 miles to where the Urals rise in central Russia. It was on this exposed plot that the rough moorland was first cleared for farming, and its enclosing stone boundary walls were probably built around the late sixteenth century.

The earliest documentary reference to buildings at 'Wythins' is dated 1567. By 1591 the land was already in the occupation of the three Bentley brothers, each with his own house at Top, Middle and Near or Lower Withins respectively. The only parts of the Elizabethan Top Withins that can be positively identified today are the window head and jambs of a two-light mullioned window which were later reused as part of the six-light parlour window at the back of the house. Their concave mouldings are characteristic of West Yorkshire houses of this period, as seen at Hollin Hey, Cragg Vale in the Calder Valley, built in 1572, and Arthington Nunnery, Wharfedale, of 1585. The only other probably Elizabethan or early Stuart feature to remain here is the central wall which now forms part of the back wall of the housebody, the back wall of the barn (except for its top right-hand corner) and the ground-floor section of the barn's end wall. This was originally an external wall, mostly built from narrow courses of rough rock flags in the barn, with relatively course blocks of gritstone in

the housebody section. There are two small windows with gritstone surrounds cut with a simple 45° chamfer to light the barn, with the adjacent doorway having its head and quoined jambs made in the same stone, but without any chamfers. All the other masonry here butts up against this wall, proving it to be the earliest part of the surviving building. It was probably the back wall of a longhouse, with a living room or housebody and back outshot at its upper end and a barn and mistal or cow house lower down, all under one roof.

## The Rebuilding of 1743

In the building contract of 4 April 1743, Joseph Pighels, Isaac Heaton and Matthew Whalley agreed to pull down a house at Withins, rebuild it on the old foundations, carve six new windows, and provide and fix the 'theaking' of sandstone slates. All was to be finished by 1 August, or else the masons were to remain unpaid. This contract confirms the date of the next phase of building at Top Withins, explaining the demolition of every part of its predecessor, except for the wall described above, and the construction of the walls which butt against it. The six new windows were for

  1 of 4 lights for the front wall of the housebody.
  1 of 6 lights for the front wall of the housebody chamber, to light a loom.
  1 of 2 lights for the back wall of the parlour (the other being re-used Elizabethan).
  1 of 2 lights for the end wall of the parlour.
  1 of 5 lights for the parlour chamber, to light a loom.
  1 for the gable wall of the attic.

By reusing the old foundations, the walls of the new house formed a rectangular block, with a large housebody to the front and a smaller parlour to the rear, these being separated by part of the old wall on the ground floor. Above rose two chambers and an attic in the roof space. The housebody was entered through the front door, which had a pair of square jambs fitted with iron pintles for hanging the door. To its left a row of square mullions provided a four-light window, while inside a fireplace and shallow chimney breast were built into the left-hand wall, with a doorway with chamfered gritstone lintel just beyond it.

This door led into the new dairy, a barrel-vaulted chamber half submerged into the hillside to keep it cool. A fireplace with a flue at its front end was provided for heating milk in open kettles for making cheese, or for boiling water to sterilise the dairy equipment. No evidence now survives to confirm how the dairy vault was roofed, for as the quoined joint halfway down the back wall proves, it never rose above ground-floor level. Since dairy windows were exempt from the window tax of 1695–1851 if they were captioned DAIRY on the outside, the single dairy window has this word carved along its lintel in typical early to mid-eighteenth century lettering.

From the left-hand back corner of the housebody a door with plain gritstone slabs as lintels led through into the parlour. Its main features were three two-light mullioned windows. One of the pair on the back wall reused the lintel and jambs of the Elizabethan window, while the other, along with the window in the end wall, were

newly carved in gritstone, with 45° chamfers. The upper part of the old wall separating the housebody from the parlour was rebuilt to include a flue from the fireplace serving the parlour. This passed up within the thickness of the wall to join the main chimney stack, and could be seen as a diagonal row of stone slabs in photographs of the 1960s, when the wall plaster had fallen away. Unfortunately this feature disappeared when the ruins were consolidated.

The fourth and final doorway from the housebody led off the back end of its new right-hand wall, through into the barn. At this date the original barn appears to have remained intact, its back wall continuing as one build around its gable end, then returning along the front wall to where it abutted the new house next to the front door.

Virtually all of the new first-floor rooms and the attic have now disappeared, but the combination of archival evidence and photographs taken during their period of decay confirm their layout. Above the housebody the house chamber had a six-light window of square-cut mullions and a small fireplace set into a shallow chimney breast on its left-hand wall. A door through the right-hand end of its back wall led into the parlour chamber, which had a five-light mullioned window for illumination. The attic above was lit by a single window in its right-hand gable, looking out over the roof of the barn. Finally, at the tip of the left-hand gable a typical South Pennine chimney was constructed of gritstone ashlar, with a chamfered ledge around its base and an ogee moulding around its cap.

## The Peat House

At a later date, probably in the later eighteenth century, the dairy walls, along with new walls extending from the left-hand end of the front, were raised to form a first floor. This was to create a convenient peat house, one door in its end wall being entered by a short flight of stone stairs from the main cart track for taking in the peats cut from the higher parts of the moors. Another door at the right end of its front wall had steep steps descending into the front yard, so that the peat could be carried along to the front door to fuel the internal fires. The roofline of the peat house continued that of the main house, photographs recording how their slates had been skilfully interleaved to create a watertight junction. During these alterations the chimney of the dairy fireplace was removed and its flue probably sealed by a flagstone. After ruination John Lock (see Appendix E) was able to peer down this hole to see into the dairy below.[6]

## The Barn

Judging by the style of its evenly coursed fine gritstone ashlar front, the barn was extensively rebuilt sometime around 1800. The front wall was completely rebuilt from the ground up, now having a deep porch with outward-opening barn doors to provide covered access for hay-carts etc. The smaller door to its right, at an appropriately lower level, led into the mistal or cow-house, its long stone jambs being carved with a narrow 45° chamfer. Round the corner, the end wall of the original barn still survives to first-floor level. Its upper section was rebuilt at the same time as the front wall, the division between the old and new parts of the gable end being indicated on its external face by a row of square put-log holes, used to hold wooden scaffolding in

place. Inside, the same line is seen as a slight thickening of the wall, along with a row of projecting blocks of stone. These were used to support a hay-loft over the cows, ideal for storing hay brought in by the barn door, and for dropping it down into the stalls. Most of the back wall of the barn retains its Elizabethan masonry, only its top right-hand corner being rebuilt. The extent of rebuilding can be seen on the external corner of the back of the barn, where the long stone quoins stop, and coursed rubble walling continues up to the eaves. The deep stone porch, with its sloping flagged roof giving added protection from rain and snow, is an almost unique feature in this area, the only other example around Haworth being just a few hundred yards away at the farm New Laithe. It is of particular significance in identifying the Top Withins site as being 'Wuthering Heights', since Emily Brontë describes how Hareton was instructed to 'drive those dozen sheep into the barn porch', something he could not have done elsewhere.[7]

## The Stable

About the same time that the barn was being rebuilt, a stable was added by building an L-shaped wall in the angle between the parlour and the back wall of the barn. It was entered by a square-jambed door facing downhill, with a narrow window to one side, and another directly above. Inside it was paved with large rectangular stone blocks, a pair set a few feet away from the barn wall having sockets to support the woodwork of the stall.

Building the stable in this position made it necessary to block the window in the side wall of the parlour. To compensate for this loss of illumination the two two-light windows in the back wall were rebuilt and extended to create a continuous six-light window. It still retains its Elizabethan, 1743 and early nineteenth century mullions, window-heads and sills.

## The Outbuildings

Directly in front of the barn door stood a small outbuilding built of narrow-coursed stone with large ashlar quoins and a gabled roof covered in stone slates. The only photographs of this building show just the sides which faced away from the farmhouse. It had a square central window in its back wall, but no evidence survives to confirm the appearance of the side which faced onto the farmyard. There are no clues to suggest its use; it may have been a peat house used before the large peat house was built onto the end of the house, or it may have housed either pigs or poultry.

## The Privy

Stone-built privies are rarely found on upland farms before the early nineteenth century, many people apparently using either the midden or muck-heap, or else the surrounding environment, for toilet purposes. The privy at Top Withins was sensibly situated at the lowest part of the farmyard, a short distance below the back wall of the barn. It was a small stone building with a roof made of sloping slabs. It lacked any form of plumbing, probably having an ash-pit beneath, which would be regularly emptied and its contents used as manure.

## Field Walls

The main cart access to Top Withins ran across the uphill end of the house, being bounded by the drystone walls that extend to each side of the peat house gable. The main gate into the farmyard in front of the house had a pair of gateposts, which still survive, and from which hung a wooden gate. Just beyond this gate, three walls, each parallel to the front of the house, formed a pair of narrow enclosures which probably served as garden plots for growing cabbages, onions, potatoes etc. The middle wall terminated at the outbuilding (see The Outbuildings as above), beyond which a narrow gate and a wall curved round to enclose the lower part of the farmyard, finishing a few feet beyond the front of the barn. From here the main footpath and single-horse track descended towards Haworth, the row of paving running along the end wall of the barn resembling that of the local pack-horse tracks. Next to the back wall of the barn the track passed through a narrow gateway in a short length of wall which descended to the privy (see The Privy as above), to complete the circuit of the farmyard.

## Top Withins Today

Up to the late 1930s to early 1940s Top Withins, although deserted, remained substantially intact, but soon afterwards the roof began to collapse, followed by the upper sections of the walls. By 1960 only a small area of the barn roof remained intact, the first storey of the front of the house and most of the peat house having tumbled down, along with the outbuilding, privy and most of the farmyard walls. Over the following decade the combined effects of wind, frost and inconsiderate visitors saw the loss of the attic wall and most of the first storey of the house, along with the wall dividing the housebody from the barn and the vaulted roof of the dairy. The accumulation of fallen masonry completely buried the interior and exterior of the house to the depth of around 4 feet or 1.2 metres, completely masking the original ground levels. Fearing for the safety of the fast-disappearing building, a series of repairs was then carried out using cement mortar not only to consolidate the surviving masonry, but to build up the wall tops to an even level. This certainly prevented further decay, but since the rebuilt sections took little or no account of the original features, it also added to the confusion of future visitors. To help them understand the surviving remains, the following tour starts at the back, downhill corner of the barn, where the footpath from Haworth arrives, and proceeds clockwise around the building (see Pl. 13).

## The Barn

The lower part of the gable end probably dates from the mid- to late sixteenth century. Note its projecting foundations and the row of put-log holes halfway up, used to support scaffolding when the upper section was rebuilt around 1800. The paving here is for the footpath and single-horse track coming up from Haworth. Beyond it, a short distance below the back corner of the barn, the small mound marks the position of the privy.

Turning the corner, the new front wall of the barn of around 1800 can be seen, with the small door into the mistal or cow-house to the right. Inside, the projecting stones halfway up the gable wall show the level at which it was rebuilt, and where a

floor was added to create a hay-loft. Most of the back wall, its original small windows and blocked doorway, appear to be of the primary Elizabethan construction. The large stone columns meanwhile were probably added at a recent date, to consolidate the building. The addition of deep porches to Pennine barns made them much more weatherproof, and enabled the doors to open outwards, saving lots of space inside for storing carts, hay and bedding for the cattle. Note the original iron pintles used for hanging the large wooden doors which stood on the line of the modern stone blocking.

## The Farmyard
Leaving the barn by the mistal door, and walking forward for a few paces, the footings of the curved wall which enclosed the farmyard still emerge from the overlying turf. Following these round to the area in front of the barn porch, the foundations of the rectangular outbuilding can be seen on a low, relatively flat mound. From here a central wall ran uphill to the surviving boundary wall, a wall in front forming one narrow sloping garden, a third wall behind forming another, which also enclosed the surviving trees. All the large deciduous trees found at this level were deliberately planted to provide much needed shelter to the exposed farmsteads, the surrounding moors remaining treeless.

## The House
The front of the house lay immediately to the left of the barn. As rebuilt in 1743, it was only one room wide, with mullioned windows at ground- and first-floor levels. The present flight of rough steps leading up to a 'doorway' is entirely modern and in the wrong position, for this was the solid end of the wall dividing the house from the barn. The vertical stone just to the left of the 'door' is the broken-off top of the original right-hand door jamb. Part of the left-hand jamb, with iron hinge-pins and graffiti carved by twentieth-century tourists, has been built in just behind it. Most of the rest of the front wall is a modern rebuild, but a vertical stone at its left-hand end is the jamb of the ground-floor mullioned window. Here the tumbled masonry is around 4 feet deep, covering much of the surviving wall and also the site of the front porch.

The room behind is the housebody of 1743, only the (lower parts?) of the back wall being Elizabethan. Just the top of the fireplace lintel and part of the chimney breast now emerge from the rubble at the left-hand side of this room, with the lintel of the dairy doorway to its right. The door by its side led through into the parlour, while the door in the back right-hand corner gave direct indoor access to the barn and mistal, ideal for winter use. The upper section of the back wall has been entirely rebuilt, removing evidence of the sockets for the floor joists, and the upper door which led into the chamber over the parlour.

## The Peat House
Returning to the farmyard, the section of the wall to the left of the housebody was part of the added peat house. Most of the visible masonry of the outer face has been rebuilt, but its inner face still shows where the doorway at its right end has now been blocked

up. Here again the original ground level lies beneath a deep layer of rubble, burying the original flight of steps that led down into the yard, for bringing the dried peats into the house. The end wall of the peat house had a gable that rose up to the roofline of the main house, a door just above the original external ground level enabling cartloads of peat to be conveniently unloaded here for storage over the winter months.

## The Dairy

Towards the back of the peat house, the remains of the vaulted roof of the half-buried dairy appear just above the present mass of rubble. On passing round the corner to view the back wall, it can be seen where the peat house was built on top of the dairy in 1743, a vertical row of quoins showing the position of the original external corner of the parlour chamber. Close to ground level the dairy window bears the word DAIRY, so that it would be free of window-tax.

## The Parlour

The next section of wall downhill was the parlour – a room actually used as a back kitchen. Originally built in 1743 with a pair of two-light windows, it was later altered to form a six-light window. Its mullions and window-heads includes a set of dates: Elizabethan characterised by hollow chamfers, a set of 1743 with 45° chamfers, and another of the early nineteenth century which are roughly carved and rectangular in section. The blocking of the central window is a modern addition.

Looking into the parlour itself, there is a blocked-up two-light window of 1743 in the left-hand wall, and the opening of a flue in the back wall, built to serve a fireplace and a bakestone for making oatcakes.

## The Stable

Probably added around the 1850s or 1860s, since it does not appear on the First Edition Ordnance Survey map, this would house the Sunderlands' 'galloway', a strong multipurpose bay or black horse of around thirteen or fourteen hands that had probably been housed in the barn up to this time. The stable retains its original paving, two of the blocks having sockets to support the wooden uprights of its stall. The left-hand wall inside is probably Elizabethan, and has a blocked door and two narrow windows of this period. Meanwhile the two-light mullioned parlour window of 1743 on the back wall had to be blocked up after the stable was built. This caused a considerable loss of light and an open view from the parlour, explaining why the external parlour window had to be enlarged around this time.

On leaving the stable, the back wall of the barn can now be seen, most of it being Elizabethan, and still retaining its original large quoins part way up its external corner. The upper part of its downhill end was rebuilt around 1800, as indicated by the lack of quoins in the top courses of the corner, just below roof level.

## The Spring

The spring lies in the rough meadow area at the back of Top Withins, almost in line with the parlour window. Its waters run in a narrow channel a short distance below

the farmstead, then by the footpath leading down to Haworth and so down into South Dean Beck. It runs constantly throughout the year.

This completes the tour of Top Withins, but there are good footpaths leading north-easterly to Stanbury and south-westerly to Walshaw Dean, these forming part of the Pennine Way. A further footpath follows the cart-track northward along the drystone wall above Top Withins towards Stanbury, while another leads downhill to the west, along the Hebden Bridge–Haworth Walk and Brontë Way to Haworth via the Brontë Bridge, this providing the most popular means of access for today's visitors.

The view up towards Top Withins from the remains of Middle Withins (*Anni Vassallo*).

# 8

# TOP WITHINS FROM 1813

In 1813 Top Withins belonged to John Crabtree and was occupied by Jonas Sunderland, who is thought to have moved there around 1811. Jonas Sunderland's wife, Ann, was a relative (possibly the sister) of John Crabtree who owned the farm. In 1821 Jonas Sunderland bought Top Withins from John and Mary Crabtree.

The Haworth parish registers show that there had been Sunderlands at Withins since at least 1719 but we do not know which farm they lived at, nor do we know how (if at all) they were related to Jonas Sunderland. The Haworth Manor court rolls tell us that a Sam Sunderland was at Withins in 1775 (Whone 1946).

The 1813 valuation gives details of 17 acres of land which, with the farm buildings, was valued at £14.

By 1838 this had been increased to over 19 acres by the addition of a 2½-acre allotment. This was intaken from Stanbury Moor by Jonas Sunderland.

Ann Sunderland died in 1832 leaving Jonas a widower at the time of the 1841 census. He was then aged around seventy-four and was described as a farmer and stuff weaver. Also living at Top Withins was his son Jonas who was, like his father, a farmer and stuff weaver. Jonas junior's wife Mary (née Feather) whom he had married in 1833 was also a stuff weaver. There is a possibility that she was Timothy Feather's sister. Jonas and Mary Sunderland had a seven-year-old son, John.

Old Jonas Sunderland died in 1849, leaving the farm to his second son Jonas (his oldest son John had died young in 1825). There was an inventory of Jonas's property made after his death which has given us the information on which Peter's reconstructions are based. Old Jonas Sunderland was buried at St Michael's in Haworth (grave E229).

In 1851 the younger Jonas Sunderland was forty-five and his wife Mary was forty-six. Jonas was a farmer of 19 acres of which 6 acres was meadow. He was also a handloom weaver. Two more children had been born since the last census – James aged eight and Ann who was just one year old. The oldest son John was now seventeen and had taken over the weaving on his mother's loom.

We are fortunate to know a good deal about the looms at which Jonas and Mary worked. Both of them ended up in Joseph Henry Dixon's 'Wuthering Heights' collection in Harrogate and are illustrated in the museum catalogue (Dixon n.d.). The larger loom, at which Jonas worked, had five shafts rather than the usual four.

This meant that he was weaving a better quality worsted than the standard twill, most likely a barathea.

In 1861, according to the census returns, all the weaving was being done by the sons, John aged twenty-seven and James aged eighteen. Jonas was now fifty-six and a farmer of 20 acres. Weaving ceased at Top Withins sometime in the next ten years. Jonas was still described as a farmer of 20 acres in the 1871 census and James and Ann were 'farmer's son' and 'farmer's daughter' respectively. No occupation is given for Jonas's wife Mary who was then sixty-seven. The elder son John had left home by then and was a farmer and gamekeeper at the nearby farm of Virginia.

James Sunderland died aged thirty-two in 1875 and his mother Mary in 1879, leaving Jonas and his daughter alone at Top Withins. Jonas and Ann were running the farm and had no other source of income. Jonas Sunderland was by then seventy-one and he died in 1888 at the age of eighty-four. Jonas, Mary and James are all buried at St Michael's (grave D322).

The bill from Haworth church for his burial survives. The total cost was £1 9s 1d.

Ann Sunderland had given birth to an illegitimate child, Mary Sharp Sunderland, in 1886. Within two months of her father's death in 1888 she had married the child's father Samuel Sharp. They are listed in the 1891 census as Samuel Sharp, farmer aged forty-nine, and Ann Sharp, farmer's wife aged forty-one. The four-year-old Mary Sharp Sunderland was described as Samuel's 'step-daughter' but it seems certain that he was her father as the 1901 and 1911 census returns say. Samuel was born at Sough near Two Laws in 1839 and his family moved to Sheep Holes farm in the 1860s.

In 1893 we get a splendid account of Top Withins and of its inhabitants (Brierley 1893. See Appendix B). Harwood Brierley walked up to Top Withins in the winter of that year and was invited into the house by Ann Sunderland whom he describes as 'jovial and blousy'. He describes the blue washed walls, the blazing fire, the high-backed chairs, a curious corner chest and the lines of oatcakes hanging up to dry. Mary Sharp Sunderland was at home, the weather being too bad for her to walk the 4-mile round journey to her school in Stanbury. She was then seven years old and Brierley describes her as dark eyed and pretty but unrobust and listless. His gift of a penny was received with a delight which 'would have moved some ... to tears'. He clearly thought that she was very likely to die young. It was however her mother Ann Sunderland who died only two years later in 1895 at the age of forty-six. She is buried in Stanbury Cemetery (grave B72).

After her death Samuel and his little daughter moved down to Sheep Holes farm in the Worth Valley where his family had been since the 1860s. It looks as though he may have continued to farm the land at Top Withins for some years as he appears there in the Electoral Registers until at least 1902. In 1907 Mary Sharp Sunderland had an illegitimate child, Percy, at Sheep Holes. In 1912 she married Walter Holdsworth and went to live at Egg Hall in Oxenhope. Samuel Sharp died in 1921 and is buried at Stanbury with his wife (grave B72).

In 1903 Top Withins was purchased for £750 by Keighley Corporation. That was not quite the end of its story though. From 1921 to 1926 it was inhabited by an old soldier, John Ernest Bagnall Roddie.

Ernest Roddie was born in 1877 and was one of the sons of the Haworth Rifle Volunteers' drill sergeant. He had moved to Manchester by 1901 and was working as a French polisher. He married in 1908 but his wife died just two years later. In 1914 he joined the Manchester Regiment of the King's Shropshire Light Infantry. After the war he returned to Haworth suffering from a stomach injury and malaria. He was unfit to resume his former occupation and decided to try his hand at poultry farming. After completing a training course he had difficulty finding a suitable smallholding until he was offered the tenancy of Top Withins. He had long joked that he would one day live at Top Withins and did not hesitate to accept the offer. In the autumn of 1921 he set to work cleaning and repairing the farmhouse, sleeping in the attic while he did so. He moved in that winter with his terrier Nell, his horse Tommy, two cats and 150 hens. The cats quickly decided that Top Withins was not to their liking and returned to the village. Their place was taken by two kittens which adapted more readily. After his first winter he reported that things were better than he had anticipated, although the weather had been very cold and the snow so thick that he could not get his cart down to Stanbury. He had been surprised to receive visitors from as far away as America, even on days of very poor weather. He had made incubators in the kitchen and had built chicken houses outside. In April 1922 his horse Tommy had died and he was seeking a replacement. Nell had been replaced by a mongrel puppy called Jerry which he described as a 'cross between a lamp-post and a walking stick'.

Roddie's move to Top Withins aroused considerable interest and a number of newspaper articles were published in 1921 and 1922 (YEP1921 and YEP1922. See Appendix D).

Ernest Roddie's name appears in the electoral registers for Top Withins from 1922 until 1926, although he is only in the rate books for 1923 and 1924. In 1925 Keighley Corporation Waterworks opened its new reservoir at Lower Laithe near Stanbury. It is unlikely that they would have renewed any tenancies for residents on their moorland farms after that date.

After leaving Withins, Ernest Roddie moved to Balcony (by 1930) and then to Croft Street (by 1938). In the 1940s he kept an upholstery shop at No. 107 Haworth Main Street which was close to his Croft Street home. Ernest Roddie died in 1950 aged seventy-two.

The electoral registers and the Stanbury rate books record several other people at Withins in the twentieth century but it seems likely that they were farming tenants who, at the most, occupied one or other of the farms at lambing or haymaking times.

By 1930 all the Withins farms were becoming unsafe, partly as the result of vandalism. In that year Keighley Corporation decided to demolish Lower and Middle Withins. In deference to the Brontë connection of Top Withins it was not demolished but had its doors and windows blocked to keep people out. A notice was also erected warning that the building was dangerous.

Over the next two or three decades the condition of Top Withins farmhouse deteriorated until only a roofless ruin was left. Since the early 1970s various attempts at consolidation of the ruins have been made. The first was carried out in 1972 by the Yorkshire artist Ashley Jackson and children from Rayleigh Secondary School at Barnsley. Unsympathetic later works by Yorkshire Water have left the rather unsightly and confusing remains that we see today.

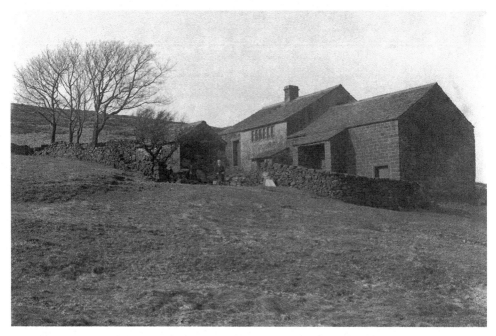

This splendid view of Top Withins clearly shows the house and barn with the mistal, barn, house and peat-house doors. The small outhouse which stood at the bottom of the garden is also shown. The house looks to be occupied so the photograph might have been taken in the 1890s.

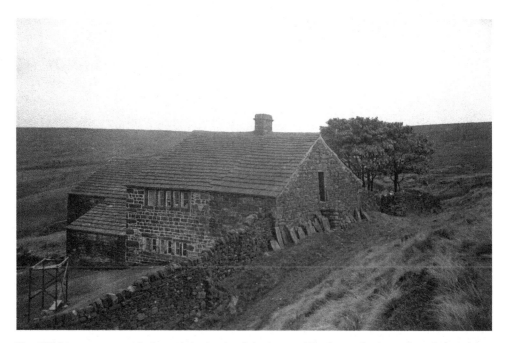

Top Withins: an unusual view of the back of the house. The house looks to be inhabited but it is not known just when this was taken. The photograph is the work of Edmondson Buck of Clitheroe who was active in the early twentieth century, and probably earlier.

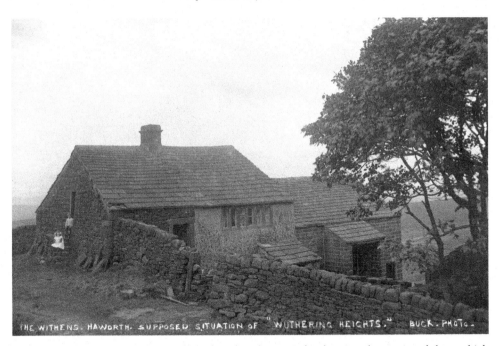

Top Withins, from the moor. Another of Buck's photographs showing the steps and door which gave access to the peat-house from the moor. The gateway which led from the moor to the house appears to be walled up, perhaps temporarily.

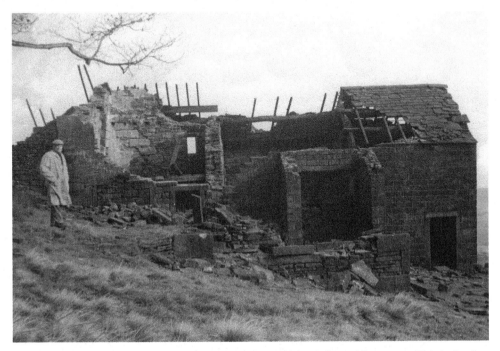

Top Withins in ruins around 1960: notice the diagonal line of step-like stones. This is the flue from the bakestone hearth.

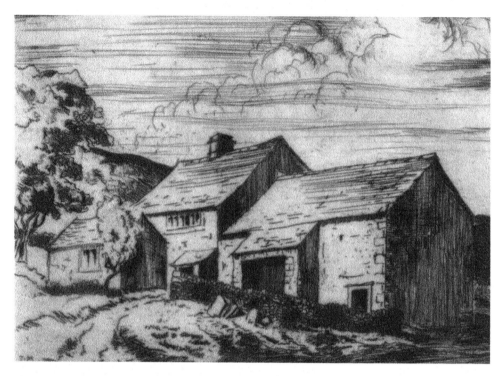

Top Withins by Thomas McKenzie. This fine engraving appeared in the very scarce limited edition of Elizabeth Southwart's *Brontë Moors and Villages* in 1923.

Weather moving across distant hills. A typical scene from this moor (*Anni Vassallo*).

# 9

# TOP WITHINS IN 1847

Emily Brontë's dramatic novel *Wuthering Heights* was first published in 1847 under her pseudonym 'Ellis Bell'. As her sister Charlotte explained to its readers, those to whom the inhabitants, the customs, the natural characteristics of the outlying hills and hamlets in the West Riding of Yorkshire were things alien and unfamiliar,

> *Wuthering Heights* must appear a rude and strange production. The wild moors of the north of England can for them have no interest; the language, the manners, the very dwellings and household customs of the scattered inhabitants of those districts, must to be such readers in a great measure unintelligible ... It is rustic all through. It is moorish and wild, and knotty as the root of heath. Nor was it natural that it should be otherwise; the author being herself a native and nursling of the moors ... Her native hills were far more to her than a spectacle; they were what she lived in, and by, as much as the wild birds, their tenants, or as the heather, their produce.

Emily's ability to capture the very essence of the moors above Haworth was unique. In her introduction to the ancestral home of the Earnshaws she tells us that its name was 'Wuthering Heights', 'wuthering' being 'a significant provincial adjective, descriptive of the atmospheric tumult to which its station is exposed in stormy weather ... Pure, bracing ventilation they must have up there at all times, indeed: one may guess the power of the north wind, blowing over the edge, by the excessive slant of a few stunted firs at the end of the house ...'

The 'Heights' element meanwhile, was probably taken from either the name of a hill and its adjacent farms halfway between Stanbury and Top Withins, or 'Withins Height' that of the black moorland summit just above the farmhouse.

Although Top Withins has long been recognised as the site of Wuthering Heights, it was never the fine Tudor yeoman clothier's house of the novel. There were many such properties locally, particularly in the Calder Valley, but only one which, 'The architect had the foresight to build strong; the narrow windows are deeply set in the wall, and the corners defended with large jutting stones ... a quantity of grotesque carving lavished over the front, and especially the principal door, above which, amid a wilderness of crumbling griffins, and shameless little boys, I detected the date "1500".'

The presence of this richly carved façade and particularly the 'shameless little boys' uniquely identify the building of 'Wuthering Heights' to have been High Sunderland. This stood around a mile to the east of Halifax, where Emily would have seen it when teaching nearby in 1838. When demolished in the mid-twentieth century the cherubs standing on their Ionic columns to each side of its doorway were removed to the nearby Shibden Hall Museum.

According to Charlotte's account of Emily, she was deeply interested in the daily lives, habits, speech and histories of local working families. This did not extend to talking to them however, or visiting their homes. Within a few years of her untimely death from tuberculosis in December 1848, her practice of walking up the South Dean valley to sit on the 'Brontë Seat', cross the 'Brontë Bridge' and continue up to Top Withins to visit the Sunderland family had become accepted as an established truth. From that time through to the present day the same route has become the essential pilgrimage for every literary visitor and tourist to Haworth and its Brontë shrines. It is difficult to understand how Emily could have been able to portray so many of the domestic scenes and practices described in *Wuthering Heights* so vividly and accurately without having entered farms such as Top Withins and spending some time with their inhabitants. Assuming that she actually did so, it would be extremely interesting to enter the porch as she would have done, and to tour its interior. By exceptional good fortune, it is almost possible to do this today, due to the survival of the inventory of Jonas Sunderland's effects taken after his death in 1849. It proceeds from room to room, listing and valuing every item, just as Emily might have seen them:

An inventory of the goods, chattels, furniture, farming Stock and other personal Estate of Jonas Sunderland of Withins in the Township of Haworth in the County of York (deceased) made the 26th day of July 1849, by me the undersigned John Binns auctioneer and appraiser:

In the House

| | |
|---|---|
| A Cupboard 7/- snap Table 4/6 | 11s 6d |
| 1 old clock 12/- 1 Table 1/- 3 chairs 4/6 | 17s 6d |
| Pot case pewter Dishes and pots | 6s 6d |
| Copper kettle 2/- Box Iron &c. 1/9 | 3s 9d |
| Tongs 1/- Sundry pots 2/- | 3s 0 |
| Baking utensils 2/3 Sundries 1/9 | 4s 0 |
| Fowling piece 5/- 4 tins 5/- pan 1/6 | 11s 6d |
| Lantern 9d Knives & forks 1/3 | 2s 0 |

In the Parlour

| | |
|---|---|
| Table 2/- pan 1/6 Sundry pots 1s 4d | 4s 10d |
| Iron Dish 10d. Baskets 1/- Old Chair 6d | 2s 4d |
| Stock 4d. Bakestone Stones & grate 6/- | 6s 4d |

Dairy Room

| | |
|---|---|
| Sundry pots | 3s |

In the Parlour Chamber

| | |
|---|---|
| Brewing Tub 2/- Barrel 1/- | 3 s |
| Old clothes horse 4d. Churn 3/6 | 3s 10d |
| Butter Bowl 6d. | 6s |

In the House Chamber

| | |
|---|---|
| Old Bedstead 4/6 Bed 15/- | 19s 6d |
| Bedding 14/6 Bedstead 6/- | 10s 6d |
| Chest 5/- Meal chest 4/- 2 Tubs 1/3 | 10s 3d |
| Old Chair 4d. Quilt 1/4 | 1s 8d |
| Wearing Apparel | |

In the Garret

| | |
|---|---|
| Old Chest 2/6 hay knife 1/9 | 4s 3d |
| Desk 1/6 Wool £4 0 0 | 4 1s 6d |
| Weigh beam & Scales | 2s |

In the Barn

| | |
|---|---|
| 6 spades 12/- old scythe 1/3 | 13s 3d |
| Bucket 1/2 wheelbarrow 5/6 | 6s 8d |
| Mallot 2/6 2 picks 2/0 | 4s 6d |
| Lever 3/6 Sundries 1/3 2 tubs 1/9 | 6s 6d |
| Ladder 8d. 2 tubs 1/7 3 forks 2/6 Shovel 1/6 | 6s 3d |
| | £14 14s 11d |

Further information on the contents of Jonas and Mary Sunderland's home comes from the work of Joseph Henry Dixon (1853–1916) a stuff (worsted) merchant who traded in the Little Germany quarter of Bradford. His two great enthusiasms were the handloom weaving communities of West Yorkshire and the Scottish borders, and the Brontë family. Using the surplus income from his business, he began to collect every relevant artefact that came within his reach. As an amateur curator of social history, he surpassed both current and future museum professionals in establishing the finest collections of their kind, carefully noting the provenance of every item, setting them up in operational condition, and illustrating and publishing them for the benefit of the public. Around 1911 he moved his collection into a purpose-built 600-feet-long museum near Oatlands Court, Harrogate, shortly after moving there. Among the exhibits were a number he had acquired from Top Withins, where they had previously been used by Jonas and Mary Sunderland. They included an oak chair and kist (chest), an egg-pan and a riddleboard for making oatcake, along with a spinning wheel, a raddle for dressing yarn, and the looms used by Jonas and Mary which he had found dismantled in the barn. Unfortunately the museum building was requisitioned by the military, probably in 1915 or 1916, and most of the collections, including the looms, sold to a Harrogate man to sell as firewood. Today only the kist is known to have survived, having eventually found its way to Oakwell Hall museum, Birstall, and is now at the Red House museum in Gomersal. However, Dixon's drawings and descriptions still provide a unique record of some of the farm's original contents.

By combining the information from the inventory with the Dixon drawings, the descriptions and photographs of later visitors and measured drawings of the ruins, it is possible to recreate the interiors of Top Withins with a high degree of accuracy. Not only does this show what Emily could have seen there in the late 1840s, but serves as an interesting example of how most of the other hill farms of the South Pennines would have been used in the last days of their dual farming/handloom-weaving economy (see Pl. 15-18).

Looking over New Intakes wall towards Lower Withins. Middle and Top Withins lay in the mist beyond (*Anni Vassallo*).

# 10

# LIFE AT TOP WITHINS

For the generations of farmers and weavers that succeeded each other at Top Withins, daily life was clearly divided into two distinct yet complementary areas of activity, one essentially out of doors, and the other inside the farmhouse.

Today it is difficult to imagine how anyone could have supported a family from the produce of the 19 acres of the acid soil around the 1,400-foot contour at Top Withins. Its nine stone-walled closes occupied the head of the South Dean beck that descended in a north-easterly direction into the Worth Valley. This location provided both water for livestock and a degree of shelter from the strong south-westerly winds as they wuthered over Round Hill. The reasons for the economic viability of this and other upland hill farms in this area are clearly set down in this description of 1775:

> there is scarcely a single instance ... of a man's living entirely by farming; the land therefore is divided into small parcels, every one, who can, takes just as much as will yield sufficient quantity of milk and butter for the support of his family. It is difficult for many of the poor to get these things [but this] is much over-balanced by a constant supply of work, good wages, and plenty of most other necessaries of life, so that I know not any country where, upon the whole, they live better.[1]

This was a very practical dual economy based almost entirely on cattle and the domestic textile industry. Although small flocks of Lonk hill sheep were grazed on the unenclosed moors, and a few pigs and poultry kept in the farmyard, it was the milch-cows and bullocks that were essential for surviving at this altitude. This is reflected in the range of tools listed in Jonas Sunderland's inventory of July 1849.

Anyone visiting Top Withins today can still see the difference between the grassland of the enclosed fields and the rough vegetation of the moorland beyond. The creation of the grassland was the result of years of hard work. Initially all the rocks on the surface had to be gathered, most being used for boundary walls, and then the roots of the heather, field-rush and bent dug out. Being extremely tough and embedded in hard ground, they would easily break an ordinary spade, and so the hill farmers developed a 'graving' or digging spade just for this purpose. Probably unique to the South Pennine hills, each had a heavy, wide wrought-iron blade, usually with a footrest just above it, both fitted to a short, strong rectangular wooden shaft. At the top, a broad T-shaped

handle shows that it was to be gripped with both hands, partly to hold the spade upright and partly to support the digger as he used all his strength to drive it into the ground. Two of the six spades listed in the barn at Top Withins were of this type, being illustrated in the Dixon's catalogue as being owned by Jonas Sunderland[2] (see Pl. 19).

In 1775 graving was described as turning 'up the earth with a spade … They distinguish … between digging and graving as the first is performed with a mattock, and the second with a spade'. Starting with a long trench 18 inches wide at the bottom end of the field, the graver drove his spade deep down a short distance away then used the handle to push the soil forward. The 'putter-ower', a man standing in front, then used his hack, or mattock, to pull the sod over upside-down into the trench, with all the loose soil thrown on top of it. In this way the whole field was gradually cleared, and its underlying stones removed.[3] At this stage the field was given a heavy dressing of lime. The main source of limestone was Boulsworth Hill, just over the border into Lancashire. Here it was dug out, burnt to a powder in kilns and then brought by packhorse along the Limers' Gate that ran via Widdop, Walshaw, the head of Crimsworth Dean, across Midgley Moor, and on towards Halifax. This route passed 3 miles to the south-west of Top Withins, and was easily accessible from the track leading up Walshaw Dean. An initial crop of oats was probably taken off the new field, but then it would have been used as pasture for grazing, or meadow for growing hay.

In this area the best meadows were those nearest to the farmhouse, and were around 4 acres, the meadow below the barn at Top Withins being 3.7 acres.[4] The farm also had another meadow and the New Laithe barn directly opposite, across South Dean. In this area meadows were known as 'mowin' fields'. Every autumn they were dressed with lime, and after Christmas, with manure from the cattle housed in the barn, the muck being spread initially with one of Jonas Sunderland's '3 forks 2/6d', a bush pulled by a horse then completing the process. This fertilised the first crop of hay, which was mown with a scythe, such as his 'old scythe 1/3d', in June or July. As each swathe of grass was cut, it was shaken out with a fork, then repeatedly turned over the following weeks until it was bone dry, and ready for carrying into the barn. A horse-drawn sledge would have been used to do this as on similar local farms, or else a hayrope 16 feet long with a wooden handle or 'rack' at one end. Having been laid out on the ground, five or six 'lazins' or armfuls of hay were set on top, the free end of the rope brought over, threaded through a hole in the rack, pulled tight, and secured there with a half-hitch. Hoisted onto the shoulder, the 'burden' was carried into the barn and up a ladder to the hay-mow – the floored area directly above the cattle stalls. Here it was untied so that a man called a shaker could take out separate handfuls, scatter them evenly and tread them underfoot to form a compact mass rising up to the rafters.

In contrast to the mowin' fields, the summerin' fields, as the pastures were called, probably had little more attention above muck-spreading. When spring brought a new growth of grass, the cattle that had passed the winter in the barn were turned out into these fields, remaining there until the onset of winter, when they returned indoors. For the following months they were fed on the hay, as it was sliced out of the hay-mow with Jonas Sunderland's 'hay knife 1/9d'. Since the inventory was taken in July, this

had been safely stored away in the garret, as it would not be needed until around October or November.

For most of the year the sheep were kept out on the surrounding moors, but around late June they were gathered and washed, probably in a temporarily dammed stream, to clean their fleece. Clipping usually followed around ten days later, hand shears removing the 'dags' or soiled parts, and the main fleeces ready for folding and rolling inside-out to form individual neat bundles. This had been completed before 26 July 1849, for by that time fleeces worth £4 10s had been stored in the garret of Top Withins, where a 'weighbeam and scales 2s.' were kept to weigh them ready for sale. Locally grown wool was far too coarse for use in the Yorkshire woollen and worsted industries, some being sold in Rochdale.[5] One of the particularly interesting features of the farmstead is the deep porches protecting the large doors of both barns. Such porches are quite rare, one of the few other local examples being at Rawtenstall in Stansfield in the Calder Valley. Since the porch at Top Withins was almost certainly the only one that Emily Brontë had ever seen, it appears to have provided the setting for one snowbound dusk at *Wuthering Heights*. Here Heathcliff ordered that 'Hareton, drive those dozen sheep into the barn porch ... and put a plank before them', just as Jonas Sunderland would have done.[6]

Due to its bleak setting and poor soil, it was not practical to grow worthwhile crops of corn here, not even oats, the most widespread upland cereal. Supplies for making wheat bread, oatmeal porridge and oatcake, along with malted barley for brewing, had to be bought in, using income generated by spinning and handloom weaving. None of the adjoining fields have any evidence to show that they had ever been ploughed. The only crops grown at Top Withins were probably potatoes, cabbages and a few pot-herbs raised in the two long, narrow garden plots walled off on the south-westerly side of the farmyard.

The surrounding moors provided little that was edible, the exception being 'blaeberries' or bilberries – the small yet delicious black berries that ripened around midsummer. Hidden in their low, dense foliage, it took a long time to gather a bowlful, but the effort was well worthwhile. In 1775 the Revd John Watson described how bilberries were 'used to feed the poor people in the months of July and August'.[7]

## Dairying

The farming activities at Top Withins relied heavily on dairy farming both to support the family and to produce valuable surplus income. By the mid-nineteenth century dairy shorthorns were the most popular breed of cattle here, being useful for both milk and meat.

During the summer months the milch-cows would have been milked in their stone-walled closes, while in winter this would have taken place when they were tethered in the barns. Since the New Laithe barn was difficult to approach from Top Withins, especially for carrying pails of milk across the rough ground and steep declivities which separated it from the farmhouse, the room at its south-eastern end probably served as a dairy. Here the milk would have been left to settle, the cream skimmed off and perhaps even churned ready for sale as butter. The existence of a sink at Lower Withins certainly suggests that this was a useful local practice. The main dairy at Top Withins however was that set beneath the peat house off the western end

of the housebody. Half buried into the ground, northfacing and with a stone-vaulted ceiling, it was ideal for this purpose. Its sole window has the word DAIRY carved on its external lintel to ensure that it would not be liable for the window tax.

Here broad, shallow lead-glazed earthenware milk pans made at the nearby Denholme and Halifax potteries would have formed part of the stock of 'Sundry pots 3s.' in the dairy in 1847. Standing on stone-flagged benches, they would have had a horse-hair or wire-gauzed 'sile' or sieve mounted above them on a frame called a 'brig'. This was used to strain off any hay, grit or bovine dandruff that had fallen into the milking pail. After standing for a day, the cream that had risen to the surface was skimmed off using a 'skenk' or 'dish to take cream off milk with' and collected into a cream pot.[8] The remaining 'old' or 'blue' milk was in demand in Haworth, both as a drink and as an accompaniment to porridge.

Once sufficient cream had been collected, it was poured into the 'churn 3s. 6d'. This was of the upright 'plunge' variety, tall and cylindrical, on most small hill farms, made of coopered oak, lead-glazed earthenware, or brown salt-glazed stoneware.[9] After being repeatedly agitated with its piston-like wooden plunger, the cream separated into butter and thin, watery buttermilk, used as a drink or to feed the pigs etc. Having been scooped out of the churn, the butter was washed in water and beaten in large handfuls in the sycamore 'butter bowl 6d', until all the buttermilk had been removed, to ensure that it did not cause the butter to turn sour. Salt was then beaten in to add flavour and improve its keeping properties. If intended for immediate use or sale it was made up into pats of half, one pound etc., but if for longer-term storage, it was packed down with further salt into tall earthenware butter pots.

It is probable that some of the milk was made into cheese, by being brought up to blood heat, curdled with a rennet called 'keslops' made from salted calves' stomachs. The curds were then salted and packed into a muslin-lined cheese vat, pressed to expel the watery whey, then stored until ripe. No cheese-press is listed at Top Withins, but local farms used lead-glazed earthenware substitutes. These took the form of cylindrical cheese vats, their sides perforated with numerous holes for drainage, and with a heavy plunger on top to provide the necessary pressure.[10] With one of these among the 'sundry pots' in the dairy, the Sunderland family could be self-sufficient for cheese to eat with their oatcakes (see Pl. 24).

The sundry pots probably also included large, vertical-sided oval pork pans and pear-shaped ham pans in black-glazed red earthenware. These were a standard product of the Denholme and Halifax potteries, being made for local farmers and weavers to dry-salt the pork and hams from their home-fed pigs ready for winter use. Mid-nineteenth century Keighley led the world in the improvement of pigs, developing the Yorkshire Large and Middle White breeds for international success.

## Cooking

As previously described, life within the farmhouse was centred on the 'house' or housebody. This was the main living room, and housed the main fireplace. Now buried deep in tumbled rubble, the fireplace would have resembled those of most of the local hill farms, measuring around 4 to 6 feet in width, and perhaps 2 feet in depth, with a

horizontal stone lintel often supported by a pair of square-cut vertical stone jambs. A peat fire would burn steadily on the flat hearthstone, with cooking utensils supported over it on an iron trivet or 'brandreth', or hung from a ratchet-adjusted iron pot-hook called a 'reckon' (i.e. rack-and-hook). By the late eighteenth century most local fireplaces had been fitted with an iron fire grate, a frame of parallel front and bottom bars mounted between a pair of stone-faced hobs. This raised the fire to a convenient height, and enabled both peat and coal to burn efficiently, and was ideal for boiling, frying or baking on a stone bakestone or an iron griddle. For baking loaves and cakes however, it was still necessary to build a stone-lined 'beehive' oven, like those collected from local farmhouses and preserved at Keighley's Cliffe Castle Museum.

However, there is no evidence that an oven of this type was ever used at Top Withins.

Some of the deserted farms in the nearby Walshaw valley show that simple fire grates supported by stone hobs were still being used up into the late nineteenth, early twentieth century. It is probable that the fireplace at Top Withins was of this kind when Jonas Sunderland's inventory was drawn up in 1847, only having a cast-iron 'Yorkshire' range fitted later in the century. With their raised grate, side-oven, side-boiler and ornamental black-leaded fronts, they were both practical for all forms of cooking, decorative, and a real status symbol. One seen in photographs of Timmy Feather's cottage at Buckley Green, a mile away to the north-east, is typical of those installed locally around the middle of the nineteenth century. When Harwood Brierley visited Top Withins in 1893, it appears that he found a coal fire burning in the range, this being 'not blue and smudgy, but red and yellow, while the hearth looked warm enough to mull ale or roast chestnuts'. However, as he stated, 'it behoves them at every "back-end" not to neglect the getting in of such a quantity of cinders, turf [peat] and coal as will suffice the winter over'.

Whether burning peat or coal in the fireplace, there were times in the hot summer months when a fire would have been a waste of time and heat, but there was still a need to boil a kettle or do a little cooking. For these occasions, or when an extra 'stove' was required, the Sunderlands used the 'iron dish 10d'. listed in the parlour in 1849, this being identical to the 'Chaumin dish ... from Top Withins, Stanbury Moor, Haworth', collected from there by J. H. Dixon. As he described

> A burning peat was placed in this Chaumin Dish, and a pie or dish of anything placed upon the peat. It is economical in dispending with the use of the fire in the grate proper. This one was used for many years at the Withins by Mary Sunderland, the mother of John O'Top. It, with many other things in the collection, remained for a long period shut up in a barn, and forgotten.[11]

The word 'chaumin', as accurately recorded by Dixon, is totally unknown elsewhere, not appearing in the *Oxford English Dictionary* or Joseph Wright's comprehensive *English Dialect Dictionary*. However, local medieval records explain its meaning. In 1316 Margery, daughter of Adam Cote, stole a 'chaminus' from the house of Richard Spynkes, while in 1317 a *caminus ferri* was sold for 10d to Sir William the chaplain of Batley; *caminus* is the Latin word for a stove or brazier, frequently spelled *chaminus* in

medieval documents. It is amazing to realise that these very practical room heaters and cooking stoves were apparently in use in this area for some 600 years, still retaining their original Latin name.

As illustrated by Dixon, the chaumin dish was a concave-sided, wrought-iron pan mounted on three twisted iron legs, their tops forged as discs projecting above the rim to support a bakestone, pan or kettle. An iron handle extends to one side, terminating in a turned wooden handle. An identical example from Halifax is 8½ inches/21.5cm diameter, 9 inches/23cm high with an 8¾ inches/22cm handle. The base of its pan has crossbars forming a grate to provide an updraught and also to allow the ashes to fall away.[12] When set on the hearthstone it was ideal for simmering or frying pans of all kinds of food, or for baking on a bakestone or girdle (see Pl. 22).

As in all farms on the Pennines, the staple foods at Top Withins were based on oatmeal. As Mrs Gaskell had noted in the 1850s, the local hills were dotted with 'patches of arable land, consisting of pale, hungry-looking grey-green oats'.[13] However, there is no evidence to suggest that any of the enclosures here have ever been ploughed for raising crops, for at this altitude and exposure oats would have failed miserably. They were being grown a little further down the valley, however. Having provided the major subsistence food of the West Yorkshire wool-textile community for centuries, these locally grown crops proved inadequate to feed the population as it rapidly expanded during the eighteenth and early nineteenth centuries. To meet this growing demand, oats began to be grown in the fertile fields of the East Riding, these being threshed in the fields and barged up to the textile towns each August and September.[14] It was probably oats from this source that Jonas Sunderland purchased to feed himself and his family, carrying them up to Top Withins in sacks slung across the back of his horse. They would have already been ground into oatmeal, sufficient to serve an entire winter, each sackful being emptied into the 'meal chest 4s.' in the house chamber. In order to keep out weevils and the air which cause them to decay, they would be trodden down beneath stockinged feet to form a dense, compact mass.

When required for use, a quantity would be scooped out and sieved, the coarse being used to make porridge, and the fine to make oatcakes. The utensils required to make porridge were very simple, just the single 'pan 1/6d.', probably an iron-handled brass saucepan, and a 'thible' or 'thyvel', a thin, flat stirring stick.[15] Once the pan had been half-filled with water and a pinch of salt it was put onto the fire. It was at this stage at *Wuthering Heights* that Catherine found Joseph, the skilled but self-righteous and bigoted old servant, standing by the fire with a wooden bowl of oatmeal. As he plunged his hand into the bowl, Catherine 'conjectured that this preparation was probably our supper, and, being hungry, I resolved it should be eatable – so crying sharply "I'll make the porridge!" removed the vessel out of his reach … Joseph beheld my style of cookery with growing indignation, "Thear!" he ejaculated, "Hareton, tha will'nt sup thy porridge tuh neet; there'll be nowt bud lumps as big as maw nieve [fist]. Thear agean! Aw'd fling in bowl an all if ah were yah! Thear, pule t' guilp [handle] off, un yah'll hae don wi't. Bang, bang. It's a marcy t' bottom isn't deaved aht!"'[16]

Usually the oatmeal was gradually sprinkled into the boiling water with one hand as the other stirred it in with the thible. Stirring then continued over a gentle heat until

the mixture had cooked to a really thick consistency that gave it the local names of panderwaff, thick-hots or thick-uns.

A richer version of 'waff' was made by melting a large tablespoonful of bacon or other fat in a pan, stirring in oatmeal over a gentle heat until it was absorbed, then adding water and stirring as it simmered to thickness. Half a cupful of milk, a spoonful of sugar and a pinch of salt were then stirred in just before serving. The alternative 'chell porridge' had a little oatmeal beaten smooth in cold water to avoid leaving any lumps. More water was then mixed in and boiled a long time to produce a thin gruel.[17]

The usual way of serving the porridge was to pour it into a dish and set it down at the centre of the table. Each person then took up a portion in their own spoons and dipped it into their mess-pot of blue [i.e. skimmed] milk before lifting it up to the mouth.[18] The mess-pots, globular, black-glazed, pint-sized and with a looped handle at the rim through which the thumb was thrust as it was held in the left palm, were a major product of the nearby Denholme and Halifax potteries. They were multifunctional, being used for porridge, milk, tea, stews and broths, and would have been included in the 'sundry pots' in the 1849 inventory (see Pl. 21).

The inventory also mentions 'Bakestones Stones & grate 6/-s.' From the twelfth century place names such as 'Bacstanbec' indicate places where flat slabs of heatproof stone were already being quarried for being propped over a fire to provide a cooking surface. The major source of bakestones in this region was at Delph near Saddleworth, which was in the West Riding until 1974. Having been quarried in the Castleshaw Valley, the local mudstone was split into slabs around ½–¾ inches or 12mm–20mm thick, cut to size and one surface carefully smoothed. Having soaked in a stream for a few weeks, they were drained, stacked in a small hut and fired with wood to emerge hard and fireproof. They were then put into packhorse panniers and carried off for sale.[19] A postcard dated 'Paradise Farm 23/2/1918' now at Cliffe Castle Museum, Keighley, reads, 'Dear Madam, the Price of a bakestone a foot square is 1s. 9d [8p]. I would be pleased to oblige you with the same, yours respectfully, James Schofield.'

The relatively high value of the bakestone in the parlour at Top Withins, and its association with a grate, shows that it was a built-in example, its square slab being mounted at table height on top of a masonry base. It would have been heated by burning peats in the grate immediately below the stone, the fumes passing up a diagonal flue in the back wall of the parlour to join the main chimney stack. The line of this flue is clearly visible in the 1960s' photographs of the half-demolished farmhouse. The bakestone was probably identical to one drawn by Arthur Comfort at Waltroyd in Wheatley, around 7 miles to the south-east[20] (see Pl. 25).

The bakestone was used to make oatcake. This was nothing like the crisp, biscuit-like product sold today as a cheese biscuit, but was a long, soft oval resembling chamois leather in appearance – a variant of the soft oatcake traditions of Staffordshire and Derbyshire. It required real skill to make successfully, some wives such as Mary Sunderland of Top Withins making their own, while others bought theirs ready-made from specialist bakers in Haworth. To start the process, warm water was poured into a large tub or pot and finely sieved oatmeal sprinkled in by one person as another stirred

it with hand and arm to form a smooth, pourable mixture. This was then left to 'sour' overnight, using yeasts which had been left in the tub from previous batches.[21]

Next morning a little more meal or water was mixed in to bring the mixture to the correct consistency, a matter of real skill developed only through long experience. The 'bakbrade' or riddling board collected from Top Withins and used by Mary Sunderland was a typical local example. It measured around 18 inches or 45cm square, its surface scored with a diamond pattern, a short handle for hanging up extending from its top, and its lower edge planed to a sharp taper.[22] Having been laid flat on a table, a thin layer of oatmeal was shaken over it through a sieve, onto which a mess-potful, or a wooden ladleful of the mixture was poured. Once held up horizontally with a hand to each side, the bakbrade was swirled or 'reeled' in a rotary motion, to make the pool of mixture to expand in diameter and reduce in thickness while sliding on its bed of oatmeal (see Pl. 27).

At this stage a spittle, a thin board around 10 inches or 25cm square with an integral handle extending to one side, was prepared by having a piece of flannel laid across it. The pool of mixture was now slid off the bakbrade onto the flannel, the spittle taken up, then smartly flipped over so that the pool was thrown at an angle onto the hot bakestone, to form a long, thin oval. Having baked on one side, as shown by the edges starting to curl up, the oatcake was turned over to finish the other side. Only now could the oatcake be removed and hung up to dry on the coarse, hairy strings of the 'creel' or 'flake' hung high in front of the chimney breast.

Fresh oatcake could be spread with dripping, lard or black treacle, rolled up and eaten, but it was also enjoyed when it had dried to crispness. In this form it was crushed and sprinkled into broths and stews, 'stew an' hard' being a popular dish in local inns. It was also broken up in a bowl, scalded with water, left to soak until soft, drained, squeezed dry and deep-fried to form a dish called 'brewis'.[23] Some toasted it over embers and put it into ale, Catherine discovering Joseph 'sitting in a sort of elysium alone, beside a roaring fire; a quart of ale on the table near him, bristling with large pieces of toasted oatcake'.[24]

The meats eaten at Top Withins would all be home-produced. At least one pig would have been killed each year, its offal being shared with neighbours as there would be far too much for the Sunderlands to eat before it went off. However, they would themselves receive reciprocal presents of offal when others killed their pigs. The sides of bacon and hams would then be cured using a mixture of salt, saltpetre and coarse brown sugar in ham and pork pans in the dairy, and then hung up in the house to dry off. Usually the hams were kept hanging until ready for use, when thick slices could be cut off and fried as a special treat, or the whole ham boiled for a major event such as a wedding or funeral. The rolled sides of bacon, meanwhile, were often packed into the oatmeal ark, to be kept perfectly dry before being thinly sliced and fried for everyday use.

Beef was treated in a similar manner, a beast being killed every autumn and its flesh salted to provide meat over the winter months. Joints would be cut off as needed, soaked, placed in a pan of cold water and simmered very slowly until tender. It could be eaten hot, but could also be thinly sliced when cold to be eaten just like modern pastrami or New York salt beef.

In contrast, mutton was probably only eaten from time to time; it was still common for an ailing sheep to be killed for the table before it actually died of its own accord. However, its boiled legs, and fried chops were very good to eat, as was its boiled head, a favourite local delicacy. Lamb meanwhile was a distinctly seasonal dish, being provided by the annual surplus of ram lambs that were usually eaten from summer through into the autumn.

As at all the local farms, hens and perhaps a few geese were kept to provide eggs as well as an occasional boiled or roast dish, 'old boilers', hens that had stopped laying, having a good flavour even if they only became tender after a prolonged simmer with vegetables and herbs.

The two narrow garden plots fronting the farmyard would have produced cabbages, onions and potatoes, these being the most popular vegetables with the weaving community. It is unlikely that they could have satisfied all the family's needs however, so that extra supplies would probably have been brought up from Haworth. Further down the Worth Valley in Keighley, and in the major textile towns of Bradford, Halifax, Huddersfield and Leeds, most families had already given up the production of their own food generations ago, having to rely on the drovers, farmers and market gardeners that sold their wares in the local markets. In contrast, the Sunderlands and their successors at Top Withins and similar upland farms continued to grow much of their own food up to the turn of the nineteenth and twentieth centuries. Even if decidedly monotonous and basic by modern expectations, it was still sound and nutritious, with its combination of low-gluten cereals, meats, eggs, cheese, butter and fresh vegetables, all largely pure, unadulterated and home-grown.

There was never any shortage of clean, fresh drinking water here, but it was never as enjoyable and nourishing as beer, nor as warm and comforting as tea. Most families still brewed their own beer up to the late nineteenth century, buying in their malt and hops from grocers and dealers. The Sunderlands were certainly doing so in 1849, using their brewing tub worth 2s and their barrel valued at 1s. It was the general practice to first sterilise the water by boiling, allow it to cool a little, then mash it with the ground malt in the brewing tub, covering it with a blanket to keep it warm as it absorbed the sugars and flavours of the malt. After being strained, the sweet 'wort' was boiled with hops to add further flavour and increase its keeping qualities, then strained once more, cooled, mixed with yeast and left in the warm to ferment. After a few days the frothy head of yeast was skimmed off and the clear beer run off the dregs either into a barrel or a number of locally made earthenware 'drink pots' to settle ready for drinking. The initial batch of malt provided a second and a third mashing, these being processed in the same way to give a medium-strength beer and a much weaker 'small beer', both ideal for quenching the thirst, but soon turning sour (see Pl. 23).

From 1784, when the government removed a 100 per cent import duty on tea, this fashionable and exclusive, expensive Chinese beverage gradually grew in popularity. As its price fell, it became popular with most working-class families, since it was quickly made, was served hot, tended to suppress the appetite, and provided a comforting social drink. It is not surprising that 'a copper kettle 2s' for making tea should have been in 'the house' at Top Withins. It was probably being drunk either from locally

made mess-pots or from factory-made cups and saucers, but to date the household midden where the Sunderland's broken china would have been thrown has yet to be found.

It was possible to make a good counterfeit tea by mashing fresh mint (pennyroyal) with black treacle, but tea usually had milk or cream and sugar stirred into it, along with rum, unless the family was teetotal.

## Weaving

Top Withins continued to produce worsted cloth up to the 1860s. By this time however, neither combing, spinning nor warping were being carried out here; instead the machine-combed tops were being spun on multi-spindled 'mules' in the mills and made up into warps. These, together with hanks of weft-yarn, were then collected from the mill and brought up to the farm to be woven on handlooms.

Most of the textile equipment used here by the Sunderland family was rescued from a barn by Joseph H. Dixon, this country's major collector of hand-weaving artefacts and Brontë relics. Most were illustrated in the catalogue of his *Wuthering Heights Collection* as set up in a huge purpose-built museum in a leafy suburb of southern Harrogate. They included a 'raddle', a long, comb-like frame used to arrange groups of warp yarns between its numerous teeth, and be loosely held in place by a removable top bar. Once their ends had been tied on to the warp beam of the loom, it ensured that they were evenly distributed as the warp was wound on under tension, and also kept the yarn in order as each individual strand was threaded through its individual heald, through the reed and onto the cloth beam. Now that the loom had been set up, the hanks of worsted yarn to form the weft were mounted on a 'swift' – a frame that enabled it to be fed out without tangling as it was wound on to a long narrow bobbin called a 'pirn' to fit inside the shuttle. This task was accomplished by fitting a pirn onto the spindle of the Sunderland's old 'great' spinning wheel, the right hand turning the wheel as the left fed the yarn onto the pirn. Once the completed pirn had been slid onto its iron spindle within the shuttle, and its loose end of yarn sucked out through the shuttle-eye to one side, weaving could commence.

Mary Sunderland's loom may have had either four or five treadles and shafts. Four was the usual arrangement for most worsted cloths, but we know that Jonas's had five, suggesting that he wove the better quality barathea. Both looms used flying shuttles; these were mounted on wheels and ran on a slay-board fitted across the bottom of the reed into a shuttle-box at each end. Sliding blocks called 'pickers' at the outer ends of the shuttle boxes were joined together by a length of cord tied in the middle to a short wooden handle called a picking-stick. This simple mechanism, invented by John Kay in 1733, enabled the shuttle to be rapidly flicked from side to side with the right hand, as the reed was pulled forwards and backwards with the left (see Pl. 26). This was a vast improvement on the old method of throwing the shuttle from one hand to the other through the warp, speeding up the weaving process and initiating the great expansion of the English textile industry. Sometimes the shuttle got stuck between the warps, so that a child had to be called to carefully retrieve it. However, the Sunderlands solved

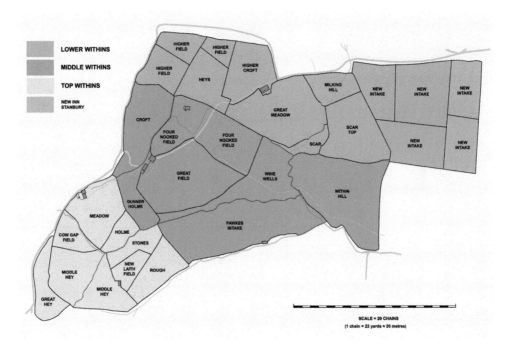

Pl. 1 The Withins farms redrawn from the tithe map of 1850.

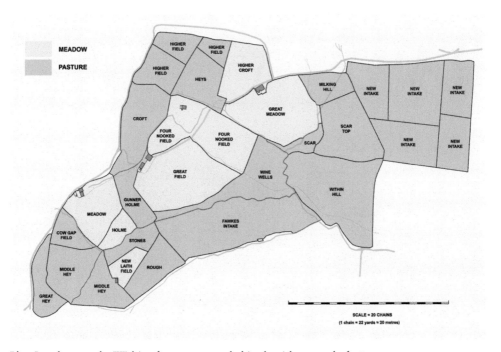

Pl. 2 Land use at the Withins farms as recorded in the tithe award of 1850.

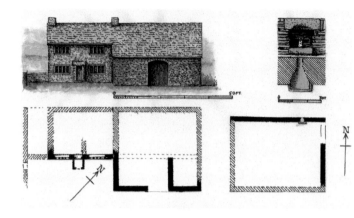

Pl. 3 Lower Withins and Heys Laithe. The farmhouse on the left appears to have been a late eighteenth- to early nineteenth-century replacement for the original Elizabethan house to its right, when it was extended forward to create a large barn. Nearby Heys Laithe is of uncertain date, but its remains suggest that it was used to house milch-cows over the winter months, the sink shown here indicating the presence of a dairy.

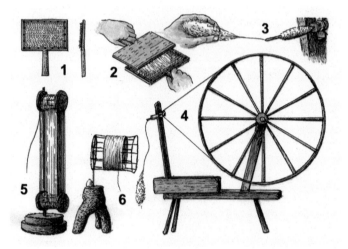

Pl. 4 Carding and spinning: after being sorted and cleaned, tufts of wool were worked between pairs of cards, rectangles of leather stapled with thousands of small wire hooks mounted on wooden boards (1–2). The resulting fluffy 'rolags' were then drawn out from the left hand as the right hand rotated the 'great' spinning wheel to form woollen yarn (3–4). This was then transferred onto a reel or swift (5–6) ready for preparing warp and wefts for weaving.

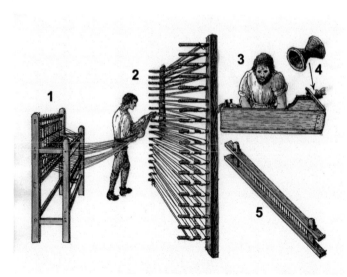

Pl. 5 Warping: having mounted bobbins of yarn on a creel (1), the weaver drew it between the pegs of the bar-tree or warping stakes to form a warp. It was then passed through a weak glue solution in a sizing cradle, one man gently working it with his hands (3). Meanwhile another man placed one foot on the sloping board in order to pull it through the sizing pot (4) to squeeze out the excess size. After being dried, the warp yarns were distributed between the teeth of a raddle (5) and wound onto a long roller called a beam ready to be placed in the loom.

Pl. 6 A basic handloom. Jonas Wheelwright would have woven on a loom of this kind. From the beam (1) alternate warp threads passed under and over a pair of lease rods (2) and through the loops of the healds mounted on the shafts (3), so that they could be pulled up and down by the treadles (4). After each throw of the shuttle had passed a weft thread through the warp the reed or 'rocking tree' (5) packed it in place to form cloth. A temple (6), a pair of sticks with spiked ends, ensured that the cloth maintained an even width before it was wound onto the cloth beam below (7).

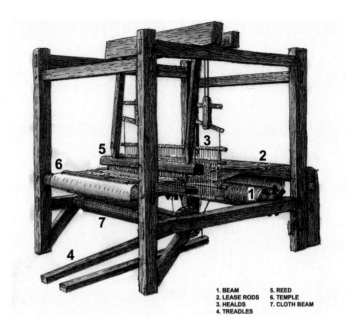

1. BEAM
2. LEASE RODS
3. HEALDS
4. TREADLES
5. REED
6. TEMPLE
7. CLOTH BEAM

Pl. 7 Middle Withins and barn This late seventeenth-century farmhouse, along with that at South Dean and other local farms, had its entry door in its end gable. This led into the housebody or main living room (H), by the side of a wide chimney hood. Beyond lay the parlour, or best bed-sitting room (P), the entry passage and dairy (D) being later additions.

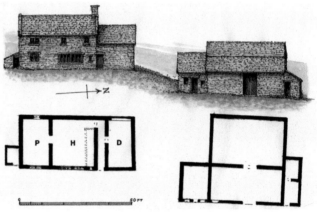

Pl. 8 The housebody and chamber, Middle Withins, 1723. John Crabtree's inventory enables these interiors to be accurately reconstructed. In the housebody life was centred by the fire beneath its broad fire-hood, with its entry door and 'heck' screen to the left, and small fire-window to the right. Up in the chamber the wringer for draining freshly washed wool, the pad-post and pot-o'-four for wool-combing, and a chest filled with the family's oatmeal all stand in front of his two looms.

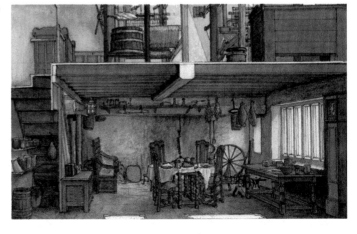

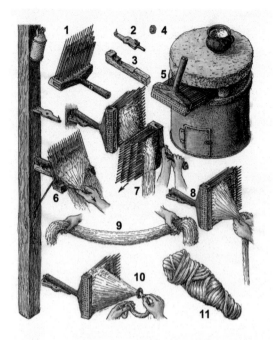

Pl. 9 Wool-combing: the fibres of long-stapled wool had to be made smooth and parallel before they could be spun into fine, strong worsted yarn. Each comb had rows of sharp teeth set into a slab of horn (1) and sockets in the side and base of its handle so that it could be mounted on an iron 'pad' (2) or a wooden 'jenny' (3). A pierced horn 'diz' (4) was also required for drawing off the combed wool. To start the process, the comb was heated on a charcoal-heated pot-o'-four (5), mounted on its jenny on the pad-post, and had oil-lubricated wool lashed onto its teeth (6). Having been moved up onto the pad, the wool was 'jiggled' or straightened with a second hot comb (7), and then drawn off each in turn by hand to form long 'slivers' of combed wool (8). After being divided into short lengths (9) and jiggled for a second time, they were drawn off through the diz (10) to produce a long, even sliver, then rolled up into a 'top' (11) to be sent to the spinners.

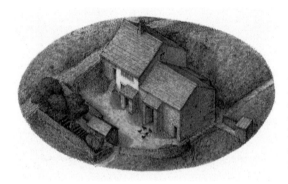

Pl. 10 Top Withins. Built into the steep hillside, the peat-house, farmhouse and barn had to be built on descending levels from the cart-track down to the footpath/packhorse track below. In common with other South Pennine 'laithe houses', it had an internal door from the house into the barn, ideal for tending the cows over-wintering in the 'mistal' at the lower end.

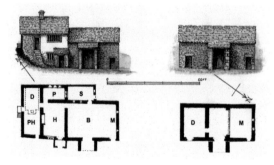

Pl. 11 Top Withins and the New Laithe

B. barn
P. parlour (here a back-kitchen)
D. dairy
PH. peat-house
H. housebody (living room)
S. stable
M. mistal (cow-house)

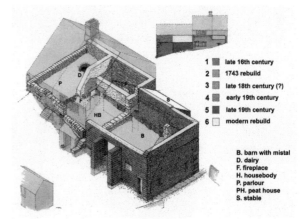

Pl. 12 Even after the farm had been deserted, its structure remained virtually complete up to the late 1940s, after which a combination of wind, frost and rain, coupled with the unwanted attention of some visitors, saw its rapid ruination.

1     late 16th century
2     1743 rebuild
3     late 18th century (?)
4     early 19th century
5     late 19th century
6     modern rebuild

B. barn with mistal
D. dairy
F. fireplace
H. housebody
P. parlour
PH. peat house
S. stable

Pl. 13 Most visitors find the ruins of Top Withins to be very confusing, especially since some parts have collapsed, some are deeply buried in tumbled rubble and others have been added in a completely inaccurate and misleading manner. This drawing helps to explain what can be seen there today in terms of its original use and its periods of construction.

3M

Pl. 14 Probably dating from the late sixteenth century, the north wall of the barn retains its original door and windows, and the east wall its mistal windows (bottom). The initials on the door lintel were added by a member of the Midgley family, Lords of the Manor of Haworth, who purchased the farm in 1691.

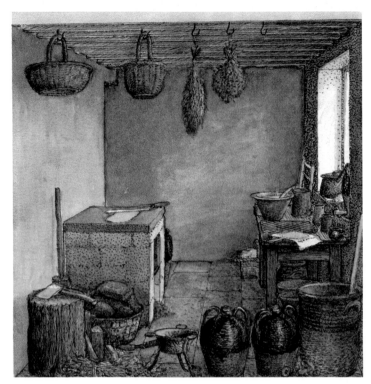

Pl. 15 Originally used as a bed-sitting room, the parlour here served as a back-kitchen in 1849. Food would be stored, beer brewed and kept in 'drink pots' and oatcakes baked on the bakestone to the left.

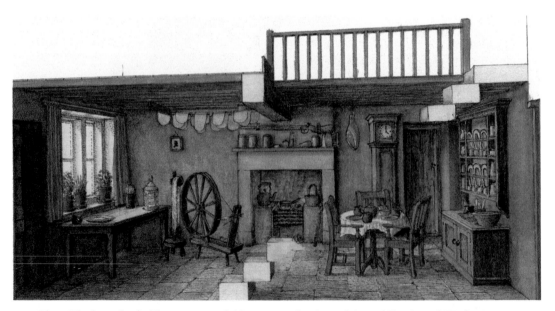

Pl. 16 The housebody. The contents of this room at the time of the publication of *Wuthering Heights* in 1847 were accurately listed just two years later on the death of Jonas Sunderland. With its table under the window for practical work, round snap-top table for meals, together with the spinning wheel and reel later collected from the barn, it was typical of the local handloom weavers' living rooms.

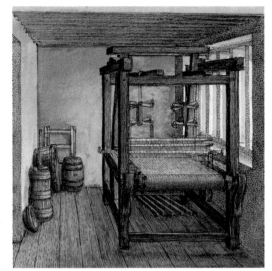

Pl. 17 The parlour chamber. The loom here would have been used by the younger John Sunderland up to 1849, when it was taken over by his wife Mary and probably used to train his sons John and James. When the inventory was taken the churn from the dairy and brewing tubs were also being stored here.

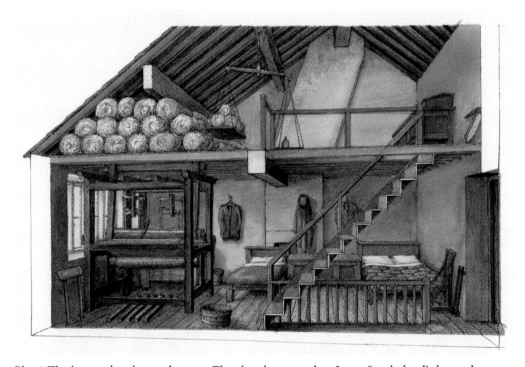

Pl. 18 The house chamber and garret. The chamber served as Jonas Sunderland's loom-shop where his five-shaft loom probably wove a fine worsted cloth called barathea. At night it also served as the communal bedroom for Jonas Sunderland (his wife died in 1832), his son and daughter-in-law Jonas and Mary, and grandsons John (fifteen) and James (six). Since there were only two beds, Jonas probably 'pigged in', the local expression for sharing a bed, with his grandsons. In July 1849 the fleeces from Jonas's sheep, together with the wool scales were stored in the garret, ready for sale, being too coarse for his own use. The hay knife was also kept here until needed to cut hay out of the barn over the coming winter.

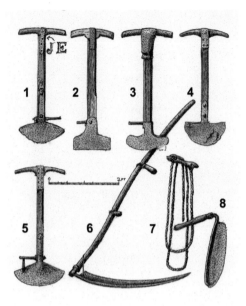

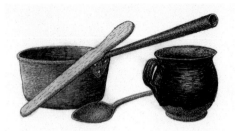

Pl. 21 Porridge was made by sprinkling oatmeal into a pan of boiling water with one hand while stirring with a wooden thible. It was then served in the pan or a dish, each spoonful being dipped in a mess-pot (right) of skimmed milk before being eaten.

Pl. 19 Graving and hay. In the South Pennines the hard, tough moorland was first broken up for improvement using a short, strong graving (i.e. digging) spade. These examples are from 1. Keighley Moor, 2. & 3. Top Withins, where they were used by Jonas Sunderland, 4. Gib Farm, Calderdale and 5. Lane Ends Farm, Saltonstall, used by Alfred Hoyles. When the hay crop was ready it was cut with a scythe (6), turned with a rake until dry, formed into burdens bound with a hayrope (7) and packed into the lofts in the barns. In winter blocks were cut out with a hay-knife (8), ready for feeding the cattle.

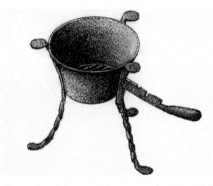

Pl. 22 This chaumin dish was used at Top Withins by Mary Sunderland. Sam Banks of Todmorden remembered how these firebaskets burned pieces of peat to boil pans of water, or had a bakestone placed on top for baking oatcakes.

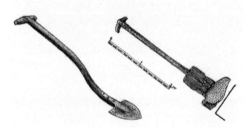

Pl. 20 The flaight spade (left) was used to pare off surface vegetation for fuel while the peat spade (right) cut out slabs of the black peat below. Both were used at Saltonstall in Calderdale.

Pl. 23 Made at the local potteries, these drink pots were used to store home-brewed beer. Note the spile at the top to release the pressure and keep the beer in good condition, and the spigot at the base for tapping it without disturbing its yeasty sediment.

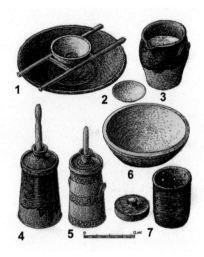

Pl. 24 Dairy utensils. After milking, the milk was strained through the brass-gauze base of a wooden 'sile' supported on its 'brig' across a black-glazed Halifax pottery cream-pan (1). Next day the cream was skimmed off with a wooden 'fleeting dish' (2) and stored in a cream-pot (3) ready for churning, sometimes using local earthenware (4) or stoneware (5 from Wood Farm, Ripponden) churns. The butter was then 'clashed' in a sycamore bowl (6) to remove the buttermilk and work in a little salt. Small cheeses were made in Halifax pottery cheese vats, pressed beneath their heavy sinkers (7 from Elam Grange, Keighley).

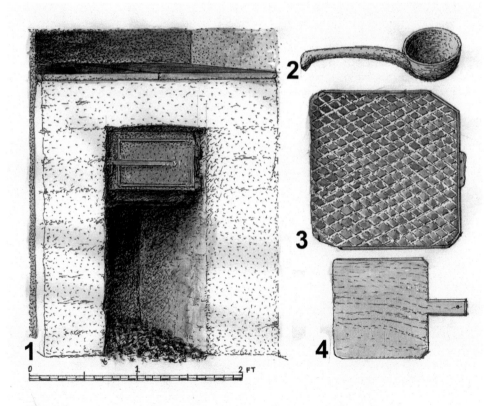

Pl. 25 The bakestone in the parlour at Top Withins probably resembled this example at Waltroyd, Wheatley, in the nearby Calder Valley (1). The oatmeal batter was taken up with a wooden ladle (2) and poured on to dry oatmeal on the 'riddleboard' (3) used by Mary Sunderland at Top Withins, and 'reeled' to form a large round puddle. This was then slid onto a piece of flannel resting on a spittle (4) and thrown onto the bakestone.

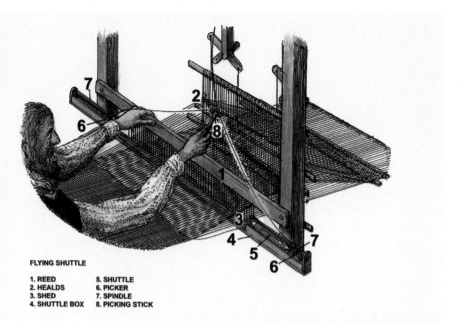

FLYING SHUTTLE

1. REED      5. SHUTTLE
2. HEALDS     6. PICKER
3. SHED       7. SPINDLE
4. SHUTTLE BOX   8. PICKING STICK

Pl. 26 Invented by John Kay in 1733, the flying shuttle greatly improved the speed and efficiency of weaving, being rapidly adopted throughout the West Riding textile industry. The reed (1) remained unchanged, but now, when the healds (2) opened a shed (3) between alternate warp threads the shuttle could be thrown through mechanically. From its shuttle box (4) at each end, the shuttle (5) was thrust forward by a picker (6) mounted on a spindle (7) every time the weaver flicked his picking stick (8) to left and right. The reed then packed each run of weft thread tight into the warp to form a smooth, even cloth.

Pl. 27 Making oatcake or 'havercake': 1) The fermented oatmeal batter was ladled onto the 'riddleboard', which had been prepared by having fine oatmeal shaken onto it through a sieve. 2) The batter was 'reeled' to spread it out into a large disc, 3) then slid onto the flannel-covered 'spittle' and 4) thrown onto the hot bakestone, 5) where it landed as a long oval, and began to bake. 6) When the edges began to curl up, it was freed from the bakestone with a special knife, flipped over, cooked on the other side, then cooled and hung up to dry.

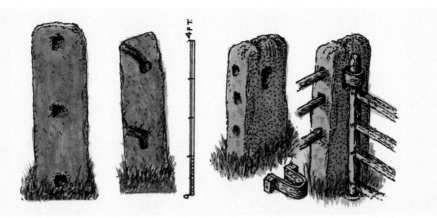

Pl. 28 Gateposts: 1) The traditional way of blocking a gateway was to use two or three wooden poles, one of their ends being pushed into the holes of one gatepost and the other dropped into the hooked slots of the opposing gatepost. These gateposts lie on Back Lane at the start of the walk. 2 Earlier gateposts, such as this example passed between Forks House and South Dean, are pierced by a rectangular hole. A bent piece of ash or similarly flexible wood was probably inserted to form a hinge for a wooden gate, the bottom of the gate pivoting in a socket at ground level. This gatepost now appears to be very short, since ploughing has caused the soil to slip down towards the adjacent stone wall and engulf its lower half.

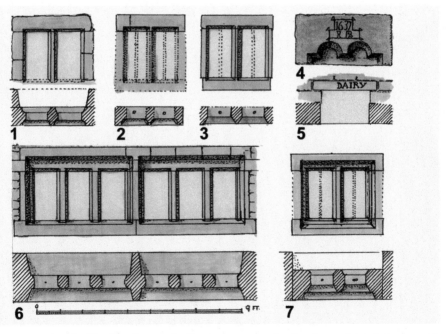

Pl. 29 Masonry details. The farmhouses built on the moors in the sixteenth and seventeenth centuries were extremely well built, their walls, windows and doorways being finely carved from the local hard, gritty stone: (1) Top Withins, late sixteenth century, (2) Lower Withins, late sixteenth century, (3) Top Withins, 1743, (4) Forks House, 1637, (5) Top Withins, 1743, (6) Middle Withins, late seventeenth century and (7) South Dean, late seventeenth century.

Sheep at Top Withins, 1997.

Pl 30 Forks House: a fine view taken by David Dodsworth around 1970.

Pl. 31 Virginia. Another of David Dodsworth's photographs taken around 1970.

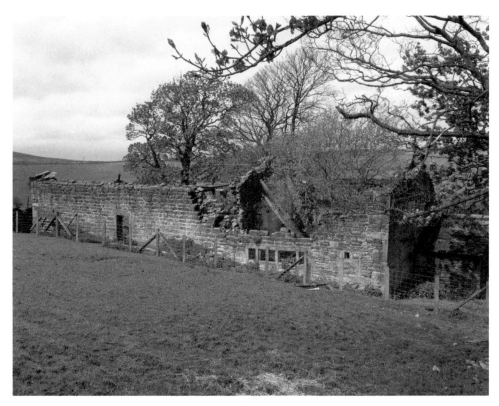

Pl. 32 'Far Enfieldside', a modern view.

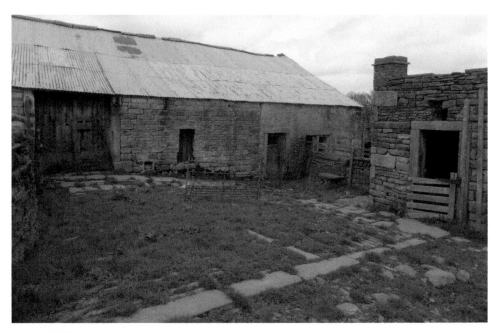

Pl. 33 'Middle Enfieldside', a modern view.

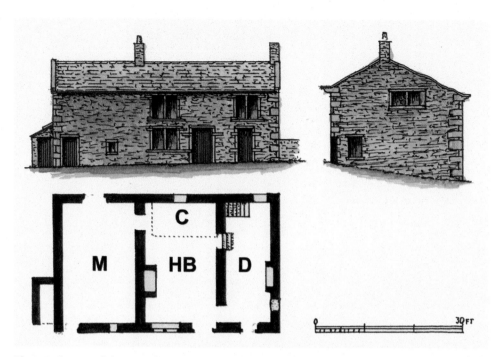

Pl. 34 Built around the turn of the eighteenth/nineteenth centuries, Middle Intake was still designed for the dual economy of handloom weaving and dairying: C. cellar, HB. housebody, D. dairy, M. mistal.

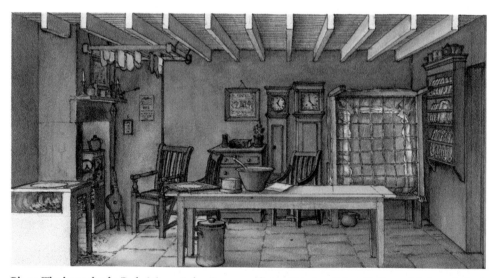

Pl. 35 The housebody, Dale Moor: John Craven collected his family's milk from this farm before 1878 and was later able to recall all its furniture still in place, including the flat-bottomed chair in which old Joseph Sunderland spent his latter days. Note the bakestone in the left-hand corner and the turn-up bed to the right.

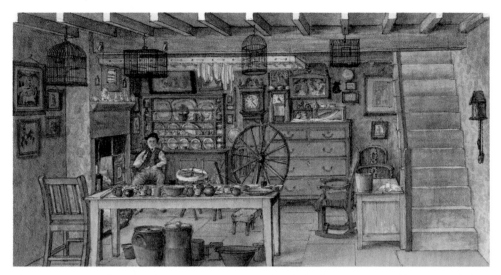

Pl. 36 Timmy Feather's kitchen, *c.* 1905. Timmy's family had moved to Buckley Green before 1851, and this room remained largely unchanged over the next fifty years. Most of the furniture was either Georgian or early Victorian, while the framed prints included later advertisements for the Cooperative Stores and Yorkshire Relish.

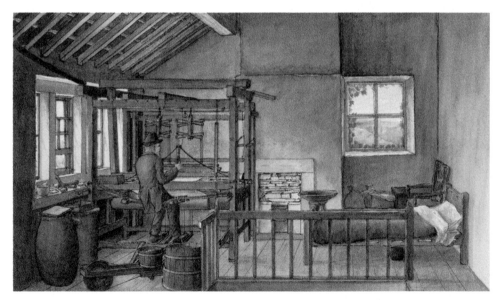

Pl. 37 Timmy Feather's loom-shop/bedroom, *c.* 1905. The loom was placed in the usual position against the long three-light window to the left. This room also housed a stone-weighted cloth press, but unfortunately this was neither sketched nor photographed and so is not shown here.

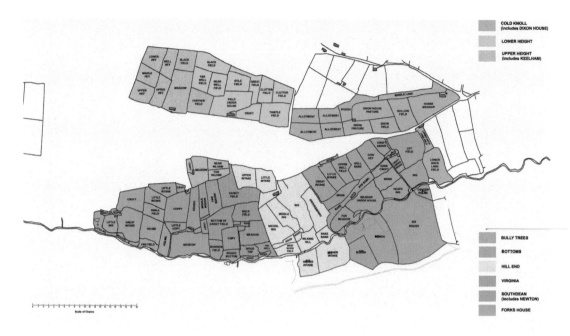

Pl. 38 The farms of Stanbury Moor, 1850.

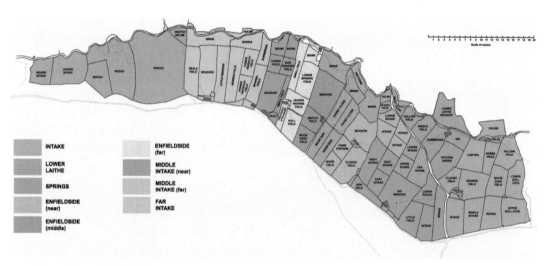

Pl. 39 The Enfieldside farms, 1850.

this problem by using a device invented by Michael Greenwood of Shibden, Halifax, called a false reed.[25]

It was still possible to earn a modest living by weaving worsteds by hand up to the third quarter of the nineteenth century, but by this time they could hardly compete with the hundreds of power looms now installed in the great steam-powered mills down in the valleys. As a result, the handloom weaving that had made life at Withins feasible had died out by the time of the 1871 census, leaving its farms to be gradually deserted and fall into the ruins still to be seen there today.

Today the thousands of visitors that walk up to Top Withins from Haworth, or up the Pennine Way from Walshaw Dean, see only a shattered ruin half buried in its own rubble, set in the bleakest and harshest of moorland landscapes. It fits ideally into their concept of the grim lifestyle so vividly depicted in Emily Brontë's *Wuthering Heights*. However, as this description clearly demonstrates, Top Withins made a comfortable, practical and productive base for generations of handloom weavers/farmers for well over three centuries. To them it represented a hospitable place of warm fires, dry clothes, food, drink and companionship, a real family home and a shelter from the gales and driving rain and snow that so frequently blasted them, their fields and their livestock.

The path up to Top Withins (*Anni Vassallo*).

# 11

# A WALK TO THE WITHINS FARMS

There are many different ways to approach Top Withins. The walk described here takes a varied route which starts in Stanbury and finishes in Haworth. This route passes by or near over twenty old farm sites besides the Withins farms themselves. Brief histories of each of these are included.

Stanbury village stands on the crest of the ridge between the River Worth and the Sladen Beck. The outward route to Withins runs along this ridge for a mile and then runs almost level along the valley side for a further half-mile before making the final ascent to Top Withins. The return route to Haworth quickly drops into the valley of the Sladen Beck and follows it for almost its full length.

The walk starts at the Stanbury bus terminus where Back Lane branches off the road to Colne (here known as Hob Lane). Before starting up the track to Withins it is worth walking a few yards along Hob Lane to look at the date stone which is built into the garden wall on the left. This double-arched door-head bears the initials IR (or, just possibly, AR) and the date 1637. It is believed to have come from Forks House which will be passed later in the walk.

Returning to the bus terminus, take the minor road up towards the moors. The fields on the left-hand side of this stretch of the road are long, narrow, slightly curved and south-facing – almost certainly they were arable fields in the Middle Ages. These are not well seen from the road but will be seen clearly from Enfieldside later in the walk. At the junction the route to Withins is straight ahead.

It is possible to take a short diversion at this point to visit Timmy Feather's cottage at Buckley Green. To do this take the road to the right and walk on past Cold Knoll End to Buckley Green, around a third of a mile. Just before the first cottages at Buckley Green are reached there is a gate on the left. Look up the field from this gate and you will see three trees and an obvious ruin. The ruined building is the Duke Top barn. What little remains of the house lies under the trees to the left of the barn. The Feather family lived there briefly and Timmy's brother George was born there in 1812. At Buckley Green there are two cottages on the right called Wildfell before the road forks. The left fork reaches Timmy's cottage after a few yards. It is the one bearing the 1832 date stone. A little beyond the cottage there is a footpath up the moor to the left which rejoins the main Withins walk below Lower Height. Timmy Feather was the last of the handloom weavers in the Haworth area and he is the subject of the next chapter.

The main walk continues up Back Lane from the junction where the Buckley Green road diverges. Cold Knoll (or Cold Knowl) is seen on the right after a few yards. In the mid-nineteenth century there were two households here. Each was occupied by members of the Moore family. They made their living by farming and weaving. By 1851 some of the children were working as power-loom weavers in the local mills. It is interesting to note that in 1861 William Moore, aged thirty-one, was 'working at a Coal Pitt'. This will have been one of the small coal mines on Stanbury Moor which will be passed later in the walk. By 1871 the occupants had reverted to farming and textile occupations.

There is a stile on the left opposite Cold Knoll. The loose-rail gatepost in plate 28 is just at the side of the stile.

After a further 200 yards or so there is a slightly wider stretch where it is possible to park a few cars. No cars should be taken beyond this point. Just where the track widens there is a field gate on the left. Through this is the site of Back Lane itself. Although it survived into the twentieth century, only a very careful examination of the site will show any signs that two cottages once stood here. In 1851 one of these was occupied by a handloom weaver named Jonathan Shackleton. Besides Shackleton and his wife Susan, the cottage was home to their seven children. The only girl and two of the boys were too young to work. Of the older boys two were wool-combers and two worked in a local textile mill. The other cottage housed a young couple, James and Sarah Bradley. He was a wool-comber while she was a worsted weaver in a mill. In 1861 the census enumerator noted that Back Lane was 'Inabited by one person but from home'. It will have been a lively place in the 1870s as Thomas and Mary Shaw had eight reservoir navvies lodging with them. By 1881 it was uninhabited.

A little further up Back Lane there is a gated track on the left which leads to Bully Trees. The name indicates that there were once bullace (wild plum) trees here. Like Cold Knoll this is one of the moorland farmhouses which survived the decline in hill farming and has been restored to make a modern home. In 1851 John Hey was farming around 30 acres of land at Bully Trees as well as producing worsted cloth on his handloom. After a couple of changes of tenancy the farm passed to Joseph Heaton who was there from around 1880 to 1910. He was followed by a succession of Marchams, Ratcliffes and Moores.

Beyond Bully Trees there is a track which descends to the Sladen Beck. Halfway down this track are the overgrown ruins of Bottoms. For much of the nineteenth century Bottoms was occupied by Claytons and Sunderlands. Joseph Clayton farmed 15 acres there from the 1820s to the 1860s. Half of this land was rough pasture on the Haworth side of the beck. He and his family were also producing worsted cloth. In 1851 Joseph and his wife and son were wool-combers and handloom weavers while the daughters wove in a mill. Unusually there was a young woman wool-comber at Bottoms. This was the Clayton's adopted daughter Nelly Pickles. In 1862, at the age of twenty-four, she married John Dugdale Sunderland. John and Nelly Sunderland remained at Bottoms for the next twenty years or more before moving to Stanbury village and then to Haworth. By the 1870s domestic textile work had all but died out and in the early years of his marriage John Sunderland worked as a stonemason

as well as farming. By 1881 he was no longer working as a mason. The census of that year describes him as farming 29 acres but the valuation of the same year lists only 14 acres in his tenancy. This discrepancy is unexplained. When John and Nelly Sunderland moved from Bottoms they were replaced by William and Hannah Sugden (1891 census). The Sugdens were succeeded by Henry Heaton (1901) and Thomas Craven (1911). All were farmers but William Sugden was also a quarry worker.

Our route however continues up the main track towards the moor. On the left is an old stone quarry which was one of the two that provided stone for the reservoir below Stanbury village. Stone was carried to the reservoir site by a narrow-gauge railway of which we shall hear more later.

In the fields on the right of the path there was a small dwelling known as Dixon (or Dickson) House of which very little remains to be seen. Timothy Feather's parents lived here briefly and his sister Sally was born here in 1815. The little house was occupied by John Moore, a handloom weaver, in 1841. With him were three daughters and a son. One daughter, Betty, also worked on a handloom and the other two girls were power-loom weavers in a mill. No occupation was listed for the boy. Ten years later only Betty and her two young children were left at home with John Moore. Both adults were still working as weavers at home. By 1861 the house was unoccupied. The fields surrounding Dixon House formed part of the land of Cold Knoll farm.

Near the head of the quarry a cattle grid and gate bring the track onto the open moor. Near here is the site of perhaps the least known dwelling in Stanbury. Just over the wall corner to the left near the head of the quarry stood Smooker (or Smoker) Hall. Despite the name this must have been a small house and it had no land of its own but stood at the head of the Bully Trees fields. When this land is ploughed the site yields a lot of stone and of 2-inch diameter clay pipe which probably carried water to the house. We know from the Haworth Parish registers that it was occupied by John Shackleton in the late eighteenth century and by Jonas and Mary Moore in the first decade of the nineteenth century. They were followed by Hannah and Michael Holmes who baptised a daughter in 1812. Smooker Hall is next mentioned in a valuation of 1813 when it was owned by Jonas Horsfall and occupied by John Sutcliffe. Finally a rate book of 1819 has an entry for 'S Hall' for which Josa Moore paid a poor rate of 7½d. It must have been abandoned shortly after this date. Although almost totally forgotten its name has lived on – the adjoining quarry is still known to older locals as Smooker (or Smoker) quarry. There is a story that the name derives from its having been the only quarry in the area where the workers were allowed to smoke. Do not go over the wall to the actual site of Smooker Hall – it is private farm land.

Passing over the cattle grid onto the moor the track enters the neck of a funnel which served to guide sheep into the lane as they were brought down from the moor. This can be seen very clearly on satellite photographs (try Google Earth). Keep to the right at the next fork in the track and carry on past Lower and Upper Height farms.

Lower Height (now called Lower Heights Farm) was a farm of around 16 acres of meadow and pasture. In 1841 the farm was occupied by Timothy Smith and his family. He ran the farm and wove worsted cloth. His oldest son Simeon was a coal miner. The coal mines on Stanbury Moor have already been mentioned in connection

with the Moores of Cold Knoll above. They were a series of small mines lying between Height and the Sladen Beck. They worked the thin seams of the Stanbury Coal from a dozen or more shafts and adits. They seem to have been active from the early nineteenth century to the 1860s and produced coal for the local mills. There was a very short-lived Stanbury Coal, Iron & Lead Mining Co. in the early 1860s. The optimistic aims embodied in the company's name had little chance of fulfilment. The company seems to have been defunct by 1863 and was dissolved in 1882 (see Gill 2004 for more details). The visible remains of the mines are mainly over in the Sladen Valley and will be noticed later in the walk.

By 1851 the Smiths had left Lower Height and for the next thirty years it was occupied by Heaton Moore and his family. As well as farming, the Moores were involved in woolcombing and handloom weaving. One of the daughters, Mary Ann, was a power-loom weaver in a local mill (probably Griffe Mill below Stanbury). Here, as at Lower Withins at the same time, subsistence farming was supplemented by both domestic and industrial textile work.

Lower Height is another of the moorland farms which has been restored and is still occupied today.

The same is true of the next farm up the moor, Upper Height. This was a similar farm to the neighbouring Lower Height having around 17 acres of meadow and pasture. Around 3 of those acres were across the moor to the south in what is now a coniferous plantation. There had once been a house here called Keelham (or Kilham) but it was in ruins by 1850. Even as early as 1813 Keelham was uninhabited. John Earnshaw who farmed 4 or 5 acres there lived at Newton. By 1838 the Keelham fields had been absorbed into the larger Hill End farm (which was also unoccupied) and were later transferred to Upper Height. Any ruins which may have remained will have been destroyed when the trees were planted in the 1970s.

In the 1830s and 1840s Upper Height had been farmed by Jonas Crabtree but in 1851 it was unoccupied. The farmer, Simeon Robinson, was then living at Lower Withins. By 1861 Robinson and his family had moved to Upper Height where he was to remain for the rest of his life.

In 1913 Keighley Corporation rented Upper Height farm as a smallpox hospital. It had a nurses' home, two wards, disinfecting room and ambulance shed. Although there had been no smallpox cases, the Ministry of Health insisted in 1921 on more provision being made. In the following year a wooden pavilion 74 feet by 28 feet with two 12 by 10 feet outshots was built next to Upper Height. It comprised two wards of five beds each with two single-bed observation or isolation wards in the outshots. A supply of water was piped from Withins. Additional accommodation for nurses was provided in the administrative block which, presumably, was in the farmhouse. The hospital was not normally open but was kept in readiness should the need arise. In May 1926 that time came when a news vendor who had been living in a common lodging house in Keighley was brought to Upper Height by horse ambulance. This was the start of an epidemic which did not subside until 1928. By January 1927 Upper Height was overwhelmed and two new smallpox hospitals had to be opened in Shipley. In the three years that the epidemic lasted there were 620 cases. It seems to have been a

relatively mild strain of the disease and there were no deaths. In 1929 the hospital did not open at all (Keighley MoH). By 1942 the hospital had served its purpose and the wooden building was offered for sale. Nothing now remains of this building and there are, so far as is known, no photographs of it.

Beyond Upper Height the track enters the belt of unenclosed moorland which separates the Withins farms from the enclosed fields of the Height farms and Forks House in the Sladen Valley. It is not clear why this land was never enclosed. One possible clue is the name Flaight Hill. Flaights were turfs cut from the moor and dried for fuel. Perhaps this part of the moor was reserved for flaight cutting. The Geological Survey notes that the area is covered with many sandstone boulders so perhaps the work of clearing it would have been too great (BGS 1997). Whatever the reason, a strip of moorland around 600 yards wide at its narrowest was left uncultivated. In the 1830s this was reduced to around 350 yards when five new intakes totalling about 17 acres were made on Scar Hill.

The New Intakes are reached around a third of a mile past Upper Height. Here you might see cows grazing as rare breed cattle are now being kept on the moor after a century when no cows were allowed. This is presumably possible because of developments in water treatment or a clearer understanding of the risks posed by cattle on water-gathering grounds.

It is difficult to imagine but in the early 1920s there was a steam railway here. When Lower Laithe reservoir was being constructed large quantities of clay were needed to make the embankment watertight. Most of it was dug from a puddle field on the right-hand side of the track a couple of hundred yards after the New Intakes are reached. The area is still recognisable as a boggy, rush-grown depression in the moor. From here clay was carried some 2 miles to the reservoir site on a narrow-gauge railway. Some of its embankments may still be found near Hill End and Bully Trees.

Just past the puddle field the end of the New Intakes is reached and the path crosses a small stream. On the left is Milking Hill which, until the New Intakes were created, would have been the first enclosed land to be reached after crossing Flaight Hill. It was a pasture belonging to Lower Withins farm. After crossing another small stream a field wall will be seen on the left running down toward the stream. This separated Milking Hill from the Great Meadow. It is very difficult to imagine now but this was one of the Lower Withins hay meadows. The dramatic shale cliff which drops to the stream near here is the largest of a number of scars created by stream erosion. It is the feature which gives Scar Hill its name. This exposure of Millstone Grit shales has a small place in geological history. In it is a marine band of dark shales laid down in one of the seas which periodically inundated the delta that deposited the sandstones. This contains traces of goniatite fossils. It was these which W. S. Bisat came here to see in 1921 with the Stanbury schoolmaster Jonas Bradley. From his detailed study of these fossils across the Pennines Bisat was able to establish the first reliable relative chronology of the Millstone Grits. At Withins Scar (as he called it) Bisat found a new goniatite which he called *Gastrioceras crenulatum* (it is now known as *Cancelloceras crenulatum*) (Bisat 1924).

A little further on, the track passes through a ruinous wall and enters Higher Croft, another hay meadow. From here to Middle Withins almost all the land on either side of the path was hay meadow in 1850.

A short distance beyond the wall the ruins of Lower Withins will be seen on the left.

The next wall is crossed where a tall gatepost stands on the left of the track. To the right is the site of the lost Lower Withins barn with the position of a sink marked by an obvious hole in the wall with an arched lintel over it. This wall also shows very clear traces of the building in the form of quoins close to the path and around 8 yards further west. These are best seen on the northern side of the wall. There is no documentary or map evidence for this building which, for convenience of reference, we propose to call Heys Laithe after the field in which it stands.

Continuing past an obvious tree another stream is crossed and an indistinct wall which marks the boundary between the Lower and Middle Withins fields. From here on the track is paved with stone flags. Just after the flags start a track will be seen running up to the right. This is modern and was created in connection with the consolidation work on the ruins of Top Withins. A short diversion up this path will take you to an obvious building platform immediately left of the path which is the site of Jack House. Little is known of this building other than that it was an outlying barn of Middle Withins farm.

It is noticeable that no building rubble survives at either Heys Laithe or Jack House. Perhaps it was removed during the construction of Lower Laithe reservoir.

The first edition 6-inch Ordnance Survey map (Sheet 199, 1852) which names Jack House also shows Harry House (site of) around half a mile over the moor to the north-west in Middle Moor Clough. No trace whatever can be found of this building which is unlikely to have been associated with the Withins farms. Given the names Jack House and Harry House it is tempting to speculate that behind them might lie a story of two brothers falling out and living apart.

Close to Jack House is a small walled enclosure which holds water. This was the water supply for the Upper Height smallpox hospital. It now feeds a trough in the New Intakes. There is a crude date stone built into the wall; it appears to read 1760 and might have come from one of the nearby buildings now demolished.

A little further up this path is a strange little valley called Benty Hole. This has been identified as worked ground by the Geological Survey (BGS Sheet SD93NE Crow Hill). It is suggested that this might have been a fireclay pit. Another possibility is that iron pyrites was found here associated with the marine band which passes through Benty Hole (pers. comm. Dr Colin Waters, British Geological Survey). Could this have been the site of the 'Stanbury gold rush' which was mentioned in a letter to the *Keighley News* in 1866? The letter is an amusing complaint by 'An Indignant Stanbury Maid' about the village's 'selfish, good-for-nothing bachelors' who had gone to dig for gold on the moor leaving the disconsolate Stanbury maidens behind. It said that some time earlier it had been reported that gold had been found on the moors leading to the exodus of the bachelors. The men had worked day and night at 'fatiguing and hazardous labours' only to discover that the supposed gold was worthless (KN 1866. See Appendix A). This might be a reference to some activity of the Stanbury Coal,

Iron & Lead Mining Co. which had been active a few years earlier (see Lower Height above). If fool's gold were ever worked on Stanbury Moor, it is perhaps more likely that it was deliberately extracted for making copperas (ferrous sulphate) for use in wool dyeing. The mining company's prospectus speaks of 'a bed of iron stone about two feet thick' on the moor. Iron stone usually refers to ores like siderite which are generally found in the coal measures and would not be expected on Stanbury Moor. Unless they were using the term very loosely to mean any iron-bearing rock, this reference is unexplained. Interestingly the prospectus also mentions the possibility of working fireclay deposits.

The main path now starts the final climb towards Top Withins. It runs south through two hay meadows belonging to Middle Withins – Four Nooked Field and Great Field – to the obvious ruins of Middle Withins itself. The plan of the farm and barn are fairly easy to see. A little searching among the rubble will reveal at least one section of a chamfered window mullion. After Middle Withins the path goes through a pasture called Gunner Holme and then, after another wall, a hay meadow which had no name other than 'Meadow'.

Finally, 2 miles after leaving the Stanbury bus terminus and at a height of 1,376 feet above sea level Top Withins is reached. The layout of the building is somewhat obscured by recent consolidation work and a copy of plate 13 will help to make sense of the ruins. Unless the weather is foul this is the obvious place to stop for lunch. The local sheep are very friendly and will be only too happy to help you eat your sandwiches. If it should be raining (as occasionally happens in the Pennines) there is a bothy for shelter – push hard, the door sticks.

Across the valley to the south-east the ruins of the early eighteenth century New Laithe stand at the head of the field of the same name. New Laithe Field was a meadow of around an acre surrounded by three fields totalling a little under 7 acres of pasture. All this New Laithe land across the stream is in Haworth, the rest of the Withins estate being in Stanbury.

An interesting addition to the walk is to visit the Alcomden Stones. There is a little footpath up Delf Hill which starts just behind Top Withins. A short distance up the path are two overgrown little quarries. These were probably the source of most of the stone used in building the Withins farms. The path soon levels out and heads northward to the trig point on Withins Height. One of the three peat pits on Delf Hill is just off this path to the left. It is the only one which is still visible but not much can be seen at ground level. From the trig point there are paths in several directions. Take the one to the west which heads for the Alcomden Stones. Around 100 yards from the trig point this path enters a very striking sunken section which takes it across Blue Scar Clough. This is particularly obvious in aerial photographs. The first edition 6-inch OS map of 1852 shows that this track went to the township boundary and no further. There is no stone quarry at the end of it so it must have been a turbary road serving peat pits on the moor. It looks likely to have been used by the Height farms rather than those of Withins but it does have branches to the latter.

The Alcomden Stones are reached shortly after regaining moor level. Here are many striking boulders including one large perched slab. This was inevitably ascribed by

nineteenth-century antiquarians to the Druids. One writer (Lewis, 1848) described it as 'a cromlech, evidently Druidical, consisting of one flat stone, weighing about six tons placed horizontally upon two huge upright blocks, now half embedded in the heather'. In fact it is quite natural, these rocks being a good example of a scarp-edge tor created by periglacial weathering in the last ice age. Down the slope to the north is a large apron of boulders which 'sledged' down the hill on a slurry of thawed mud at the end of the last ice age. One of these just below the main group of stones has three deep basins on a near vertical surface. It is well worth finding.

From here a great expanse of moor and bog stretches north-westward to Crow Hill and Boulsworth in Lancashire. This was the scene of the Crow Hill bog burst of September 1824 which sent thousands of tons of peat, mud and boulders down the Worth Valley. Patrick Brontë feared for the safety of his children who were out walking on the moors at the time. Later he preached a sermon on what he supposed to have been an earthquake. Harwood Brierley came to view the site of the bog burst in 1894, guided by William Kay, a Stanbury quarryman. Kay spoke of having walked across Stanbury bog when it had 'shakked like a jelly'. He knew one spot 'wheer ya could stond un sway sixty yards o' swamp up an' dahn same es a rantipowl' – that is to say, like a see-saw. (Brierley 1928)

From Top Withins walk back to Middle Withins and take the signposted path to the right. It crosses Great Field diagonally and then drops across Wine Wells pasture to the stream below Scar Hill. After crossing the stepping stones at the confluence of two streams the footpath follows the bottom of another pasture called Within Hill. Shortly after crossing the stream a signpost is reached. If you look to the right here you will see the slot-like Rough Dike where it discharges into South Dean Beck. This dyke runs the full length of the south-eastern boundary of the Withins fields. Just past Rough Dike there are the remains of a sheep fold beside the stream (better seen from a little further on, looking back). This is the only definite fold at Withins. Its situation strongly suggests that it was used as a wash fold. In the north-eastern corner of Within Hill not far from the wall which divides it from the Lower Withins pasture called Scar Top there is a small building platform. The two-celled building which clearly stood here must have been the 'lathe or barn builded on Wythin hill' mentioned in a deed of 1620. When the light is right it is just possible, from a distance, to make out a track leading up to the barn. Although it is not marked on the 1:25,000 Ordnance Survey map there is a faint footpath that runs along the wall over Scar Hill which is useful for visiting the laithe platform. The continuation of this path on the northern side of Scar Hill crosses the northern end of a long ditch which cuts across Scar Top pasture. This ditch remains unexplained but might be an older field boundary. Both the sheep fold and the Within Hill laithe are on land belonging to Middle Withins.

Beyond Within Hill there is quarter of a mile of uncultivated moorland before the next fields are reached. Where the path leaves the enclosed land there is an obvious tributary valley to the right. This is Crumber Dike which runs down from the glacial meltwater channel at Harbour Hole.

The next field wall to be reached marks the land of Forks House. Just over the wall which lies alongside the path are the moss-grown ruins of two or three cottages. A few

yards further on the path passes through a gate and reaches the ruin of Forks House itself with its attendant tree (see Pl. 30). Forks was unique on the Stanbury Moors in having a small mill as well as the farm. The mill was built around 1800–10 by Hiram Craven of Dockroyd who went on to construct the Lees and Hebden Bridge turnpike road (today's A6033) and the Ouse Bridge in York. It is listed in the 1813 valuation as a factory. All that remains today is the goit and dam, now dry, and a very little masonry. They lie between the cottage ruins and the stream. Two of the cottages were occupied by Timothy Smith and Joseph Thornton in 1813. They and their families must have been the mill's workforce. In all probability this would have been a very small, water-powered spinning mill. The cottages have been referred to as a 'kembing hole', that is a woolcombing shop (pers. comm. Harold Horsman). Joseph Craven's 1907 book on Stanbury tells us that 'a Mr. Sunderland … who used to atend Halifax Market with his piece goods, woven in the neighbourhood by handloom weavers, and who carried them on pack-horses, had a little mill up in this moorland place'. This was John Sunderland who owned Forks House in the early nineteenth century. From Baines' 1822 trade directory we learn that John Sunderland of Stanbury was a worsted manufacturer. All these facts taken together mean that Forks House Mill was a worsted spinning mill.

In 1817 a valuation was made of Forks House (otherwise known as Royds House) and South Dean. It was made on behalf of Benjamin Rawson, Lord of the Manor of Bradford, who was interested in buying property at South Dean from John Sunderland. Rawson's main interest seems to have been in the coal mines on the land. He bought the property in August 1818 and the farms were then let back to the Sunderlands. On the sketch map accompanying the valuation the most westerly field, a pasture of 1½ days' work, contains the mill, the mill dam and 'three low rooms for cottages' (Wood 2014 p.64). (A day work was a measure of land equal to two-thirds of an acre.) The mill must have been short lived as it does not appear in the 1838 valuation and the 1850 tithe map shows it as 'Old Mill'. There is a story that it was used as a stamp mill in the 'Stanbury gold rush'. This seems unlikely as the 'gold rush' can be dated to the 1860s and the mill was already a ruin by 1847 and had gone completely by 1892 (OS 1852, OS 1894). It is no doubt coincidental that there is a mine adit in the stream bank a little to the west of Forks House Mill. It is a well-constructed, stone-lined, arched tunnel that is blocked by a roof fall a short way in. It is thought to have been an exploratory excavation seeking the continuation of the coal seam which had been mined further down the valley (Gill 2004). The geology of the area makes it unlikely that any coal would have been found here (Waters 1997).

Turning to the farm at Forks House we find the now familiar pattern of a small dairy farm. It had 11 acres of land of which 3 or 4 acres were hay meadow and the rest pasture. In 1813 John Sunderland, the owner, lived here. He farmed both the Forks House and the South Dean land. After the 1818 sale Sunderland rented the three South Dean farms (Forks, South Dean and Virginia) from the Rawsons. In 1838 his son Joshua Sunderland had a sub-tenant, Robert Feather, in Forks House. Robert Feather was born at Middle Withins in 1801. He was Timmy Feather's eldest brother. The Feather family were to be at Forks for a century and they illustrate many of the

ways in which hill farming was supported by changing second occupations over the course of the nineteenth century. At first Feather worked as a stuff weaver while the land was farmed by Joshua Sunderland. By 1851 he had taken over the farm and was also a gamekeeper. On the tithe map of 1850 Forks House is named Keeper's House. The Rawsons who owned Forks were Lords of the Manor of Bradford (of which Stanbury was still a part) and would have owned the shooting rights on Stanbury Moor. Having one of their tenants acting as a part-time gamekeeper no doubt made good sense at that time. Textile work was also playing a part in supporting the family. Three of the children were weaving in a local mill and one boy was wool-combing at home. Although there is no mention of handloom weaving it is reasonable to assume that Robert and Mary were still weaving worsted at home. Certainly by 1861 their daughter Ann was working at a handloom having left the mill where she had been a power-loom weaver. Two of her brothers were wool-combers while the youngest boy was winding bobbins for her. Two more brothers were weaving in a mill. Ann Feather's move from power-loom weaving to take over the household handloom from her parents is unusual. After a further ten years all textile work had ceased at Forks. The two sons who had been combing wool were now, in 1871, working as a carter and a reservoir labourer while their father ran the farm. John, the carter, had left home by 1881, leaving Robert running the farm and William working as a quarryman. William's employment as a hand wool-comber will have vanished in the 1860s as the process was mechanised. The building of the nearby Ponden and Watersheddles reservoirs in the 1870s gave him a new way of earning his living. After working as a reservoir labourer for some years, a move into quarry work is not too surprising. His father's death in 1883 led to a further change of occupation when he took over the family farm. In 1891 there were just William and his widowed mother Mary living at Forks. Mary Feather died in 1893 and the following year William married Emma Jane Wallbank, the widow of a Stanbury clog maker. At the age of sixty he was running the farm while his new stepson, William Wallbank, was a stonemason. William Feather died in 1920 and his widow Emma Jane in 1928. The electoral registers show a John William Feather at Forks in 1925 and 1929 – what relation he was to William is not known. The last known tenants of Forks were Jack and Mary Elizabeth Slater in 1934. It seems likely that the place was abandoned shortly after. The ruins of Forks House stood for a few more decades before being cleared away in the 1970s or thereabouts. Little remains on the site now apart from some old roof timbers and a little masonry beside the path. The keeping cellar actually runs under the path but is scarcely visible now.

Beyond Forks House the footpath follows the field wall through pasture land for about 300 yards passing the early gatepost depicted in plate 28. The reservoir railway ran through this field before turning northward to cross the moor to the New Intakes and the puddle field. Its course across the moor can be quite easily distinguished as a strip of rough grass running through the heather. Beside the path is a fine gatepost with a square hole. When you reach it look across to the left toward the plantation and you will see two trees. These trees mark the site of Newton. This seems to have consisted of two dwellings that did not have any land of their own. In 1813 Newton belonged to John Sunderland of Forks House. The tenants were John Earnshaw and Joshua Smith.

John Earnshaw farmed the land at the nearby Keelham. Sometime after Benjamin Rawson bought the property Newton was abandoned and by 1850 was in ruins.

The footpath now goes through a stile and enters fields which have reverted to rough pasture. The ruins of South Dean will be seen on the right.

There are deeds for farms at South Dean dating back to the early seventeenth century. In 1813 John Sunderland with his brother Joshua inherited Forks, South Dean and Virginia from his father William Sunderland of Bully Trees who died in 1813. We have already seen that John Sunderland was then living at Forks House. From there he farmed the land of both Forks and South Dean. The house at South Dean was occupied by Jonas Moore. John Sunderland bought Joshua's share of the property in 1818 before selling to Benjamin Rawson later that year (pers. comm. David Riley).

By 1838 John Sunderland's son Joshua was the Rawsons' tenant at South Dean. Joshua himself was at the New Inn on Hob Lane in Stanbury (later known as The Eagle and more recently as The Old Silent). South Dean was occupied by a sub-tenant, Heaton Moore, who had been there since around 1830.

In 1841 Heaton Moore was a thirty-five-year-old farmer and stuff weaver who lived at South Dean with his wife Mary and their four young children. By 1851 the Moores had moved to Lower Height and South Dean was occupied by John and Maria Sunderland. John, aged thirty-five, was a farmer of 10 acres and a handloom weaver. His wife was also a handloom weaver and their son George was winding bobbins for them. No relationship has been found between this John Sunderland and the John Sunderland who owned South Dean up to 1818 (pers. comm. David Riley). They were still at South Dean in 1861 and were still weaving on the handlooms. George was now working as an agricultural labourer, his younger brother John was a weaver in a mill and the youngest boy, Robert, was described as a scholar but may well have taken over the bobbin winding.

The Sunderlands must have left South Dean shortly after the 1861 census as it was occupied by Emanuel Smith in 1863. In 1871 he was a forty-three-year-old farmer living on his own and farming 12 acres of land. He was still there in 1881 but seems to have moved away, perhaps to Damems, before his death in 1887. After Smith left South Dean it remained unoccupied and fell into ruins.

Just beyond South Dean the path forks. The main route continues down towards the stream while the left branch leads back to the starting point and should be taken if you have left a car on Back Lane.

## To Return to Back Lane
*(The walk to Haworth continues after this)*
The route back to Stanbury continues at the same level towards the tree ahead, which marks the site of Virginia. The path passes beside a mound to the right which is the site of a coal mineshaft. From this an obvious drainage ditch leads down south-westward towards the stream. The 1817 survey of the South Dean farms tells us that this shaft was 37 yards deep and that it reached a 12- to 14-inch-thick coal seam. On the 1817

plan the drain is labelled 'Dike Coal'. More mineshafts can be found up to the left of the path around here.

The site of Virginia is obvious enough but the building was demolished around 1995 and little now remains. Like Forks House and South Dean, Virginia was inherited by John Sunderland in 1813 and sold by him to Benjamin Rawson in 1818. In 1813 it was occupied by William Sunderland. After the sale to Rawson, Virginia was leased by John Sunderland until his death in 1824 and then by his son Joshua. By 1838 it was sublet to John Moore. By 1841 John Moore was living at Hill End and was presumably farming the Virginia land from there. Virginia itself was empty. In 1851 Robert Jackson had taken the farm and was also a handloom weaver. His wife Zillah was working as a dressmaker. The Jacksons were succeeded by John and Sarah Pickles who were there in the early 1860s.

In February 1863 John Sunderland of Top Withins (known as John o'Top) married Nancy Pickles of Hob Cote at Keighley parish church. At that time they already had an infant daughter named Mary Ellen. Shortly after their marriage they went to live at Virginia. There is no mention of the Sunderlands weaving at Virginia in the census returns but we know that John was working at a handloom at Top Withins two years before his marriage. It may well be that they did some handloom weaving at Virginia when they first moved there but the trade cannot have lasted long. Joseph Dixon had a loom from Virginia (which he calls South Dean) in his museum at Harrogate. This was a large loom with ten treadles. Dixon says it was harder to weave on this loom than to learn to play simple bass parts on the organ. He states that Nancy stopped weaving on 1 October 1863. (Dixon n.d.)

In 1871 and 1881 John Sunderland was a farmer and gamekeeper. As at Forks House in 1851 we have one of the Rawsons' tenants on the moor acting as their gamekeeper. Nancy Sunderland died in 1888. In 1891 John was living at Virginia with his daughter, Mary Ellen Pickles, who died in 1893. John Sunderland married Rebecca Denby of Oxenhope in 1894. In 1901 he was still farming at Virginia where he lived with his second wife Rebecca. By 1911 John had retired from farming and he and Rebecca were living at No. 25 Uppertown in Oxenhope. He died in 1913 and was buried with his first wife and daughter in Stanbury Cemetery. Rebecca died in 1918 and was buried at the new Lowertown Wesleyan burial ground.

After the departure of the Sunderlands a succession of families lived at Virginia until 1945. It then seems to have remained empty until it was finally demolished in the 1990s (see Pl. 31).

The path now turns left and then passes through a gate into a large pasture. The two very obvious mounds to the right of the path mark the positions of two more coal mineshafts. The reservoir railway passed between them. The best surviving embankment of the railway is around 80 yards further north but is not on the line of the footpath. Just before the ladder stile that takes the path out onto the moor you pass the site of Hill End. There is now nothing to show where this farm stood, the last remains having been cleared away some years ago.

In 1813 Hill End belonged to Thomas Pickles who lived and farmed 24 acres there. Thomas Pighills (probably the same man) still owned it in 1838 but the house

was apparently empty and the land untenanted. This state of affairs must have been short lived as John Moore and his family were living there in 1841. Moore was a thirty-five-year-old farmer and stuff weaver. By 1850 the farm belonged to Emanuel Hudson and was occupied by Joseph Pickles. Pickles farmed 23 acres at Hill End and also worked as a wool-comber. His wife Susey was a handloom weaver. They were both twenty-nine years old and they had four young children. Ten years later three of the daughters were working in a worsted factory. There is no mention of handloom weaving at Hill End in the 1861 census. In fact there were only nineteen handloom weavers in the whole of Stanbury hamlet in 1861. All but one of these lived on farms. There were seventy-three handloom weavers in the hamlet in 1851 and two-thirds of them lived on farms. The 1841 census does not specifically identify handloom weavers but there were around 140 stuff weavers of whom half lived on farms. These figures clearly show how the domestic textile industry declined in the mid-nineteenth century. It is noticeable that the remaining handloom weavers tended to be from farming families. The textile industry still played its part in supporting the hill farms as the farmers' children found work in the mills.

In 1863 Hill End was jointly owned by Emanuel Hudson and Frederick Spencer. The new tenant was George Feather. He was to stay there for half a century. In 1871 George Feather and his second wife Jane (he had been married to Sarah Moore of Lower Height but she died in 1859) were both thirty-seven years old. They had three children James (11 and from George's first marriage), Robinson (seven) and Alice (five). Feather was farming 22 acres and had no other occupation. As the children grew up they took jobs in a mill. Robinson became a weaver and Alice a spinner by 1881. Their younger sister Emma (eight) was at school. By 1891 Robinson had left home and Alice had become a weaver. Robinson returned home by 1901 and was working on the farm but later became a gamekeeper, which was his occupation in 1911. Jane Feather died in 1911 and George two years later. Robinson Feather stayed at Hill End until he died in 1925. In 1901 and 1911 his sisters Alice and Emma were both living at Hill End. Alice was to die unmarried in 1934. Emma had married Frederick Ratcliffe in 1898 and they had three children. Frederick seems to have lived separately at Shaw Top in Oxenhope where he was a boot- and clog-maker.

After the death of Robinson Feather Hill End had three more tenants, including the splendidly named Barzillia Bennet, before falling into disuse by 1948. By the late twentieth century there was little left on the site; now there is nothing there at all.

From the site of Hill End cross over the ladder stile and follow the path which heads north to an obvious track. Turning right on this track, the parking place on Back Lane is reached in quarter of a mile.

## Continuing the Walk to Haworth

From the junction of paths near South Dean the main route follows the obvious path down the hill towards the Brontë Bridge. A little way down this path a ditch crosses it. This is the 'Dike Coal' which leads from the mine shaft mentioned above. Another shaft top is passed before the Brontë Bridge is reached and there is an adit draining into the stream just upstream from the bridge but it is far from obvious. Perhaps it was this

adit that was visited by Joseph Craven (Craven 1907): 'I once went up this mine in a trolley to see one of my companions. We had nothing but a candle with us, and when we reached my friend he was lying on his side working at the seam – a very shallow one.'

The present bridge across the South Dean Beck was built in March 1990. Its predecessor, itself one of a long line of bridges on the spot, was destroyed by a flood on 19 May 1989. The stone for the new bridge was flown in by helicopter from Gillson's quarry on Brow Moor in Haworth.

This area has long been reputed to be a favourite resort of the Brontë sisters. As well as the Brontë Bridge, there are the Brontë Waterfalls and the Brontë Seat nearby. The waterfalls were originally known as Harbour Falls (Hall n.d.). The earliest appearance of the name the Brontë Waterfall is probably 1873 when it was the caption to Wimperis's illustration of the falls (Gaskell 1873). Confusingly the waterfall near Ponden Kirk was also called the Brontë Waterfall (e.g. in the *Yorkshire Weekly Post* 8 January 1887). John James thought that it was to the waterfall at Ponden Kirk that Charlotte Brontë walked with her husband in November 1854 (James 1866, p. 17). This walk led to a cold which precipitated the illness that resulted in her death the following year. Mr Nicholls himself told J. Horsfall Turner that 'the fall in question is that which is usually called the Brontë Fall, near the Parsonage at Haworth'. (Interview with Charlotte Brontë's husband, anon, *Yorkshire Post*, 12 September 1894)

The route from the Brontë Bridge towards Haworth is unmistakable, being walked by thousands of visitors every year. After rather more than half a mile the site of Far Intake is passed. The site is marked by two trees but little remains of the building. In 1813 this farm belonged to Lister Ellis and was occupied by Abraham Sunderland. At some time in the 1830s or 1840s (the records are unclear on this point) William Helliwell moved here from Walshaw in Calderdale. We do know that he was there in 1849 for in January of that year his young son Joseph was lost on the moor. There are differing accounts of this story but it is clear that for some reason the three-year-old child strayed onto the moor unobserved and was not missed for some time. He went missing on Saturday, 27 January. William Helliwell and his neighbours searched the moors all that afternoon and night. On the Sunday morning hundreds joined the search which was hampered on Monday and Tuesday by snow. Joseph's body was found on the moor 2 or 3 miles from home on Wednesday. He was buried in Haworth churchyard on Saturday, 3 February 1849. The incident was the subject of a number of verses by local writers. (Schroeder 1851, Vol.1 p.391; Dewhirst 1975)

More confused are stories about there having been a public house called the Packhorse Inn or 'Betty's' at Far Intake (Stobbs 1962). There is no known documentary evidence for this inn but beer shops and less formal drinking establishments were not uncommon on the moors so there may be some truth in the story. There is a footpath between Far Intake and Cold Knoll which crosses the Sladen Beck by a footbridge locally known as Betty Bridge. The footpath is old but the bridge seems to date from the early twentieth century so it might not be relevant.

William Helliwell and his wife Ann farmed 16 acres of land of which almost half was meadow. By 1861 the family had left Far Intake and moved back to Calderdale.

When Ann Helliwell died in 1869 she was brought back to Haworth to be buried with her son Joseph in St Michael's churchyard (grave E536). William joined them when he died in 1884.

Just before the obvious ruin at Middle Intake a wall corner is reached. Immediately before this wall there was once a wooden tearoom beside the track. This was erected by John Metcalfe in 1922 (Haworth building plan No. 848 at Keighley Library) and was run by him and his wife Alice Hannah for around eight years. It catered for visitors walking to the waterfalls and to Withins but is said never to have made much money as the Metcalfes were devout Methodists and would not open on Sundays (pers. comm. Barry Metcalfe, KN 1945). Alice Metcalfe was a great-niece of Timmy Feather. This is a good place from which to view Stanbury's medieval arable fields mentioned earlier.

The ruin at Middle Intake is one of two buildings that once stood here. The second building was in the field beside the track just a few yards beyond the surviving ruin. Each of these had its own land. The surviving building stands at the head of two fields totalling just 3 acres, half of which was meadow and half pasture. This would have been enough to support a cow and a few hens but cannot have come near to providing a living for the resident family. Jonas and Susy Thornton who lived here in 1851 with their three young children must have made most of their living from wool-combing (see Pl. 32).

The now vanished farm immediately beyond the ruin had 8 acres of land. Of this 2½ acres were hay meadow and most of the rest pasture. If the tithe award is to be believed there was a quarter of an acre of arable land just beyond the farmhouse. One of the pastures had the interesting name of Dog Stander Field. Dog Stander was a local name for common ragwort. This was one of the ingredients found in an 1819 recipe from a book kept at Rush Isles farm near Ponden Reservoir. The flowers boiled in spring water made 'an exelent Licquid for the scurve or the Leperese New found ought wich will cur If ever Soo Bad' (Rush Isles). The land here belonged to the Curate of Luddenden and will have provided part of his income. The farmer in 1851 was Joseph Booth. Again the farm was supported by woolcombing at which Booth, his wife Ann and two of their sons aged ten and eight all worked.

Continuing past Middle Intake two ruins are seen in the field between the track and the reservoir. These are two of the three Enfieldside farms. The third is now almost vanished but a small section of wall still stands in the field before a small stream valley is reached. These three farms seem never to have had names which properly distinguish one from the other. It is convenient to refer to them as 'Far, Middle and Near Enfieldside', going from west to east. It must be emphasised that these names are not used in the records (at least not in this way) – they are adopted purely for convenience. (see Pls. 32-33 & 39)

'Far Enfieldside' is named on the tithe map as Endfieldside but in 1813 it was referred to as Matcoat and in 1838 as Matt Coat. Coat (or Cote), as well as being the usual name for a pigsty or hen hut, was also used for dwellings. Perhaps Matt was an earlier occupier of the farm; Matthew was not an uncommon name in Stanbury. In the early nineteenth century the farmers were called Pickles or Pighills but by 1851 John Feather was farming the 8 acres of land. Here again it was textiles that provided the rest of the

family's income. John Feather and his eldest son, also John, were wool-combers. His wife Mary was a handloom weaver and her eleven-year-old daughter Mary wound the weft yarn onto bobbins.

At the bottom of the Far Enfieldside land there was a small mill which was destroyed when the reservoir was built. It was variously known as New Mill, Little Mill, Robinson's Mill and Hazel Mill (the last name deriving from the novels of Halliwell Sutcliffe who would have found the earlier names too prosaic). The mill was built around 1806 by Abraham Sunderland who, as we have seen, lived at Far Intake. It was quickly acquired by William Newsome who operated a spinning mill here. The mill later passed to William Robinson and then to George Taylor. (See Thompson 2002 for a full account of this mill.) In 1851 it was occupied by Abraham Howker and his wife Hannah who worked as wool-combers. By 1861 it was unoccupied and it remained empty until it was demolished around 1912.

'Middle Enfieldside' is the building which has its gable end facing up toward the track. It is unnamed on the tithe map, in 1813 and 1838 it is called Intake (as are several of these farms) but the 1851 census calls it Old Hall, Henfieldside. In 1851 John Sutcliffe had been farming his 6 acres here for at least thirteen years. His wife Sarah had died some time earlier, probably in 1835. Three of his children were still at home. John (twenty-nine) was a wool sorter, Edward (eighteen) was a wool-comber and Harriet (sixteen) looked after the house. Nobody seems to have been weaving there in either 1841 or 1851. The land of this farm and of 'Near Enfieldside' was owned by the Curate of Silsden. Silsden Curacy had been formed in 1712 and had received a grant from Queen Anne's Bounty to help support the curate. It may be that this land had been bought with that grant to generate income for the curate. (Pers. comm. Michael Baumber).

Between the two farms belonging to Silsden Curacy there is a block of land that belonged to the Taylors of Stanbury and was farmed from Stanbury. Near Enfieldside was a 7-acre farm, half meadow and half pasture. The farmer in 1851 was John Laycock. His wife Isabella was a handloom weaver and their oldest child Robert wound the bobbins. However, John Laycock himself was, as well as being a farmer, not a weaver or a comber but a stonemason. It is less than a mile from his farm to the quarries on Penistone Hill and he probably worked there.

The last farm before the road is reached is Springs. This stood derelict for many years but has been beautifully restored and is once again occupied. For much of the nineteenth century Springs belonged to the Taylor family of Stanbury and was occupied by the Shackletons. Between 1813 and 1838 Luke Shackleton extended the farm from 8 acres to 18 acres by creating intakes both to the west and to the east of the older enclosed land. By 1850 the area of farm land had reduced to about 16 acres of which 5 acres were meadow and the rest pasture. One of the meadows, Ridding, was quite a distance from the farm on the Stanbury side of the beck near Sladen Bridge. In 1813 Ridding looks to have been an arable field.

From at least 1841 until the 1860s the Shackletons worked as stonemasons. Like their neighbour John Laycock they probably worked at one of the quarries on Penistone Hill whose tips can be seen ahead. There was also at least one handloom at Springs that was in use until the 1850s. When the building was examined before

its restoration the slots into which the handloom had been fixed could still be seen in the beams.

In the valley below Springs was another farm, Lower Laithe, which was lost to the reservoir to which it gave its name. Like Springs it belonged to the Taylors who lived at the Manor House in Stanbury. In 1851 John Clapham was farming around 13 acres at Lower Laithe. Most of the 4 acres of meadow was just across the beck in Stanbury. Clapham, assisted by his wife Hannah and his daughter Mary, also worked as a wool-comber.

Lower Laithe Reservoir was built between 1911 and 1925 by Keighley Corporation Waterworks. It had been planned as long ago as 1869 when an Act of Parliament was obtained to construct reservoirs for Keighley in the Worth Valley. Watersheddles and Ponden reservoirs were built in the 1870s but the proposed Bully Trees and Lower Laithe reservoirs were deferred for some forty years. When the proposed Bully Trees dam site was examined in detail it was found to be unsuitable and a revised plan for a larger reservoir at Lower Laithe was submitted to Parliament. This is the reservoir which was opened by the Marquis of Hartington in 1925.

Beyond Springs there is a cattle grid to cross shortly before the Oxenhope–Stanbury road is reached. At the junction of the Enfieldside track and the motor road an old, sunken lane can be seen running down toward the reservoir. This is Waterhead Lane, the old road to Stanbury village. It had to be closed when Lower Laithe Reservoir was built and was replaced by the new road over the reservoir embankment which opened in 1925.

At the road turn left and walk down toward the reservoir. The farm on the left is Intake, the last of the Enfieldside farms still working. There is a date stone over the door which reads MMP 1761. The couple whose initials appear in that inscription might just have been ancestors of the Joseph Pighills who lived there in 1813. He farmed 23 acres as did Holmes Pighills in 1838 and Mary Pickles (formerly Pighills) in 1851. This relatively large farm had 9 acres of hay meadow and 14 acres of pasture. Mary Pickles had another 2 acres of pasture on the Stanbury side of the valley. None of her family was a textile worker but a lodger, Thomas Howcroft, was a wool-comber. There was a handloom weaver, George Holmes, in the cottage next door. Holmes's wife was a bobbin winder and his son a wool-comber.

Intake now farms the whole of the Enfieldside land which is still productive.

In the field wall below Intake is a date stone bearing the initials IAW and the date 1706. It is tempting to think that this might have come from Lower Laithe but a list compiled by the Stanbury schoolmaster Jonas Bradley tells us that the date stone there read SMT 1819.

Just before the reservoir a track goes off to the right. Follow this track past the gate to the Sladen Valley Water Treatment Works which opened in July 1994.

On the right is a deep hollow which used to hold a small reservoir known locally as the 'Blue Lagoon'. It held a supply of water which was used to wash the sand from the filtration beds. Around 40 yards further, just before the track starts to climb, a gate on the left marks the site of Dale Moor (pronounced Dollymoor) Farm. Dalham Moor (as it appears in the court rolls) was bought from Michael Heaton by Richard

Emmott around 1775 adding to the Haworth estate which he had acquired around twenty years earlier. Joseph Sunderland was Emmott's tenant at Dale Moor for most of the nineteenth century. He was there in 1813 and he died there in 1878. During that time he and his wife Susan (who died in 1864) farmed around 13 acres of land, one third meadow and two thirds pasture. His three bachelor sons, William, Joshua and Joseph, were handloom weavers in 1841. Thirty years later all three were still unmarried. Joshua had become a carter during the 1860s but William and Joseph were still weaving. After their father's death in 1878 and William's in 1880, Joshua and Joseph took over the running of the farm. Joshua died in 1886 and Joseph was joined at Dale Moor by his uncle, another Joshua, by 1891. Joseph left Dale Moor during the 1890s and spent his last years at Hollings nearby. He died in 1905 and is buried in Haworth churchyard with his parents and brothers.

Joseph Craven (Craven, 1907; pp. 88-9) says that his family got their milk from the Sunderlands for forty years. He gives us an invaluable description of Dale Moor as he knew it (see Pl. 35):

> The farm was better known as Dolly Moor, and by this name all the Sunderlands were known, 'Doad o' Dolly Moor,' etc. I have spent many hours here watching the men weaving at the hand-looms and the women winding the spools. At other times the mother would be baking oat cakes on the 'baxton,' that is, the bakestone. The house was large and old fashioned and furnished according to the times. It stood on the hill side. Standing at the door you would have seen a wood partition which shielded the hearth stone from the door. As you entered you might have seen a flat bottomed chair, an oak chest of drawers, then two oak-cased clocks, and a 'turn-up' bed. There was a large oak plate-rack filled with plates of an old-fashioned type. Following under the windows was a large table; turning towards the fire you saw the 'baxton.' The centre of the house was for chairs etc. Near to the fire, at the time the writer used to go, sat the old farmer. There he would sit and talk on all kinds of topics. Often he would tell about the battle of Waterloo and how they used to cast lots to get the young men to be soldiers, how they used to go to Haworth Fair and how the recruiting soldiers would be there and what amount of money they would offer to young men. He would often talk about what they had to eat, and how seldom they got wheat bread and at what price it stood. It was then 7s. per stone and very poor stuff even at that high figure. He often told about having to go to Laycock [a village near Keighley] for flour and having to come back with barley meal.

The presence of 'two oak-cased clocks' might seem unusual. It might be connected with the fact that the Heatons, who were here before the Sunderlands, were clock makers.

The track continues up to Cemetery Road which skirts Penistone Hill. When the reservoir was being built the track was used to carry stone from Dimples Quarry to the construction site. It is said to have carried a branch of the reservoir railway (Bowtell 1988). Certainly a section of rail can be seen standing beside the top of the track.

A few yards along Cemetery Road toward Haworth is a gate giving access to the cemetery. This municipal cemetery was opened in 1893, the church burial ground

having been closed in 1887. There were burials at St Michael's after 1887 but only in existing graves which were not yet full. It is worth going into the cemetery to see the grave of Lily Cove. Go up the path from the road to the main entrance, walk up to the perimeter path and turn right. Lily Cove's grave is marked by the black marble stone on the left. Elizabeth Mary Cove was a parachutist who appeared at fairs and galas around the country. On 11 June 1906 she took off from Haworth gala field on West Lane suspended from a balloon. The planned parachute descent went badly wrong and she was killed in a fall near Ponden Reservoir. The balloon and parachute are depicted on her gravestone, which was erected by public subscription.

From the lay-by just beyond the cemetery there is a footpath which may be taken to avoid walking on the road. After reaching West Lane look out for a small gate on the right immediately past the bus stop sign that gives access to a stone-flagged path across the fields to the Parsonage. Like the fields to the south of Stanbury these were very probably medieval arable fields.

There is, of course, much of interest in Haworth itself. Most visitors will want to see the Parsonage Museum and St Michael's church with its Brontë memorials and remarkable burial ground. In the village are many buildings which date from the eighteenth and nineteenth centuries, many of them associated with the domestic textile industry. A little further away is the Haworth station of the Keighley and Worth Valley Railway, which operates steam trains to Oxenhope and to Keighley. Haworth also offers a range of facilities for the walker, cafés and public houses abound and there is a wide variety of shops.

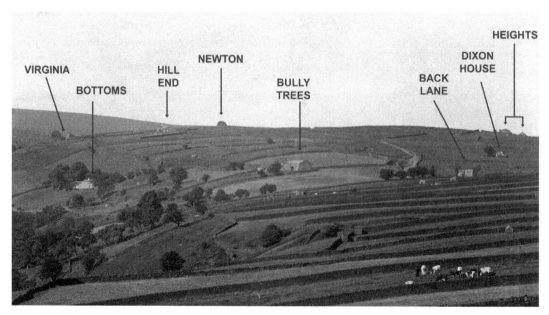

The farms on the way to Withins. An early twentieth-century view of the lower part of Stanbury Moor taken from Stanbury village with the farms identified.

Back Lane (R) and Cold Knoll (L) in snow, 1912.

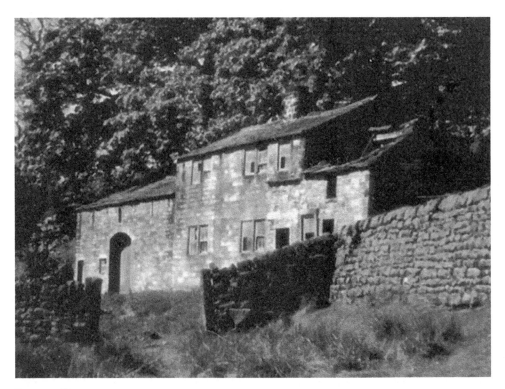

Bottoms Farm, *c.* 1970.

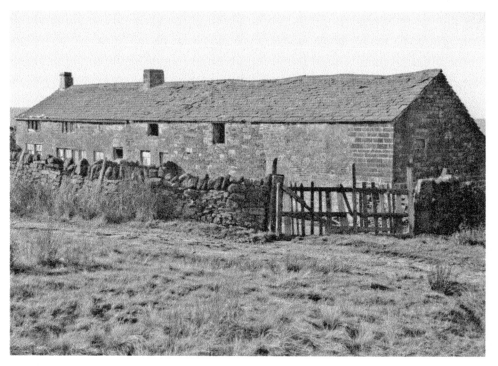

Lower Height, photographed by Harold Horsman in 1965.

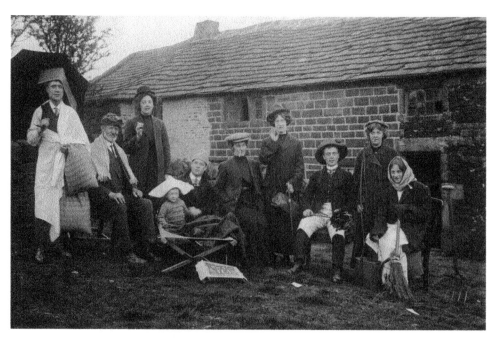

An intriguing, but so far unidentified, party in fancy dress. This most unusual group was photographed at Lower Height, perhaps around 1930, by the Haworth photographer Fred Shuttleworth.

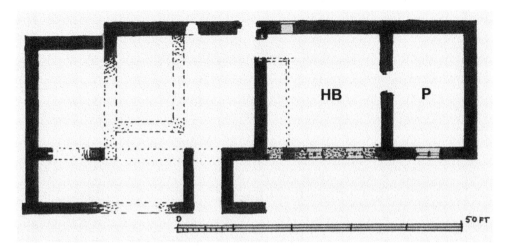

South Dean. This gable-entried, late seventeenth-century farmhouse was particularly well built from large well-cut blocks of stone, although little now remains except for its back wall. Its main living room was the housebody (HB) with its wide fire-hood, and the parlour (P). Their door-jambs had deep slots for sliding bars to secure their doors.

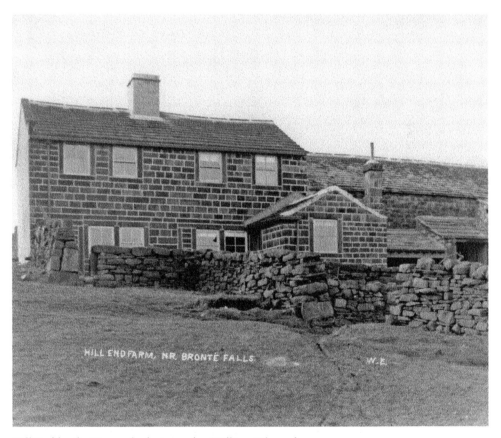

Hill End by the Haworth photographer William Edmondson *c*. 1910.

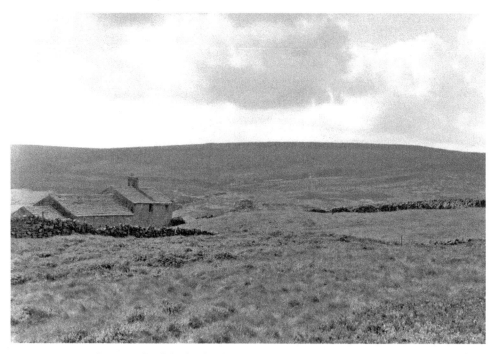

An anonymous photograph of the back of Hill End, which emphasises the lonely situation of the farm.

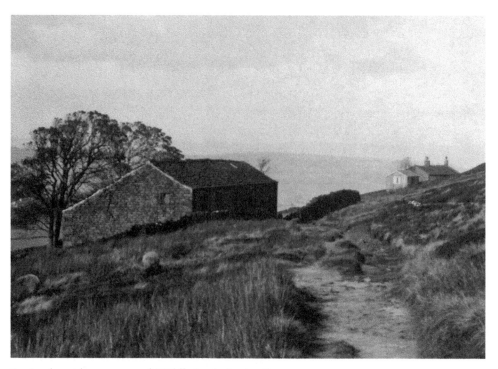

Far Intake with tearoom and Middle Intake in the distance, 1920s.

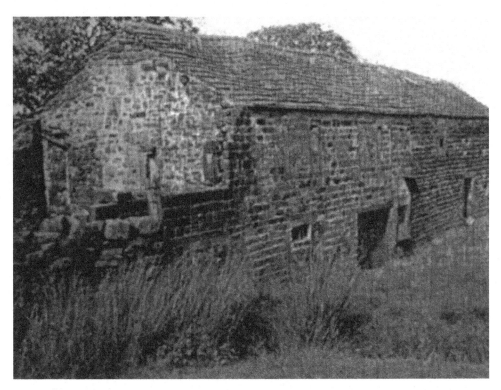

Far Intake, early 1960s.

Metcalfe's Tearoom near Middle Intake. Alice Hannah Metcalfe (seated without hat) and her three daughters Linda (in doorway), Audrey and Edna, 1920s.

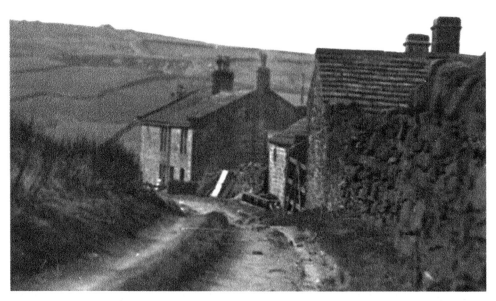

An early twentieth-century photograph in which both the Middle Intake farms are seen.

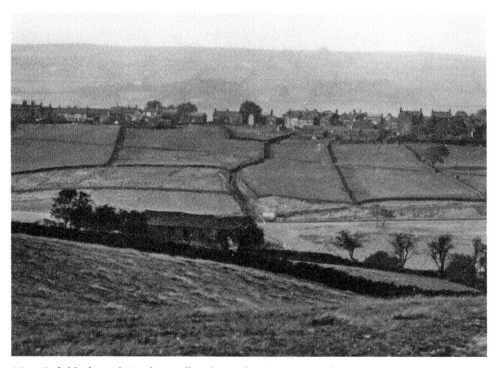

'Near Enfieldside' with Stanbury village beyond. Perhaps around 1930.

Springs: another of Harold Horsman's splendid photographs, this one taken in 1964.

A man rests on the grass bank above Dale Moor in the early twentieth century.

92

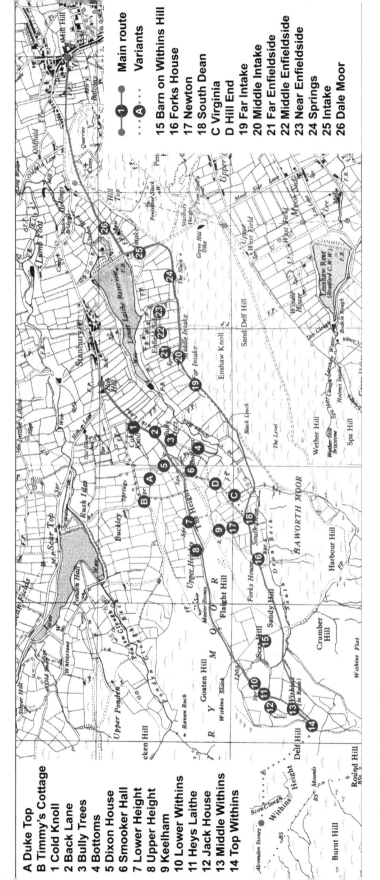

A walk to the Withins farms.

A Duke Top
B Timmy's Cottage
1 Cold Knoll
2 Back Lane
3 Bully Trees
4 Bottoms
5 Dixon House
6 Smooker Hall
7 Lower Height
8 Upper Height
9 Keelham
10 Lower Withins
11 Heys Laithe
12 Jack House
13 Middle Withins
14 Top Withins

Main route
Variants
15 Barn on Withins Hill
16 Forks House
17 Newton
18 South Dean
C Virginia
D Hill End
19 Far Intake
20 Middle Intake
21 Far Enfieldside
22 Middle Enfieldside
23 Near Enfieldside
24 Springs
25 Intake
26 Dale Moor

# TIMOTHY FEATHER, THE LAST OF THE HANDLOOM WEAVERS

In 1841 there were 116 handloom weavers in Stanbury hamlet out of a total population of 971 people. Ten years later the population had grown to just over 1,000 but there were only 73 handloom weavers. Over the next half century the population of Stanbury all but halved – there were just 511 people living in the hamlet in 1901. Of these only one was a handloom weaver.

That solitary craftsman was Timothy Feather of Buckley Green (also known as Buckley Green Bottom).

In the chapters on Withins and the other farms of Stanbury Moor we saw the importance of handloom weaving and other domestic textile trades in supporting the small moorland farms in the first half of the nineteenth century.

By the early twentieth century Timothy Feather had become a rarity and was visited by photographers, journalists, people wishing to buy cloth and the merely curious. A number of these visitors left accounts of their visits and a great many photographs. The fact that 'Timmy' lived and continued weaving into the twentieth century means that we have an unusually good picture of the life and work of the handloom weaver. Although his dwelling was not on the Withins moors, we may take him as representative of all those who were weaving in the moorland farms since the invention of the flying shuttle. Timmy's connections with Withins were however closer than it might seem. We have already seen that his oldest brother, Robert, farmed at Forks House and that his sister Mary was possibly the wife of Jonas Sunderland (d. 1888) of Top Withins. In fact his connection is even closer than that: he was born at Middle Withins. So strong is the association between Timmy Feather and the cottage at Buckley Green that this fact has been completely overlooked.

James Feather married Ann Jackson at Haworth parish church on Christmas Day 1800. James was perhaps the son whom John Feather of Stanbury had baptised in January 1779. It has not been possible to find a baptism record for Ann Jackson but she was probably related to the Jacksons who were at Withins from the 1780s or earlier. James's and Ann's first child, Robert, was born at Withins on 17 March 1801. Robert was followed by Mary (1803), Lydia (1805), John (1807) and James (1810) who were all born at Withins. In 1812 George was born at Duke House (later Duke Top). The 1813 valuation confirms that James Feather was living in a cottage at Duke House, Coltknowl End. The ruins of this house can still be seen around 100 yards south of the

track from Cold Knoll to Buckley Green (SD999366). In 1815 a daughter, Sally, was born at Dickson House (later Dixon House) which has been mentioned as being in the fields belonging to Cold Knoll. The Feathers then returned to Withins where William was born in 1819, followed by Ann in 1821 and Timothy in 1825. The birthplace of these last two is only given as Stanbury in the parish registers but Timothy is stated to have been born at Withins in the 1891 census. A rate book of 1819 makes it clear that the Feathers were at Middle Withins alongside the Jacksons.

Timothy was born on 20 January 1825 and was the last of the Feathers' children. It seems probable that his mother died just five months later. Patrick Brontë buried an Ann Feather of Stanbury on 27 June 1825, who was forty-one years old at the time of her death. If this is the right Ann Jackson she must only have been sixteen or seventeen when she married James Feather. One complication here is that there is a report (YDO 1909) of Timmy having spoken of his mother as though he remembered her.

By the time of the 1841 census James Feather was a sixty-year-old widower living at Lower Slack (near Ponden) with three of his children, George, William and Ann. James junior was living at Buckley Green with his wife Betty, their four children and his younger brother Timothy. Also living at Buckley Green was Sarah (baptised as Sally) with her husband John Clayton and their three young children, Robert, Ann and John. The oldest of James and Ann Feather's children, Robert, was living at Forks House with his family – they are dealt with in the section on Forks House.

James Feather senior, James Feather junior, Robert Feather and John Clayton were all stuff weavers. No occupations are given for the other members of their households but it is reasonable to assume that they were involved in worsted weaving in one capacity or another. In other words most of Timmy Feather's family were handloom weavers in 1841.

There is much less certainty about James Feather's other children but the best matches found in the records are given here. Mary Feather might have been married to Jonas Sunderland at Top Withins. Lydia Feather had probably married Robert Shackleton, a joiner, in Bradford in 1830 and was living in Bradford. The Shackletons later moved to Oxenhope where they lived at Shaw Top. They are both buried in the Lowertown Wesleyan burial ground. John Feather, the fourth of James's sons, might have been the man of that name who married Ann Holdsworth in 1829. John and Ann Feather were living at Stairs Hole in Oxenhope in 1841 and 1851 but by 1861 had moved to one of the Enfieldside farms. They and their children all worked as handloom weavers.

By 1851 old James Feather, now seventy-two years old, had moved to Buckley Green with his sons George (thirty-eight) and William (thirty-four). Ann had married William Holdsworth in 1845. They were both wool-combers in 1851 and lived in Stanbury with their two young children, James and Alice. The younger James Feather (forty-one) and his wife Betty (thirty-six) now had seven children between the ages of one and eighteen. Timmy, twenty-five years old, was still living with them.

Sally Feather's first husband, John Clayton, had died in 1844 but she was still living at Buckley Green with her second husband, Thomas Lund. They had married in Keighley in June 1849. Sally's children Robert, Ann and John Clayton were living with

them along with her youngest child Wilkinson Lund. They were soon to move into one of the two cottages now called Wildfell.

Six of the Feathers at Buckley Green, including Timothy, were handloom weavers, one was a wool-comber, one a wool carder and one of the children was a bobbin winder. Three more were working in a textile mill.

In 1850 the Haworth tithe map was surveyed and from it we can get a good idea of the buildings in which the Feathers and their neighbours were living. Approaching Buckley Green from Cold Knoll there were two cottages on the right which were owned by William Sunderland's executors. These are now known as Wildfell. The occupiers in 1851 were Martha Sunderland and John Nicholson. Martha Sunderland was a thirty-nine-year-old widow who lived there with her father James Shackleton and her daughter Mary. John Nicholson, aged thirty-two, lived with his wife Sarah and son William. Both the Nicholsons worked in a worsted mill, almost certainly Griffe Mill where they were living in 1861. They had moved by 1854 (rate book) and the house had been taken by Thomas and Sally Lund. A little further on was the farm which was down to the right. It is now called Buckley Green Bottom Farm. In 1851 there were a mistal, barn and other buildings that were used by the John Crabtree of Cold Knowl End. There was also a cottage which was occupied by Timothy Smith, a 67-year-old handloom weaver, and his wife Sarah.

Beyond the farm the track splits in two. The right fork goes past the backs of the Feathers' houses and down to Buckley itself. This then consisted of two farms and a cottage. The first farm was occupied by Samuel Shackleton who farmed 11 acres. He and his wife Sarah were handloom weavers. The oldest of their five children wound bobbins for them. In the cottage was Joseph Sunderland, a thirty-four-year-old widower, who was also a handloom weaver. His daughter Sarah (fourteen) wound his weft onto bobbins for him. At the second farm was John Walton Moore. He farmed 14 acres of land while his illegitimate son Jonathan Sunderland was a wool-comber. Both these farms were, as one would expect, dairy farms as is shown by the mistal and barn belonging to each of them.

A few yards on the left fork at Buckley Green are the four back-to-back cottages called Buckley Green. These were the main home of the Feather family. The tithe award and 1851 valuation show that James Feather senior, James Feather junior and Isaac Butterfield were living there. It seems very likely that Thomas and Sarah Lund were also in one of these houses but this cannot be proved: they are in the 1851 census returns but not in the tithe award or the 1851 valuation. The Feather and Lund households have already been detailed above. Isaac Butterfield was a thirty-three-year-old handloom weaver. His wife Sally and her sister Matilda Sunderland were weaving in a mill. Sally's and Matilda's mother, Betty Sunderland, who also lived with them was a bread baker. Betty was the mother of John Moore's illegitimate son mentioned above. Ten years later the Butterfields had gone but Betty and Matilda Sunderland were still at Buckley Green. By 1871 Jonathan Sunderland had taken over his father's farm and his mother and sister, Betty and Matilda, had gone to live with him. It should be noted that Matilda Sunderland was to remain at Buckley, probably in the cottage next to her brother's farm, until her death in December 1909. We shall meet her again later.

The further of these cottages bears a date stone which reads R/GM/1832. Jonas Bradley, in an unpublished note, said that the 'R' stood for Robinson. The house was probably built by the George Robinson who had married Mary Heaton at Haworth in 1807. George Robinson was a worsted manfacturer, possibly at Little Mill and Lumb Foot Mill. He died in 1833, the year after the Buckley Green house was built. The Feathers inhabited this house from shortly after it was built until Timmy died in 1910.

Old James Feather died in 1857 aged seventy-eight and is buried in St Michael's churchyard at Haworth. After James's death Timothy moved in with his older brothers George and William. It was probably this move which brought Timmy Feather to the cottage that has been associated with his name ever since; he would not move again. His move would have helped to ease the situation at James's and Betty's house where there were six children aged from eight to twenty-one. Their oldest son William had married and was living nearby with his wife Elizabeth and their two young children. The Lunds were also still at Buckley Green with two children as well as Sally's daughter Ann Clayton and her illegitimate child.

Of the twenty-one members of the Feather family who were living at Buckley Green in 1861 ten were employed in textile work: four were handloom weavers and six worked in a worsted mill. James was now a farmer and Thomas Lund an outdoor labourer.

From this time the number of Feathers at Buckley Green began to fall as the younger generation grew up and moved away. By 1871 William and Elizabeth Feather had moved to Hob Hill at Stanbury where he was working as a warp dresser. This left ten members of the family at Buckley Green. James and Betty Feather were farming at Buckley Green and just two of their children were still at home. James's three brothers, George, William and Timothy, were still sharing the neighbouring house. Only Timothy was now weaving on the handloom full time although James was weaving as well as farming. Thomas Lund was working as a reservoir labourer as was George Feather. They would have been working at Ponden Reservoir just down the lane from Buckley Green. Three members of the family were employed in a worsted mill.

Thomas Lund died in 1874 and his widow Sarah moved to Hob Hill with her son Wilkinson and his wife Mary. At the time of the 1881 census only two of the houses at Buckley Green were occupied by Feathers. James and Betty were farming; their daughter was a dress maker and their son a power-loom weaver. Next door only William and Timothy were left as George had married in 1875 and gone to live on Well Lane in Haworth. The sixty-eight-year-old George was still employed as a warp twister in a mill. Timothy worked on alone at his handloom. Just one elderly neighbour, Joseph Moore, was also weaving by hand.

Timmy's brother William died in 1888 and was buried with his father at St Michael's. The following year George's wife died and he returned to share the cottage at Buckley Green with Timothy. By 1891 George was retired and Timothy was weaving cotton instead of worsted. James had retired from farming and was living with his wife Betty and daughter Ann. The farm had been taken over by his son James (thirty-seven) who was a widower with a seven-year-old son Albert. Betty Feather died in 1896 and is buried in Haworth churchyard.

In 1901 there were three generations of Feathers living at the farm at Buckley Green: James now ninety, his son James (forty-seven) and grandson Albert (seventeen). The two younger men ran the farm. George had died (probably in 1891) and Timothy was alone in the cottage which is still referred to as 'Timmy Feather's cottage'. At the age of seventy-five he continued to weave at his loom.

The elder James died in 1902 and was buried in Haworth with his wife and daughter (grave D355). The younger James and his son Albert moved to Near Slack shortly afterwards (1904 valuation list).

Although all of Timothy's family had died or moved away he did not long want for company. It was about this time that his fame as the last of the handloom weavers started to spread and visitors began to arrive on his doorstep. From the accounts that some of these visitors wrote we get a much more rounded picture of the man than is given by the official records recounted above.

Timmy Feather was never very sure just when he had been born: 'We hed noa birthdays and teea parties i' them days an' soa aw can't tell reight.' (YDO 1909) When the 1901 census was taken he told the enumerator that he had been born about the time of the Crow Hill Flood (2 September 1824). The enumerator that year was Jonas Bradley, the Stanbury schoolmaster who will have been a regular visitor at Buckley Green. When Jonas was next up there Timmy had second thoughts about the date of his birth: 'Aw believe aw're wrang abaht my birthday. Will there be ony bother abaht it? Aw've been thinkin' on't ower, an' it 're' awther twenty wick afoor t' Crow Hill Floid or twenty wick at after – an' aw'm nooan reight sewer which.' (YDO 1909) The matter was finally cleared up in April 1907 when the Revd T. W. Story, the rector of Haworth, sent Timmy a copy of his entry in the baptism registers. In the accompanying letter Story told Timmy that he had been eighty-two that January and that 'The day of your birth was 20 weeks to a day after the Crow Hill flood, as the bog burst on September 2, 1824.' (KN 1960) He was the youngest of ten children, six boys and four girls. It is unlikely that he had much schooling – certainly he never learned to read or write. He did have a vague memory of reading and writing having been taught at Scar Top Sunday School. He described it as 'a low-raam'd biggin' which, presumably, he must have attended for a while. Still, 'naan o' ya'r fooak cud read or write, an' tha wur ten iv us – all 'and lume weeavers'. (STS) Even with the whole family engaged in weaving times were hard and the Feathers knew great poverty. Timmy was in his teens during the period of deprivation known as 'The Hungry Forties'. Elizabeth Snowden recalled that Timmy had told her mother that 'they had oatmeal porridge three times a day, and bread – wheaten bread – only on Sundays'. (ES) This did not put him off porridge though. When, in 1905, Whiteley Turner asked him if he ever ate porridge Timmy replied, "Do E iver av ma porridge? Eaah! iv'ry mornin', an' thay're t' best meeal E get i' t' daa.' (STS) Photographs of his house in the early twentieth century show that he also ate havercake, probably bought rather than made at home by then. He also had a butcher who called every Monday. The meat he bought needed to be well simmered: 'E caan't chew it es E used ta cud; E's baart teeth.' (STS)

We have seen that he was born at Middle Withins but it is not clear just when he moved to Buckley Green. Whiteley Turner said that he had lived 'under this same roof

ever since he was a lad'. James Smith said in 1908 that Timmy had lived at Buckley Green Bottom for sixty-five years. (JS) Judging by the rating valuations and census returns the Feathers must have arrived at Buckley Green around 1839 or 1840. Although his occupation is not stated in the 1841 census it is very likely that he was already weaving by then. He told James Smith that he and his brothers used to carry their pieces for many miles to sell them when trade was slack. (JS) The Piece Hall at Halifax was their most likely destination on these tramps. When the railway came to Calderdale he and some other Stanbury weavers decided to walk to Hebden Bridge with their pieces and catch the train to Halifax. This would have saved them around 4 miles walking each way. The train however, unnerved them completely; Timmy complained that 'shoo bumped and shoo banged and shoo rattled, an' there wer smoke and steam ivverywheer'. The tunnel just before Sowerby Bridge proved too much – they got off at the old Sowerby Bridge station and walked the last 2 or 3 miles to Halifax. (RC) The railway between Hebden Bridge and Halifax had opened in October 1840. If the weavers made their trip in the first few months that it was open they might have encountered Branwell Brontë when they fled the train at Sowerby Bridge; he worked there until the end of March 1841. Timmy must have overcome his fear of rail travel later in life as he visited Morecambe Bay three times and once went as far as Liverpool. (STS) On one of the Morecambe excursions he even went to sea: 'E paid a shillin' et Marcum ta gu on t' watter, an' E rade reyght aht, an' it niver tuke naa hod o' ma; it macks sum fooak pick up [vomit], ya kno'. Eaah!' (STS)

This trust of novel forms of transport did not extend as far as the motor car though. It is recorded that a car came to Buckley Green to take Timmy to vote in an election (probably the general election of 1906). He refused to get in the car until stones had been wedged under its wheels to stop it moving. (ID) This is probably the occasion captured by Jonas Bradley when he photographed Timmy sitting in John Rushworth's car (a 1905 Rexette tricar).

From his youth until the 1880s he wove worsted cloth. As he told Keighley Snowden, 'I once wove worsted, reighte good pieces. I don't think there's ony pieces made now like 'em. What I wave 'em for – worth £5 a piece and 42 yards long, nobut! I did. I could ha' wovven one 'i nine days happen, an' I hed six-an'-twenty shillin'. Ea!' (KS) He also spoke of those days to James Smith: 'Aw used to weyve worsted, an' aw cud addle summat then. Ther' wor a lot of handloom weyvers i'them days." (JS)

Handloom weaving was hard work and weavers worked long hours but Timmy still found time and energy for recreation. He had been a renowned clog dancer and jumper as Whiteley Turner recorded: 'His greatest delight in his younger days was jumping and clog-dancing; "an' mind yo,' says he, 'a brother o' mine an' ma cud clatter it." He relates with pride how he once saved his native village, Stanbury, from disgrace at the hands of the Haworthites in a jumping match, by cutting a rival's mark by over two feet!' Dancing and jumping were not accompanied by wilder ways, he was 'niver whaat ya ma call a bad'n'. He did not drink and wondered why anybody would. (STS) Although an abstainer he did smoke tobacco. During Whiteley Turner's visit Timmy filled a short, black, clay pipe with shreds of tobacco from his waistcoat pocket saying, 'E av a pipe naa an then. It's naa'en a yar sart o' bacco E reck'n.

E'er niver used ta baa mare na tue macks - leet an' dark - naa, e'ers a scaare or tue diff'rent saarts.' (STS)

Turner tells us that 'Timmy abhors Sunday visiting, and will not on that day talk of his loom, or allow any to see it. He has grown very devout in his latter days.' (STS) Nearly fifty years ago I spent an evening talking to a ninety-year-old man who had once met Timmy. He had been in a group who called at Timmy's cottage while out for a walk on the moors. When they left the leader of the group gave Timmy sixpence. As they walked up the moor path behind the cottage the leader made them pause and look back. Timmy was standing in his doorway with his head bowed. 'He's giving thanks to God for the sixpence.'

The market for hand-woven worsted declined, causing him to lament, 'Handloom weyving isn't what it used ta be.' (JS) The obvious move to power-loom weaving in a mill did not appeal to him: 'aw nivver made nowt o' paahr-looms. Aw once tried it, but aw liked mi own loom best at hooam. an' aw gav' ower in an hour or two.' (JS)

When worsted weaving on the handloom no longer paid he switched to weaving cotton twill. It is not clear where his market for this cloth was in the 1880s but by the twentieth century his customers came to his door anxious to buy. He bought his warps and weft from local spinning mills. There are a number of photographs (taken in 1904) of him 'bargaining over a warp' with the Merralls who had large mills in Haworth and Oxenhope. Incidentally the Merralls were connected by marriage to the Robinson who had built Timmy's cottage.

Once a new warp was set up in his loom he could weave many pieces before requiring a new one. Whiteley Turner inquired about this: 'Did ya saa whaat langth wur ma warp when E first gat it? This et E av in naah wur fower 'underd yards lang when E started on't five or six weeak sin.' The cloth found a very ready market – indeed he could not keep up with the demand: 'E daar saa E'll 'av wovven a 'underd yards fra it naah; but it's all gaan, an' iv E'd es mich agaan ready E cudn't ableage iverbody et waants sum. Fooaks 'r plump weearisome; thay're fit ta pool ma aht o' t' 'ahse fer 't.' When Turner had this conversation with Timmy in 1905 he had just been obliged to increase the price of his cloth: 'Haa mich do E sell ma cotton a yard, did ya ax?' 'Waal, E 'av sell'd it at savenp'nce-awpney, but thay rase ma t' waft a awpney a pund, abaat three weeak sin', an' E'm faarst ta charge eightp'nce naah; E caan't work fer nowt, ya kno'; Naah!' (STS)

Part of the trouble was that he could no longer work such long hours as he did when younger: ''Am gettin an oud man naa, and weyvin's hard wark' (CHD), 'Aw can nobbut weyve abaaht five yards a day nah.' (JS) Another problem was his difficulty in getting weft yarn: 'Naa, ya'll na'an 'inder maa fra ony wark. E's na'an ower 'tic'lar thrang just naa; E's raather short o' waft.' (STS)

Most of Timmy's many visitors came in the hope of seeing him working at his loom. He would generally take them up to the chamber so they could watch him 'weyv a pick er two'. (MH) When weft was in short supply the demonstration would be correspondingly short so as not to disappoint other visitors.

Before any weaving could be done the weft yarn had to be wound from the hanks he bought onto small bobbins (or pirns) which fitted into the shuttles. For this Timmy

had two main pieces of equipment: the swift top and the bobbin winder. Many photographs were taken of Timmy winding bobbins. Whiteley Turner records one occasion: 'Spool-reel, swift-top and armchair are requisite to complete the picture, and these are quickly placed outside the cottage door. Timmy has undergone the process such a number of times that he knows exactly what is required of him, and the instant the photographer is ready he betakes himself to his armchair, sitting as if winding a spool.' (STS)

Timmy never ceased to be amazed at the interest shown in him and his craft: 'Ivry daa's alaaike a'most, e'ers allus sum'dy cumin ta luke et ma, aither fine fooak er poor fooak. E caan't seea whaat thay con seea i' aither maa ert' owd lume.' (STS) He remarked in bemusement that he had had his photograph 'taen maany scooas o' times. Ya con buy ma fer tuppence on a paast-card, aaither i' Stanb'ry, Ha'orth, Keeathla or Bradfo'd, thay saa. Eaah!' (STS) He would have been even more astounded to learn at what prices these postcards now change hands (one of those reproduced here cost £20 recently).

Several visitors left descriptions of his work at the loom but some are rather confused as they did not properly understand the loom and its operation. Perhaps the best is James Smith's description: '... the old man led the way upstairs, lamp in hand, for by this time it was getting quite dusk. After watching him for some time weaving his fine twill cotton, working the four treadles at one time, moving the sleigh-board or hand-tree, manipulating his picking stick and shuttle, and breaking off from time to time to attend to this little matter and the other, one marvels at his activity and alertness. No need of spectacles here. With the aid merely of a small oil lamp, his sleeves tucked up almost to his shoulders, the old man, apparently insensible to the coldness of the room, went on with his "weyving", intensely proud of the product of his handiwork. ... "Eeahgh, it's a bit of gooid cotton."' (JS)

Keighley Snowden gave a little more detail of the process: 'The left arm pulls the sleyboard, the right arm throws the shuttle; the feet move upon the treadles, 1-3-2-4, 1-3-2-4.' He also described the sound of the weaving: 'Timmy's loom is of wood, and makes but a dull plunge. It goes click-plug, click-plug – 106 unvarying beats to the minute. Any time this sixty years you might have heard it – the last heart-beats of a dying industry.' (KS)

There is an often quoted calculation of the amount of weaving that Timmy must have done on his loom over the years that he worked at it: 'on this ancient loom he must have woven in sixty years, at a modest computation, 234,780 yards of stuff. This supposes that on the average he has worked 250 days of ten hours in the year. The mark of his grasp on the 'hand-tree', or sley-board, states the fact impressively. Sixteen picks to the quarter-inch of cloth, 36 inches in a yard. If this be taken as the average, his hand has pulled and pushed on the moulded place 540,000,000 times.' (KS) (see Pl. 37)

A few samples of the cotton cloth that he wove survive today. One is part of the last piece that Timmy wove before his death. On examination it proved to be a 32 inches wide, 2/2 cotton twill with hopsack selvedges. It had 46 ends to the inch and 60 picks to the inch.

It was a very hard-wearing cloth which 'had the reputation of wearing like pin wire'. (KN 1910a)

Those who came to Buckley Green were often as struck by the quaint interior of the house as by the old weaver himself. Keighley Snowden left us the best description of the jumbled room in which Timmy lived: 'There is an eight-day clock, with three other time-pieces, of which the only one going is a cuckoo clock with naked weights and pendulum. There are four birdcages, two cases of stuffed animals, two oak chests, a chest of drawers, a long table, three or four old carved chairs, and his bobbin winder, all packed into a space 15 feet square, and the floor is strewn with bowls and tins, and the table littered with all a bachelor's kitchening – jugs and mugs and basins, syrup tins and a porridge thible, old spoons and forks thrown anyhow, a tea-pot, plates, a clay pipe, and a dusty tea-caddy. There are no birds in the cages now; he could not keep them singing after his brother died, not understanding them; but three sickly plants survive on the window ledge, and the walls are covered close with pictures.' (KS) (see Pl. 36).

Whiteley Turner described how Timmy had to evict hens from the house before they could sit down and talk: 'scrambling on to the table amid a jorum of pots, pans, tins, etc., securing two early spring chickens from amongst the window plants and politely transmitting them to the open air'. He kept around eighty hens whose food was kept in sacks in the chamber. He maintained that they kept him 'fra rickettin, when short o' waft or warp'. (STS)

There was only one other room at Timmy's house, 'an upper room, leading directly from the kitchen, was partly given to Tim's loom – a massive thing of wood deeply stained by time and use. The other half was occupied by Tim's bed, also of wood'. (KN 1910a) At the top of the stairs to the chamber 'surmounted by huge stones of native millstone grit, was his press. This was a very important thing in the preparation of Timmy's "cotton" for the market, for he assured [me] that "like hams and bacon, cotton mended wi' keepin"'. (JB 1910)

As to his personal appearance, he was short – no more than 5 feet – and slender. Keighley Snowden thought that you might catch in 'his strong, old face a look of Gladstone and of Dr Temple'. His smallness led to his being called 'oftener Little Timmy than old Timmy'. (KS) Elizabeth Snowden gave a good account of the different names by which he was known, 'His name was "Timmy" only to the visitors, an affectionate name bestowed in the first instance by Mr Jonas Bradley, the village schoolmaster at Stanbury, and thereafter used by the great number of visitors. But to the local community he was "Owd Tim". In addressing him directly we said "Tim" and when my father referred to him in a solemn moment he spoke of him as "Timothy". (ES). Nobody normally called him Timothy "cept fine fooaks".' (STS)

Although the stream of visitors will have staved off any danger of loneliness, not all were welcome: 'Tim liked his privacy, especially on a Sunday when he had his weekly wash. But many people were ill-mannered. They would walk into the cottage without knocking, even go upstairs without being invited. If the door were barred, as my mother recommended him to do when he wanted quietness, they would stare in at the windows, so he then had to draw the blinds for enough privacy to wash himself.' (ES)

He was a proud and independent man who had a horror of not being able to pay his own way. He was grateful for a reduction in his rent which was granted by William Lipscomb – land agent for the Savilles who owned the cottage. 'Once when he coom for t'rent,' he said, "Mr Feather, aw'm bahn to settle yer rent." Aw said, "Thank ye; aw can do wi' 't. It's hard wark mak'in' ends meet wi' hand-weyin'. 'Yah knaw it 'ud allus been 9d. i' t'wick afore an' nah he said it 're to be sixpence i' t'wick. It're a rare do that."' (KN 1910c).

Later he was offered financial help by friends but refused. 'Nowgh, aw wiln't, aw cannot, Ther's been ten on us i' our family – six lads and' fower lasses – an' nooan o' them did it, an aw willn't.' (JS) At Christmas in 1908 a load of coals was delivered to his house, the gift of an anonymous donor (YDO 1909). Shortly afterwards he qualified for the old-age pension of 5 shillings a week. It took his friends a long time to persuade him that this was not charity. When first told of it he said, 'Me, getting brass for nowt. Me, a pauper.' (RC) His objections were overcome at last and we have a photograph of his first pension postal order dated 1 January 1909 and bearing his mark. His reaction to all this largesse was, 'What! Aw nivver knew nowght like it! Nowght to pay! An' they browght a looad o' coils afoor Kursmass, an' nah five shillin' i' t' wick as lang as aw live. An aw've done nowght for nawther on 'em!' (YDO 1909)

Susannah Greenwood, remembered as the kindest woman in Stanbury, used to visit from time to time to clean up for him. (ES) The family of Robert Snowden who were his neighbours from around 1898 gave him much support in his later years and for this he was very grateful. Once when his shirt had become very discoloured, despite his attempts at laundry, Esther Snowden boiled it for him to try to restore its original whiteness. (MH) The Snowden children ran errands for him and delivered his milk. There was an odd episode on one occasion when Lizzie Snowden took his milk: 'he had a big parcel ready wrapped in newspaper and tied with weft. I was asked to take this parcel down to Matilda and say that Tim had sent it for her. I did as I was told, and was surprised to be told by Matilda: "Tak it back, and tell 'im I dooant want it." So I took it back, discomfited and vaguely uneasy that I had been involved in a situation that baffled me. Tim didn't say anything as I handed him his parcel back.' (ES) Matilda Sunderland lived in the cottage at Buckley Farm, which her brother ran. This has been interpreted as Timmy's attempt at wooing Matilda but he seems to have been none too keen to admit any woman to his life. He made his views on women clear to Whiteley Turner: 'E's naa daat thay're vary useful i' thay're plaace, makin' a meeal an' suing yar buttons on, but E think E'll be able ta wither ma bit o' time aart es E am.' (STS)

There was a very touching episode when Lizzie's little sister Lydia took Timmy's milk one day: 'He asked her her name. "Lydia." His face melted; he said wistfully: "I 'ad a sister Liddy," and told her to wait a moment. He produced a small cotton poke from his pocket and drew out a silver threepenny bit and gave it to her.' (ES)

The most charming of all the photographs of Timmy shows him sitting outside his cottage with Mary Snowden standing beside him.

In June 1910, through economic necessity, the Snowdens moved to Haworth. Timmy was dismayed by the news: '"Yah nooan bahn to flit, are yer? I sall niver see 't winter

thru baht yer." My mother explained as gently as she could that the poor income of the intake farm couldn't fill all the children's mouths, and we had to move to Haworth. He didn't say any more, but he wiped his eyes with his red handkerchief and went quietly back home.' (ES)

He died just five months later on 30 November 1910.

I shall never be able to look at that grubby old handkerchief hanging from the loom at Cliffe Castle in quite the same way again. His nephew James had spent the Tuesday evening with him and found him in good spirits, eating a hearty supper and singing an old song. At eleven Timmy went to bed and at midnight James left for his own house. Early the next morning Timmy's neighbour, George Whitaker, found him ill and sent for James. When James arrived he found his uncle too weak to speak and he died soon after. (KN 1910b)

Three days later, 'a wretched day it was – rain, sleet, snow &c' according to Jonas Bradley, Timmy's friends and neighbours arrived at the cottage in Buckley Green to find the windows draped with sheets. Timmy was laid out in an open coffin in the downstairs room where a fire was burning. The mourners crowded into the room as a local farmer-cum-preacher read the ninetieth psalm and spoke of Timmy's life. Two little bunches of white chrysanthemums were placed in the coffin, the lid was screwed down and the coffin was carried out to the hearse. The cottage was locked and the funeral procession made its way through Stanbury to St Michael's church in Haworth. The curate, L. P. Jackson, conducted the funeral service and Timmy was lowered into the grave in which his father and brother William already lay. (KN 1910b) There were Feathers, Moores, Heys, Snowdens Greenwoods, Sunderlands, Whitakers, Nicholsons and other families present. It is particularly interesting that Miss Mary Sharp of Stanbury was among the mourners. (KN 1910b) She was the little girl who had left Top Withins with her father fifteen years previously. Perhaps she was, after all, Timmy's sister Mary's granddaughter?

It was not long before Timmy's loom, his bobbin winder, his hat, his red handkerchief and other paraphernalia were installed in Keighley Museum in Victoria Park. Timmy had agreed to let the loom go to the museum but could not bear to part with it while he lived. When well over eighty he had said, 'Nay, aw mooant part wi' 't. Wahtivver s'all aw do abaht addlin' mi livin' if aw part wi' t'loom?' (KN 1910d) There had been a suggestion of taking Timmy, loom and all to the Bradford Exhibition in 1904. Timmy was willing enough 'but if they touched that loom to move't, why, deary me! it 'ould fall i' bits'. (KS)

The loom was first displayed to the public on Sunday 8 January 1911 (KH 1911a). Following a report in the *Keighley Herald*, as many as 8,000 people turned up to see it the next Sunday. The display room was small and only one door gave access to it. Two glass cases were smashed in the crush, the sole attendant could not cope and the museum had to close early. It was the busiest day the museum had seen since opening in 1899. (KH 1911b)

When the museum moved to Cliffe Castle the loom went with it and was back on display by 1964. It later spent six years in storage but was back in the museum by 1992 and remains a popular exhibit today.

Timmy Feather at the door to his cottage. *c.* 1905.

Timmy Feather in John Rushworth's car, *c.* 1906.

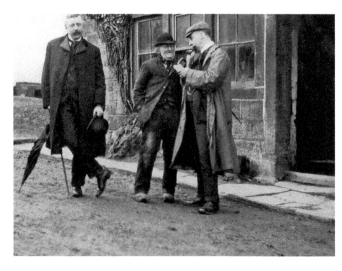

Timmy bartering over a warp with the Merralls, 1904.

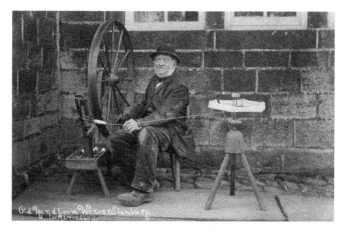

Timmy winding bobbins, *c.* 1905.

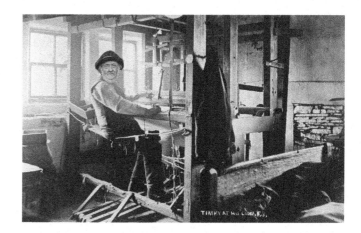

Timmy weaving at his loom, *c.* 1905.

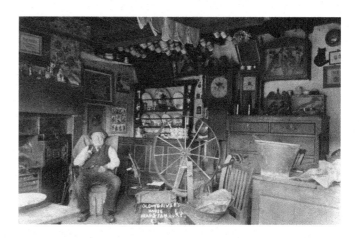

Timmy in his kitchen, *c.*1905.

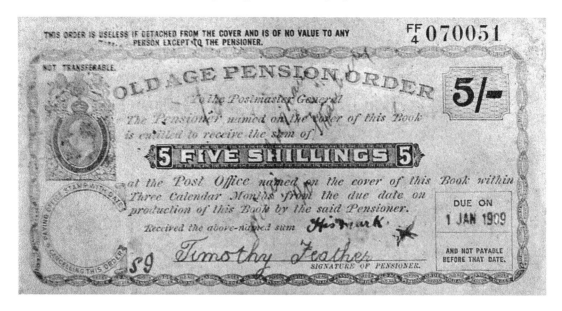

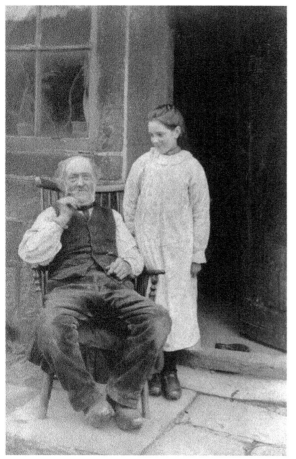

*Above*: Timmy's first old-age pension order, 1909.

*Left*: Timmy outside his cottage with Mary Snowden, *c.* 1905.

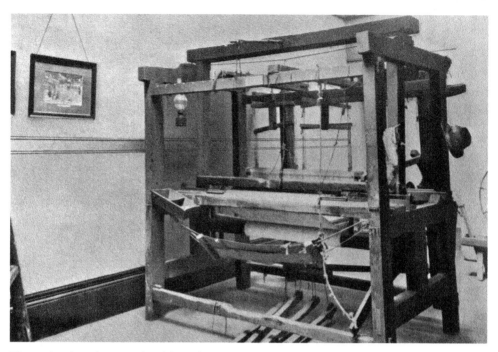

Timmy Feather's loom in the old Keighley Museum at Victoria Hall.

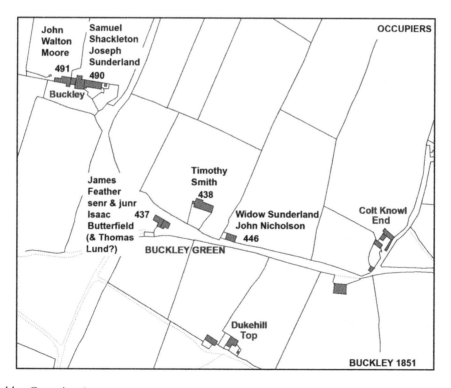

Buckley Green in 1850.

# APPENDIX A

# THE COMPLAINT OF THE STANBURY MAIDENS

Keighley News, 5 May 1866

*To the Editor of the Keighley News*

SIR, – Somebody has been writing to you about the Stanbury bachelors, and inviting the maids of other places, in want of husbands, to make application to them. With your permission, sir, I will tell you and your readers, on behalf of the unmarried females of this anti-conjugal village, a little more about these selfish, good-for-nothing bachelors, so that the foreign maidens may not be taken in with the invitation.

Some time ago it was reported that gold had been found in the neighbouring hills, and most of the male inhabitants – especially the bachelor portion – left their lawful employments and rushed to the "diggings," in eager haste, like too many other folk, to become rich. Yes sir, Peru, El Dorado, California, and Australia were to be nothing in comparison with the Stanbury diggings. Many of the diggers, especially the bachelors, worked day and night; and some of them had a narrow escape with their lives, while undergoing their fatiguing and hazardous labours. After being some time at work, many of them were almost beside themselves with joy at the thought of having gathered, as they supposed, enough of the much-loved treasure to support them through the remainder of their days. It had all the appearance of gold, in its bright and glittering aspect, but, alas! it turned out after all to be a spurious and worthless article, – very much like themselves, I assure you, sir: I mean the bachelors, you know; for if they had been true men, not counterfeits, there had been no need for them to remain in what they are pleased to call in their ignorance a state of "single blessedness."

Yes, sir, I repeat it, there is a perfect analogy between them and the spurious substance they imagined was gold; or else, instead of lavishing all their affections, as they appear to do, on even the real, but insensitive, gold, they would – having first made *themselves* worthy – bestow their love on us, who are capable of loving them in return. Yes, sir, let these unsocial, selfish, half-human creatures called bachelors remember what a wise man once said, namely, that "whoso findeth a wife findeth a good thing," and that the price of a virtuous one is "far above rubies." And I should like to know who dares to bring a charge against the characters of the Stanbury maids! No, sir, this is not the reason of our remaining single; neither is it because we are wanting in outward attractions, though I say it myself; but the real reason is because the men, or those who

like to be thought such, are now looking out for a fortune *with* a wife, instead of a fortune *in* a wife. It is not so much the woman as her wealth they seek to wed, and men like these are not worthy of a wife.

But I must conclude, again cautioning maids in want of husbands from coming to Stanbury to seek them.

I am, sir, yours truly,
AN INDIGNANT STANBURY MAID.

# APPENDIX B

# HARWOOD BRIERLEY'S VISIT TO TOP WITHINS

Extract from the article *Up South Dean Beck* by Harwood Brierley
*Leeds Mercury Weekly Supplement*, 23 December 1893, page 5, columns 3 & 4

I looked up the dean, a mist was creeping down from the high, whistling moor, and as far as I could see, three meanly built farmsteads stood at the head of the valley on a hill-side under the moor, looking a long way into the dean, which rattled down in sinuosities from its origin on the left. These three out-of-the-world abodes are locally called "Th'Withrens" – or, in our maps – "The Witherns" – and the highest one is called "Top oth' Withrens." To-day it seems built right into the sky, and stands with castle firmness.

A hard pull brought me there, and I stepped into the rough stone porch, coloured inside with blue-wash instead of white-wash, and rapped at the door with my stick. I knew that the two houses below called respectively "Middle oth' Withrens" and "Bottom oth' Withrens," were quite empty now, the former having lacked a tenant for some time and the latter being used only at certain periods of the year, and therefore I was not quite sure I should find this "Top oth' Withrens," in its far bleaker situation, occupied in mid-winter, when snow is not for many days together out of the crannies. But at my bidding the good housewife came immediately, looking as jovial and blousy as ever. She recognised me in a moment, although I had only seen her once before, many months ago.

"Will yo come in an' sit a bit?" she asked, widening the doorway space.

I was glad to be accommodated with a high-backed chair in the presence of such hospitality. Here was a good specimen of a north country moorland home. It contained a fire that was not blue and smudgy, but red and yellow; while the hearth looked warm enough to mull ale or roast chestnuts. The walls were, again, blue-washed; the chairs all had tall backs: there were fully half a score lines of oat-cakes stretched across

the dark ceiling: and a curious chest of dark wood fitted into an angle of the walls. Opposite to me, in another high-backed chair, sat a wistful little home-bird for that day – the prettiest little creature that these wilds could surely show, her eyes dark yet "gazelle-like," but she had a certain unrobustness of frame that told of long journeys to and from school, of the coldness and general unsuitability of the clime, and the lack of the influence of merry playmates. There was something that affected me in her vapid listlessness, and I rebuked myself for my intrusion when I saw the shadow of a suspicious glance that perhaps, after all, I might be the new rent man or somebody's bailiff armed with a distraint. The effect that a penny had, would have moved some sentient women to tears.

"Well, I suppose you rarely have a visitor up here in the winter months?" I asked the housewife.

"Not we," she replied. "Yo' see, we're reeght out o' th' world up here. There isn't so many fond o' th' moors."

"Have you ever heard this house, or the hills behind it, called 'Wuthering Heights'?"

"Naa, it gets cawd all sorts, Some reckons it's t' last place God made, but we call it 'Top o' th' Withrens.' T' maister's down i' th' fowld now, but when he comes in he'll tell yo' plainer ner Aw can."

"I should think your winters are very severe?"

"Th' wind maks some flaysome dins at times; we get wer jackets bencilled [buffetted] oft by't; but wer used to it yo' know, an' so we get ower it somehow."

"Does your little girl go to school?"

"Ay, she does when she's fit. But it's a long trail fra here to Stanb'ry all be hersel'. Aw couldn't find i' me heart to turn a dog out on such a day as this."

Having sat a bit, talked a bit, and regulated the clock – time 1.55 p.m. – I proceeded to depart with mixed feelings. Here is an abode, I thought, wherein to mould the genius of an Emily Brontë, and at the same time to destroy life if it should not be particularly robust. Oh; what of the farmer's little daughter?

The "Top oth' Withrens" is the highest house at the head of the South Dean valley. Behind, and still higher, is a waste of trackless moor, which entails a fatiguing walk if your aim is to be in Widdopdale, by which Heptonstall or Hebden Bridge may be reached. From the little yard at the front of the house, Stanbury and Haworth are visible, with the dip of the Worth valley beyond, and on a clear day "Keighley Hoil," with its exalted chimneys and clouds of smoke, is on the north-east horizon. But here no flowers blow, except the ling in summer. The Witherns' early spring-time is not graced with golden crocuses, silver snowdrops, and embossed daisy-cups. No turnips are grown, no potatoes; there are no cows to milk, no wheat to beat with the flail. The live-stock consist of a few black-nosed sheep and roupy fowls, while the sole harvest is the hay-harvest, which in all its meagreness takes place not in June, but August. There is no road to the house, and, therefore, as the occupants are sometimes snowed-up, it behoves them at every "back end" not to neglect the getting in of such a quantity of cinders, turf, and coal as will suffice the winter over.

I am inclined to believe that between the names "Top oth' Witherns" and "Wuthering Heights" there is a powerful analogy. "Witherns" is a somewhat common place-name in the West Riding; but this is the "Top oth' Witherns," and if such was the name of

this house, or its predecessor, in Emily Brontë's day, it may possibly have suggested to her the title for her books. Owing to the nearness to Haworth, and the appearance of the hill on whose side the "Witherns" stand, it was not for mere whim's sake idealised as the actual "Wuthering Heights" in the illustrated edition of the novel. Emily Brontë herself tells us that "Wuthering" is a significant provincial adjective implying atmospheric tumult.

<div align="right">Harwood Brierley</div>

## APPENDIX C

# WHITELEY TURNER'S DESCRIPTION OF TOP WITHINS

*A Spring-Time Saunter*, 1913, Chapter XIII

After that climb of 451 feet from Timmy's we welcome the sound of running water, but are puzzled to know whence it comes. A little searching, however, and we discover a spring a few feet away, literally hidden in a drapery of herbage, and we drink freely. There! an excellent substitute for the cup of tea we dearly should have enjoyed with our open-air lunch.

And this, the Top Withens, is "Wuthering Heights," the name of Heathcliffe's dwelling. The building, however, indicates the situation only of "Wuthering Heights;" we are told, Law Hill, Southowram, near Halifax, where Emily Brontë was teacher from September, 1836 to March or April, 1837, is recognised as the original externally. Notwithstanding, we will make comparisons. In Emily's masterpiece we read that "'Wuthering' is a significant provincial adjective, descriptive of the atmospheric tumult to which its station is exposed in stormy weather. Pure, bracing ventilation they must have up here, at all times indeed. One may guess the power of the north wind blowing over the edge by the excessive slant of a few firs at the end of the house, and by a range of gaunt thorns, all stretching their limbs one way, as if asking alms of the sun. Happily the architect had foresight to build it strong, the narrow windows are deeply set in the wall, and the corners defended with large jutting stones."

The building before us comprises mistal, barn, house – which at one time had a thick coating of plaster – and peat house, substantially and firmly planted end-on to the hill-side. While subjected to "the power of the north wind blowing over the edge," it is considerably more exposed to the storms of the east which drive across Haworth Moor. The narrow windows are deeply set in the wall. The panes originally were evidently leaded and diamond-shaped, for a last remnant hangs partly torn from

a mullion. We peer through this opening, knowing the place is unoccupied, and behold a weird hearth. A rudely-constructed table and seats, a dinted enamelled kettle, and heaped-up ashes in the rusty grate suggest occasional visits by shepherds. Crouching in the cramped house porch we try the door, but find it securely fastened, as are also those of the barn and mistal. Access is only obtainable to the lofty peat house, now serving as shelter for moorland sheep. There appears to be no date on the building. Across the yard, where grass springs up between the rough pavement, are two tiny fenced strips – probably sheep folds, but suggesting an old-time garden – at the top of which a group of young sycamores bend their slender limbs northwards, as if imploring mercy from the elements; at the bottom, beside an outhouse lit with leaded panes, a "gaunt thorn" inclines in the direction of its more youthful associates, and like a decrepit person with bent body, and ready for the call, seems reconciled to its fate. We are tempted to rest on the slab beneath the tree, while we look down the dale into wild expanse. Before us is a sweeping stretch of Haworth Moor, and beyond the eye wanders over the north side of the Worth Valley. Anyone approaching from Haworth (in a beeline over three miles distant), say on a visit to Bronte Waterfall, would be under the ken of our glass till they dipped into "Hazel Dene," a mile below. We would fain linger, but time forbids, and the wind blows chill.

# APPENDIX D

# ERNEST RODDIE AT TOP WITHINS

*Yorkshire Evening Post*, 8 September 1921

A FARM AT "WUTHERING HEIGHTS"

Top Withens, the black and weather-battered old farmhouse, high on the moors above Haworth, known to Bronte lovers as "Wuthering Heights", is about to become the home of an ex-soldier who has commenced poultry farming.

For some few years the house has been unoccupied, as are also the farmhouses of Middle and Lower Withens, down the hill, and it had fallen into a sad state of disrepair, though far from being a ruin.

Tramping over the moors from Stanbury, I was warned by villagers that I should have trouble in reaching Top Withens without a guide, but though the rough moor track loses itself into the heather near Middle Withens, I made my goal. The house, a black mass, stands in the shelter of the moor top, and, once sighted, is a sure landmark.

From the distance an impression is obtained that "t' Top" is a big, rambling house, but a closer inspection shows it to be only a small place – so small as to support the view that Emily Bronte, in her gruesome story, made the farmhouse a composite picture of Top Withens and of High Sunderland Hall, a much bigger building near Halifax.

A fortnight ago the farm buildings presented a dismal picture. The windows were all broken, there was a layer of peaty mixture over the floors, and the papers left by picnic parties were scattered about. It is different now. The poultry farmer has set about his formidable task in no uncertain style, and already the result of his work is apparent.

"I'm a native of Haworth," he told me, "and for many years it was a joke with me that some day I would set a poultry farm at Top Withens. I came out of the army unfit for my former work, and having a fancy for poultry, I took a training school course. I was unable to get a suitable holding, but a short time ago I met the landlord of Withens. We talked, and then he said – he knew my old joke – 'Well, there's Top Withens waiting for you.' Immediately I decided to take it."

"Very soon I came up here and started to make the place fit to live in."

NO TROUBLE WITH GHOSTS

"Any trouble with ghosts?" I asked …

[A paragraph here about the "Wuthering Heights" ghost stories]

"I don't think ghosts would trouble me, or my poultry," was the reply. "I can't speak for the birds but I've slept better in the attic than I've slept for many a long month. I've met no ghosts yet."

The peat house and the hay chamber the poultryman intends to use as semi-intensive chambers for winter. He will make the house comfortable, but will occupy only the rooms he requires, and he intends to get a big supply of books for the winter, for he will live alone.

From Top Withens, it is a mile to the nearest occupied house, and it may be that at times he will find himself unable to get down to Haworth, four or five miles away over the moors. Then he will have the company of Nell, his fox terrier, Tommy, his horse, his 150 head of poultry and his books.

## *Yorkshire Evening Post*, 22 April 1922

FARMING ON "WUTHERING HEIGHTS"
A PIONEER WHO DOES NOT FIND THE MOORS BLEAK OR INHOSPITABLE

*"Only three peewits to an acre at Withens, and one of them starves"*
So say the villagers of Haworth and Stanbury. They merely repeat a phrase which has been in the mouths of their folks for many years. Once all the three Withens farmsteads were occupied, and a hardy people tore a living from the soil. That was a long time ago.

Now the three Withens farmhouses, standing on the fringe of the moors high above Haworth, seem to emphasise the truth of the old saying. Lower Withens – nearest Stanbury – is a ruin, and has been unoccupied for years. Middle Withens – higher up the hillside – is in a similar state of disrepair; and from a distance, Top Withens, known to Bronte lovers as "Wuthering Heights," looks little better.

I stepped onto the moors just beyond Stanbury, and took the Withens track, but it wound about and lost itself, and so did I. Then I cut through the withered bracken – there is but little sign of the new yet – and so came to the crest of a hill.

From the hill, I took a guiding line, passed the two lower Withens, and so came in sight of the black, weather-beaten building of Top Withens. A thin curve of smoke from one chimney told me that the poultry farmer who is trying to disprove the old saying is still an optimist.

He came up the hillside in answer to the barks of his dog and he had a cheery smile of welcome. His hens scattered to meet him; the dog rattled his chain; and a couple of kittens peeped out of the porch to see what the commotion was about.

"Still as optimistic," he said in answer to my greeting. "Yes, I think Top Withens is the place for me all right. The hens get on well, and so do I."

"EVERYTHING ALL RIGHT"

It is close on six months since this ex-soldier took Top Withens over, and all through the winter he has lived there with only the company of his books, his dog, his horse Tommy, and his poultry.

"I am more optimistic than I was before," he continued. "Perhaps I haven't got the house as I should like it, but it's done for me through winter and I hope to be straight for Whitsuntide. Things are turning out better than I expected – everything's all right at Top Withens.

"We have had some rough weather up here, but it's not done any damage. It's been fearfully cold at times since Christmas, and there have been days when the snow's been so thick I couldn't get the cart down to Stanbury. But it's never been so bad that I couldn't get over the moors to the next neighbour who lives a quarter of an hour away.

ON "WUTHERING HEIGHTS"

"A man can't be lonely at 'Wuthering Heights'; Scarce a day passes but some Bronte admirers visit it. I think there have only been two days this winter without someone passing by, and there have only been two days when I have not got eggs from my birds. Thousands of people visit this farmhouse in a year. I've been here the worst half of the year, and I've been surprised to see people here on the most wretched of days. They come from all parts of England, and I've talked with visitors from Scotland and America."

The poultry farmer left the Army a poorly man – he suffered from a crushed stomach, for he was buried in a trench, and from malaria, picked up in Greece. He says the life on the moors has done him any amount of good.

We made a brief inspection of the poultry farm. In the kitchen of the house I was shown a couple of incubators with dozens of day-old chicks, and here I was introduced to the two kittens who prefer dry bread to meat. They never harm the chickens or the hens, but are terrors for mice.

"When I first came up here," said the farmer, "I brought a couple of cats with me. But they didn't like living here and returned to the village. These kittens are settling nicely."

JERRY, THE MONGREL

In the yard Jerry met us. Jerry, as his master put it, is a "cross between a lamp post and a walking stick," and has taken the place of Nell the fox terrier.

Jerry was in sad disgrace. Some young chicks were turned into a pen and Jerry, who is only a six-month's-old puppy, went to play with them. He killed 14.

And now there is need for another horse, Tommy died the other day. He strained himself pulling the cart over the moors and never got over it. He did good work. When the farmer bought Tommy he was aged and thin. But the moor air gave him a new lease of life, and had it not been for the strain he would probably have lived for a long while.

When we were looking through the barn I heard the story of the "Hunter's wind."

The ex-soldier told me that the first question of nearly every visitor to Top Withens is about ghosts. He laughs and tells them to ask Jerry, and Nelson, the one-eyed fowl.

The "Hunter's wind" is different.

AN OLD SUPERSTITION

"One day." He said, "I had my brother staying with me. I brought Tommy up from the village and let him loose in the field. Suddenly my brother, who was in the kitchen, shouted and asked what Tommy was doing. I looked out of the window, and there was Tommy lying in the field. Then my brother exclaimed 'Listen!' and we heard the noise of horse hoofs beating on the ground. I remembered the legend of the 'Hunter's wind' – which is said to foretell a death. I have heard it many times since."

After I had inspected chicken-houses, which the farmer had made with the aid of a saw, hammer, and a table-knife, we made everything secure, and set off across the moors to Stanbury.

The farmer chatted of the birds of Top Withens, and told me of one he could not identify. It hovers round at night making a buzzing noise like a giant mosquito, and he has never seen it, though he has heard it often.

. B. B.

# APPENDIX E

# JOHN LOCK'S DESCRIPTION OF TOP WITHINS

Souvenir Guide to Haworth, John Lock, 1956, pages 64–6

DESCRIPTION OF TOP WITHENS ("Wuthering Heights")
Without knowing the exact date of its construction, it is generally agreed that Top Withens is several hundreds of years old : certain it is that there was a building on this site in Tudor times, which by its unique situation has been a focal point on the Haworth landscape for centuries past.

Although the house has been empty for about a quarter of a century and is in a dilapidated condition, due not so much to the fierce winds as, alas! to the depredations of visitors, who insist in taking away roof-slates, pieces of stone from porch and walls,

and have been known to heave at the timber rafters for firewood, it is nevertheless worthwhile to describe the old place at this point.

Opposite the front porch there are the ruins of a mistal, and on a slope in what used to be the garden, the two hardy sycamores that still survive. There used to grow a mountain ash beside the mistal.

Entering through the narrow porch, you come into a large raftered room with a stone fireplace. A second, smaller room lies through the door opposite, containing also a stone fireplace and from the window of which there is a fine view over the moors towards Haworth. Through a door to your left you pass into a narrow vaulted cellar, On entering this there is an opening on your left, a small compartment with a square shaft in the roof. Putting one's head through this one finds oneself looking through the floor of a large barn which was formerly the peat house.

Turning back into the main room you notice the bottom steps – all that survive of the stairs – that led to the bedrooms, the doorway to one of these still being visible. When lived in, a small attic ran the length of the house - the dormer-window still survives - thus giving the house three storeys.

If we enter "Wuthering Heights" by the wider doorway, we find ourselves in a large barn with the floor at two levels. Here the rafters are of unshaped trunks of trees. A second doorway takes you on into a little back barn with a small window at ground level.

The former entrance to the farm was a bridle-path on the north side (the end of the track is still visible) leading into the garden through the gap in the wall where a stone gate-post remains. On this north wall of the farmhouse is the high window of the peat house – three stone steps used to lead up to it – through which can be seen, opposite, the shaft in the floor which you have looked up through earlier.

It is difficult these days to picture the farm as it was not so many years since, when there were chickens in the enclosed garden and cows on the surrounding moor; and the house itself had oak-studded doors and bottle-end window panes.

# NOTES & REFERENCES

## GENERAL REFERENCES for CHAPTERS 1, 4, 6, 8, 11 & 12

*Printed sources*
Brierley 1893: Brierley, Harwood, *Up South Dean Beck, Leeds Mercury*, 23/12/1893.

Dixon n.d.: Dixon, J.H.; *Folk Lore with Old Things of the Brontës, of Brontë Land and of 'Thrums'*, (catalogue of the Wuthering Heights collection at Oatlands), Harrogate n.d. c.1911.

On Dixon see also: Steven Wood, *Joseph Henry Dixon's Oatlands Museum, Harrogate*, Brontë Studies, Vol. 41 No. 1, January 2016.

Kelly 1889: Kelly & Co, *Directory of the West Riding of Yorkshire*, London, 1889.

KN 1945: *Haworth Couple, A Golden Wedding, Keighley News*, 21/4/1945

T&A 1948: *Far Withens*, Telegraph and Argus, 19/11/1948.

Turner 1913: Turner, Whiteley, *A Spring-Time Saunter: Round and About Brontë Land*, Halifax, 1913.

Whone 1946: Whone, Clifford (ed.); *Court Rolls of the Manor of Haworth*, Bradford, 1946.

YEP 1921: *A Farm at "Wuthering Heights", Yorkshire Evening Post*, 8/9/1921

YEP 1922: *Farming on "Wuthering Heights", Yorkshire Evening Post*, 22/4/1922

*Documents*
*(To indicate the source of every item of information would have overwhelmed the text with footnotes. The sources used in the chapters written by SW are listed below.)*
Abstracts of Withins Deeds 1567–1891 (KLSL, BK466)
Haworth Township Rating Valuations 1813/14 (CC), 1838, 1851, 1863, 1881 (KLSL)
Haworth Township Supplemental Valuation Lists 1863–1894 (KLSL)
Stanbury Supplemental Valuation Lists 1904, 1905, 1917, 1934 (KLSL)
Haworth Township Rate Books 1819, 1845, 1849, 1854, 1856, 1858 (KLSL)
Haworth Township Rate Book 1842 (BPM)
Haworth Township Census Returns, 1841–1911 (copies at KLSL).
Haworth Tithe Map c.1850 and Apportionment 1853, WYAS Leeds.
Haworth Parish Registers (WYAS Bradford, copies at KLSL)
Haworth Churchyard Monumental Inscriptions (Margaret Jennings et. al. KLSL)

Electoral Registers (WYAS Wakefield, online at Ancestry.co.uk, 1919 onwards at KLSL)
Census Returns, Parish Registers etc. outside Haworth were accessed at Ancestry.co.uk

BPM = Brontë Parsonage Museum, Haworth
CC = Cliffe Castle Museum, Keighley
KLSL = Keighley Local Studies Library
WYAS = West Yorkshire Archive Service (Bradford, Leeds and Wakefield offices)

# NOTES for CHAPTERS 2, 3, 5, 7, 10, 11 & 12

*Chapter 2. Farming at Withins*
1. Long, W.H., 'Regional Farming in Seventeenth Century Yorkshire', *Agricultural History Review* VIII (1960) 103–115.

*Chapter 3. Lower Withins*
1. see Jenkins, J.G., *The Wool Textile Industry in Great Britain* (1972) 67, 73–4, 101–2, 125–6, 162–4 for descriptions of wool textile processes at this period.
2. Heaton, H., *The Yorkshire Woollen and Worsted Industries* (Oxford 1965) 197–100 and OED 'Warping'.
3. EDD 'Porty'.
4. Heaton 342.

*Chapter 5. Middle Withins*
1. see Jenkins 85–9 for details of the woolcombing process, also Roth, H.L., *Bankfield Museum Notes, No. 6. Hand Woolcombing* (Halifax n.d.)
2. Heaton 338.
3. Sigsworth, E.M., 'William Greenwood and Robert Heaton, Two Eighteenth-Century Worsted Manufacturers' *Bradford Textile Society Journal* (1952) 66.

*Chapter 7. Top Withins*
1. Coppard, J.T., Engledew Sir F. & Hotson, J.Mc.C., *An Agricultural Atlas of England & Wales* (1976) 39.
2. Watson, J., *The History and Antiquities of the Parish of Halifax* (1775).
3. Watson, 2.
4. Watson, 536.
5. Stuart, E., *The Brontë Country* (London 1888) 171.
6. Bronte. E., *Wuthering Heights* (1841) (1965 ed.) 56.

*Chapter 10. Life at Top Withins*
1. Watson, B.
2. Dixon, J. *Folklore with Old Things of the Brontës, of Brontë Land and of 'Thrums'* (Harrogate 1906) nos. 199–200.
3. Watson, 538, Crump, W.B., *The Little Hill Farm in the Calder Valley* (London 1949) 45.

4. Crump. 51.

5. Crump. 65.

6. Brontë, E., *Wuthering* Heights (1847) 56.

7. Watson, 736.

8. Watson, 545.

9. Brears, P., *The Old Devon Farmhouse* (Tiverton 1998) no. 1432.

10. Cliffe Castle Museum, Keighley, no. 740 donated from Elam Grange 15 March 1917. A further example is to be seen at Shibden Hall, Halifax.

11. Dixon, no. 202.

12. Cliffe Castle Museum, Keighley, nos. 275 donated 1 December 1911 and 613 donated in 1918. Halifax Museum Service AH708 and 1934.46 (re–numbered 1963.175).

13. Gaskell, E., *The Life of Charlotte Brontë* (1857) (1975 ed.) 55.

14. Brears, P., *Traditional Food in Yorkshire* (Totnes 2014) 104–5.

15. Dixon, n. 2.

16. Brontë, E., *Wuthering Heights* (1847) (1965 ed.) 179.

17. Travis, J., *Notes of Todmorden & District* (Rochdale 1896) 118.

18. Brears (2014) 100–2.

19. Walton, J., 'Bakestone Making' *Halifax Courier* 30 October 1937.

20. Crump. 31.

21. Crump, 30, quoting Easther, A., *A Glossary of the Dialect of Almondbury and Huddersfield* (1883).

22. Dixon, no. 5.

23. Leeds University, Brotherton Library, H. Bedford MS 432/4p.97.

24. Brontë, 269.

25. Dixon, Mary Sunderland's loom no. 16; raddle nos. 75 & 286; Jonas Sunderland's loom no. 91; swift no. 106; Jonas & Mary Sunderland's spinning wheel no. 108; false reed no. 221.

*Chapter 11. A Walk to the Withins Farms*

Bisat 1924: Bisat, W.S.: *The Carboniferous Goniatites of the North of England and their Zones*, Proc. Y.G.S., New Series, Vol. XX, 1924.

Bowtell 1988: Bowtell, Harold D.; *Lesser Railways of Bowland Forest and Craven Country*, Croydon, 1988.

Brierley 1928: Brierley, Harwood; *The Swamp of Wuthering Heights*, newspaper cutting [*Leeds Mercury?*] 6 August 1928.

Craven 1907: Craven, Joseph; *Stanbury : A Brontë Moorland Village*, Keighley, 1907.

Dewhirst 1975: Dewhirst, Ian; *Gleanings from Edwardian Yorkshire*, Driffield, 1975.

Dixon n.d.: Dixon, J.H.; *Folk Lore*, (catalogue of the Wuthering Heights collection at Oatlands, Harrogate), n.d. (c. 1911).

Gaskell 1873: Gaskell, E.C.; *The Life of Charlotte Brontë*, London, 1873.

Gill 2004: Gill, M.C.; *Keighley Coal*, Sheffield, 2004.

Hall n.d.: Hall, A.E.; *Views of Haworth*, n.d. (c.1895–1900).

James 1866: James, John; *Continuation and Additions to the History of Bradford*, London, 1866.

Keighley MoH: *Borough of Keighley Annual Reports of the Medical Officer of Health*, 1913–14 and 1921–29.

KN 1866: *Complaint Of The Stanbury Maidens*, *Keighley News*, 5 May 1866

Lewis 1848: Lewis, Samuel; *A Topographical Dictionary of England*, 7th edn., London, 1848.

Rush Isles: The Rush Isles Commonplace Book, MS, WYAS, Bradford 23D97.

Schroeder 1851: Schroeder, Henry; *The Annals of Yorkshire*, Leeds, 1851.

Stobbs 1962: S[tobbs], J.; *Former Packhorse Inn*, *Keighley News*, 15 Sept. 1962.

Thompson 2002: Thompson, Dennis; *Stanbury A Pennine Country Village*, Calgary, 2002.

Waters 1997: Waters, C.N.; *Geology of the Crow Hill, Wadsworth and Oxenhope Areas*, British Geological Survey Technical Report WA/97/7, Keyworth, 1997.

Wood 2014: Wood, Steven; *Haworth, Oxenhope and Stanbury from Old Maps*, Stroud, 2014.

Maps

BGS1997: British Geological Survey, 1:10 000 series, Sheet SD93NE (Crow Hill), 1997.

OS 1852: Ordnance Survey, 6 in. to 1 mile, first edition, Yorkshire Sheet 200, 1852.

OS 1894: Ordnance Survey, 25 in. to 1 mile, first edition, Yorkshire Sheet 200.13, 1894.

Documents

See list under General References above.

*Chapter 12. Timothy Feather*

| CHD | Chas H. Day – *Keighley Herald* 20/9/1907 |
| ES | Elizabeth Snowden – "Owd Tim Feather as seen by the little girl who lived at nearby farm." *Keighley News*, 3/12/1960 |
| ID | Ian Dewhirst – *Yorkshire Life*, July 1959 |
| JB 1910 | Jonas Bradley – "Owd Timmy", *Hebden Bridge District News*, 16/12/1910 |
| JS | James Smith – Labour Leader 19/6/1908 |
| KH 1911a | Anon – "Owd Timmy's" Handloom; A New Attraction at Keighley Museum, *Keighley Herald* 13/1/1911 |
| KH 1911b | Anon – A Record Crowd at the Museum, *Keighley Herald* 20/1/1911 |
| KN 1910a | *Keighley News*, Obituary 3/12/1910 |
| KN 1910b | *Keighley News*, Funeral 10/12/1910 |
| KN 1910c | Anon – The Old Weaver's Rent, *Keighley News* 17/12/1910 |
| KN 1910d | Anon – Timmy's Loom for the Keighley Museum, *Keighley News* 17/12/1910 |

KN 1960      Anon – "Timmy Feather is still famous fifty years after his death at Stanbury", *Keighley News* 26/11/1960

KS      Keighley Snowden, – "The Last Hand-Weaver", *Yorkshire Weekly Post* 23/3/1907

MH      Martha Heaton, – "Recollections and History of Oxenhope", 2006 (MH's visit was in 1906)

RC      Rowland Cragg – "At Home with a Hand-Loom Weaver", *The Dalesman*, Jan 1957

STS      Whiteley Turner – *A Spring-Time Saunter*, 1913 (WT's visit was in 1905)

YDO 1909      Anon – *Yorkshire Daily Observer* 11/1/1909

Documents
See list under General References above.
The census returns and parish registers were the most important sources for this chapter.

# INDEX

*Bold page numbers refer to illustrations*

Glittering view from Top Withins (*Anni Vassallo*).